Octopus

Chinese Watercolours

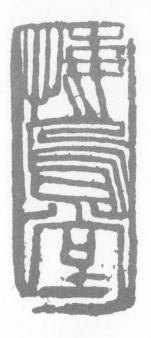

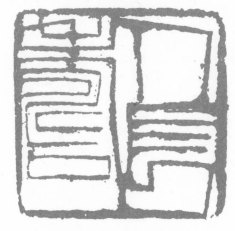

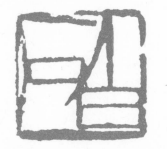

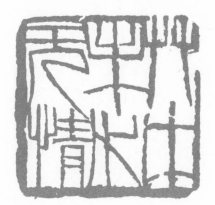

Chinese Watercolours

Text by Josef Hejzlar

Photographs by B. Forman

This edition published 1980 by
Octopus Books Limited
59 Grosvenor Street, London W 1
Reprinted 1983
ISBN 0 7064 0795 4
Printed in Czechoslovakia
2/11/02/51—05

Translated by Till Gottheinerová
Revised by Natalie Graham
and Derek French
Graphic design by Bedřich Forman
© 1978 Artia, Prague

Contents

I Retrospective over a Millenium

The Shanghai School of painting is Chinese in all its facets; inextricably linked to past Chinese culture, it represents a unique continuity in art and thought which cannot be found anywhere else in the world. Nothing changes this basic fact — even if some of the external stimuli on works by the Shanghai masters may have come from overseas. These painters are not part of an exceptional phenomenon in the history of Chinese art, but their work is very striking and enchanting, and represents modern art in the true sense of the word.

The number of surviving pictures, treatises and references in literature can sometimes mislead us about the unique status and values of certain art movements. One might assume from the innovations of the Shanghai masters — which gave rise to certain similarities with contemporary European development — that it took the form of an alien branch grafted on to the old Chinese tree or a Chinese 'Renaissance'. Careful study of the old material reveals that the new trends — at least in the last millenium — played a vital part in the development of Chinese painting. Compared with their predecessors the Shanghai Group enjoyed renown and have left us with a wealth of documentation. They were active at a time when reputation spread more quickly and — what was important — further; their work came into being at a time when the officially acknowledged values were being reassessed. Fortunately, during those few decades that passed when the masters of the School were at work, their fragile scrolls did not suffer damage and loss.

The art of the Shanghai painters represents a logical link in the chain of China's unbroken development over a period of several thousand years. The country's immense cultural heritage, well documented and preserved in general consciousness, was always regarded as a legacy. Such cultural wealth hinged on a free, creative and individual approach to its individual components — it was never a matter of a mechanical follow-up of the preceding movement. Many masters or schools brought old conceptions up to date without worrying about the danger of discontinuity. The national character acted as a mighty magnetic field, in the centre of which currents of various character and intensity arose and vanished. This 'magnet' has an amazing spiritual vitality, because it developed all philosophical, moral and aesthetic aspects of human existence.

This continuity of artistic development was an essential part of the struggle for unity of the country. It was directed against all contrary trends, which were used in power politics and in the economic sphere and were upheld by geographical, linguistic and other peculiarities. Seeking out patterns of the past to understand the old masters, uphold tradition and develop it further — contributed towards the country's spiritual unity and the dialectics of its development. Traditional values depended on natural respect for ancestors, and showing personal modesty and humility, always so highly rated in China. Among the countless artists we would hardly find a single one who did not in some way follow up the past. The principles of Chinese painting were neither so simple nor revolutionary that a painter could afford to neglect the experiences and wisdom of his forefathers.

During a period of traumatic events for the Chinese when traditional values were no longer adhered to, the artistic past became a refuge and springboard for the Shanghai masters. Besides, circumstances were favourable, because the official art of the time was spiritless and rank with indifference. The choice and quest of the Shanghai artists was determined by the period — namely the cruel touch of the West. The specific environ-

ment, the justification of the very existence of a School, the problems of human dignity and the personality of the artist — all these matters influenced the painters. They not only needed the concrete lessons of the past, but authoritative support in their struggle against the dominant conservatism and conformism. The famous names of masters of the older and more recent periods became an exorcism and banner for them.

Flower and bird painting

They came closest to the 'hua niao hua' tradition, the painting of flowers and birds, which at that time were popular subjects of painters with the most frequent commissions. This genre had undergone the most lively and promising development during the last several hundred years. It called for continuation. There existed a directness of relationship and life-giving tension between the artist and the world of nature — which so frequently came to the fore in this tradition of painting. Figural and landscape painting of the time was subject to artistic, philosophical and literary doctrines, and did not offer the creative spirit sufficient courage or confidence. This does not mean that the problems of figural and landscape painting remained outside the sphere of interest of the Shanghai School. Both these genres were highly significant in the work of the School's founders.

'Hsieh-i' painting

Closely connected with the painting of flowers and birds was an art trend that has recently been called 'hsieh-i', which means 'writing the meaning'. The word 'hsieh' means 'to write' and refers to the painter's brushwork, which resembles the calligraphic manner of writing in a loose brush technique. The word 'i' indicates 'meaning' and refers to the content of the work, drawing attention to its significance and the substance of things. It is typical that this endeavour to stress significance in painting deepened interest in the study and observation of nature, on the one hand, and, on the other, more than before accepted the status of the subject in the work; it forced the artist to express his own personal attitude to the world depicted. 'Hsieh-i' painting was not only a matter of less controlled brushwork, as is sometimes suggested, but also of giving greater vent to the artist's imagination and ideas. For this reason perhaps, most works of the 'hsieh-i' style show a far more direct feeling for life than the pictures of the traditionalists.

'Hsieh-i' painting aimed at suggestion, or condensing reality. The formal principles of 'meaning painting' required a minimum of media: all that was needed was ink and a few strokes of the brush. Purity of treatment was a prerequisite of this free expression. This method required high virtuosity in using the brush; it could best be achieved by exacting instruction in calligraphy and precise and fluent work, which presupposes the close study of nature. The result is spontaneity, typical of the 'hsieh-i' style — usually it is a cloak for intrinsic knowledge and will-power. The 'hsieh-i' trend did not lay down any binding rules of painting as did the other schools. It consisted of freely expressed ideas and emotions and unencumbered sweeps of the brush. It did, however, contain a comparatively unified conception of artistic work which the painters from different periods approached without sectarian prejudices.

The beginnings of 'hsieh-i' painting

The beginnings of 'hsieh-i' painting are difficult to define. We can only place them according to references in surviving material. Its further development has a logic of its own and clear marks of 'hsieh-i' painting can be found over the millenia. This style was nearly always present to counter the acknowledged, official and academic art forms. We might interpret it as the human need to go against the current, to be different from the rest, be oneself and discover what is new, unknown, antagonistic. Since the 'hsieh-i' painters reacted sensitively and mostly in opposition, to other trends and the atmosphere of a given period, they learned and adopted a great deal from the other, traditional schools of painting. At the same time, however, they maintained their independence and exceptional status. In some periods official critics considered these exceptional art forms to be eccentric, of no import and at times even inadmissible. Sometimes the 'hsieh-i' style was regarded as the curse of Chinese painting, barely acknowledged as part of its unique development. The intolerant attitude to 'hsieh-i' painting came to the fore in the last two dynasties, when the different political, philosophical and religious attitude of the masters provoked deep antagonism even to their artistic work. The problem was that the oppositional trend could not harmonize with the traditional division into the 'Southern' and 'Northern' Schools of Painting, even if it bore some similarities to the Southern School.

Modern Chinese art historians attribute the beginnings of 'hsieh-i' painting to different periods: most often the 10th century, but also the 12th and 13th centuries, and some-

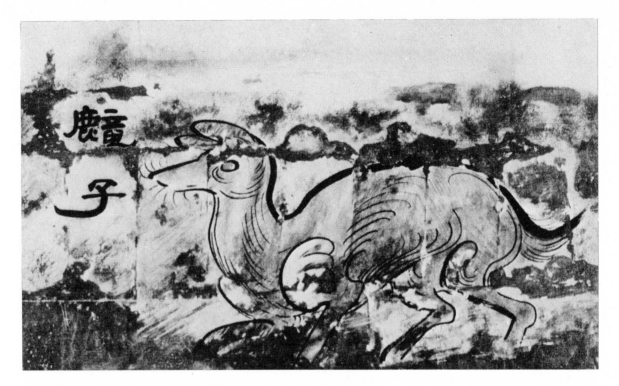

I Antelope, painting in a tomb in the Wang-tu district, Han period

times not until the 17th century. Clear marks of this orientation in painting can, however, be recognized in much older works. Chinese and Western literature cite examples of Han wall paintings, especially the well-known painted tiles in the tombs near Lo-yang, now in the Museum of Fine Arts in Boston. The sparingly sketched figures with lively expressions and poses are executed with a calligraphic temperament. Similarly bold strokes of the brush and abridged drawing can be seen on the murals in the tombs at the Wang-tu district of Hêpei province, likewise from the end of the Han dynasty. We are forced to resort to evidence from underground tombs, but we know that during this dynasty ink had long been used for painting on silk. From the beginning of the second century A.D., ink served for painting on paper; at that time appeared the basic technical media typical of 'hsieh-i' painting. Hardly anything has survived from the subsequent long period of the Sixth Dynasty. Here too, we must seek examples from wall paintings — in this case the Buddhist rock temples. The 'hsieh-i' technique can best be seen in Tun-huang: these are paintings of an illustrative character, sometimes with marginal ornaments, from the period of the Northern Wei, and the Sui and T'ang dynasties, in which we can find the passionate, spontaneous portrayal of content and a loosened brushwork, which hides the joy derived from free work with the brush. What brilliant brush technique is used in making the lines on the flowing garments of the flying apsarases; it does not belie the calligraphic training, which played a major role in converting imported art to essentially Chinese forms of expression. We are probably dealing here with a reaction to scroll painting, whose influence spread with the arrival of masters from the inland areas. From this it was but one step to the T'ang master Wu Tao-tzǔ, whose work is known only from description and a few later copies of ink painting with flowing strokes and sensitively drawn lines. The strength of the individual lines changed not only with regard to the shape depicted but also according to the position of the brush, similar to a rough calligraphical expression of Chinese characters. There is evident stress on the meaning of the picture. These facts probably led older Chinese historians to the statement that Wu Tao-tzǔ was a protagonist or even the founder of 'hsieh-i' painting, while Li Ssǔ-hsün was the founder of 'kung-pi' or 'laborious brush' painting. From the work of two great T'ang masters Chinese painting became divided into these basic techniques.

The painter Wang Wei, who lived at the end of the T'ang period, is often quoted as

11

a further milestone in the development the 'hsieh-i' trend. Surviving pictures are probably copies; Wang Wei is obviously linked with the 'hsieh-i' trend for his monochrome painting, loose brushwork, the broad use of ink values and the technique of washes. This attribute is also due to Wang's renown as a poet. He was one of the typical painters-literati ('wên jên hua') and in this field of work 'hsieh-i' painting was soon to gain most of its new stimuli.

The Sung Dynasty and the mature 'hsieh-i' style

While we have so far made conjectures about the early stages of the 'hsieh-i' style, we know with certainty that it came into being in its proper and mature form under the Northern and Southern Sungs. The three hundred year period of that dynasty was one of social upheavals and ceaseless struggles for existence as a state, ending catastrophically for China; but it was also a time of technical development when production and trade flourished. Not only did rational thinking, natural and human sciences develop, but also painting and literature. The spread of scroll painting and relaxed social attitudes gave rise to a certain type of bohemianism and prestige relationships among artists, which involved competitive struggles, the formation of groups, the development of criticism and a theory of painting, and an interest in collecting. The Sung Academy of Painting was of an undeniably high standard, for the leading masters associated beneath its roof. But painting developed equally outside the Academy; where it was less dependent on the taste of the Court and the ruling mandarins, so that artists could express their individualism and sensuality more freely. And it was in this independent sphere of work that 'wên jên hua' painting — that of the literati — made itself most widely felt. In Sung painting we can distinguish a great variety of forms of expression. Here we find concreteness and romantic sensitivity, stress on social problems or refuge sought in solitude. The painters were attracted by the panorama of the landscape, by the army or busy towns just as much as by a withered leaf, a stone or tufts of grass. This passion for the new world of beauty was expressed in manner that might be called ingenious simplicity — one aspect typical of 'hsieh-i' painting. Equally important are the general trends towards subtlety and highly refined treatment. At that period the slightest touch of the brush and every one of its marks were evaluated. Moreover, the suggestive beauty of allusion or implication was revealed, as can be seen in ink painting, special çeladon glazes and porcelain. This art derived its content and philosophy also from Taoism and Buddhism; its set form from calligraphy, folk prints, pottery and other crafts.

'Mo-ku' painting

Freer and more lyrical forms of expression were the artist's aims when flower and bird painting developed at the start of the Sung period in the middle of the 10th century. Rejecting official Court painting of the Huang line, Hsü Hsi developed a style known as 'mo-ku' ('without bones'), that is, painting without linear drawing or outlines. The chief medium was ink, at most lightly coloured — while the Huangs, representing the laborious 'kung-pi' painting, used entirely opaque colours. Hsü Hsi's brushwork and treatment were looser in comparison with those of the Huangs. While there were few dissimilar views held by the Huangs and Hsü Hsi — both Schools, moreover, encouraged the careful study of nature — in their later development they adopted an entirely different approach. 'Mo-ku' painting can be considered one of the main predecessors of 'hsieh-i' art, especially in its use of ink and colour washes, the rejection of contour lines and its more lyrical expression. With regard to landscape, 'hsieh-i' painting followed up the monochrome landscape that had developed in the 10th century together with 'mo-ku' painting. Its founders, Ching Hao, Kuan T'ung, Chü Jan, Tung Yüan and Fan K'uan were clearly inspired by working in the open air. The painter's best aids in nature walks were the brush and a silk cushion soaked with ground ink. Chü Jan and Tung Yüan were particularly important in the development of 'hsieh-i' painting; their aim was to simplify landscape scenery and catch a certain mood into which they projected their own feelings.

Painter Shih K'ê

At that time a figure painter appeared, Shih K'ê, a native of Ssuch'uan. Like Wang Wei he was a painter-literatus, or painting scholar. The well-known Contemplating Ascetics attributed to him are probably later copies, but there can be no doubt of the originality of style on the surviving scroll. Here for the first time in the history of Chinese painting the mature 'hsieh-i' style is exemplified; this is sometimes called 'ta hsieh-i', the great 'hsieh-i'. The figures of monks are painted with passionate bravado, in a strange atmosphere of gloom and ridicule. With a few furious strokes of a broad and frayed brush (or

some other tool?) the artist created a very expressive sketch. Many of the outline strokes are almost identical to strokes on calligraphic characters of the rough and flowing style of writing. The extreme contrasts of dark and light values of ink leave a unique impression as do the strokes with broad and fine brushes. Master Shih K'ê was a true predecessor of the Individualists of the 17th century, or expressed in Chinese — he was their elder brother.

Painting of the literati

In the second half of the 11th century 'hsieh-i' painting gained effective support with the spread of 'wên jên hua', the painting of the literati or scholars. Painting had always been a subject of education under the mandarin system of examinations, but a less important one; it was literature and calligraphy that played the major role. Later, with refinement of morals and individualistic trends in high Sung society, there arose the need to abandon the vulgar and stiff environment of the office as well as stereotype social contacts. Educated people and officials sought spiritual refuge not only in poetry, calligraphy and music, but also in painting. Often this art form was of progressive character, because it expressed opposition to official culture and rituals, even the policy of the Court. The orchid, chrysanthemum, bamboo and plum — objects with clear symbolical and literary significance were the artists' most popular subjects.

The best exponents of flower and bird painting among the literati under the Sung dynasty were the poets and scholars Su Tung-p'o (1035—1101) and Wên T'ung (11th century), and in landscape Mi Fei (1051—1107) and his son Mi Yu-jên (1090—1170). Their work contained some novel elements: a dream atmosphere, romantic harmony, musical treatment, an obsession for the touches of the brush and delicacy of ink. These positive elements were, however, accompanied by certain weaknesses that arose out of the literati's amateur approach to painting. They have often been heavily reproached for these shortcomings. But let us imagine Su Tung-p'o's bamboo thicket with the Moon or Mi Fei's hills painted with the technical expertise of a craftsman. Could one be without the infinite charm of these little masterpieces?

Generally though, from their literary, philosophical and general education the painters-literati were able to express in their pictures purity of thought, subtlety, ingenious simplicity and intelligence in the expression, selection and conception of nature subjects in symbolical compactness of meaning. At times we can detect certain anthropomorphic trends, perhaps derived from Taoism which equates animals and plants with Man and his world, and embraces a symbolic system linking natural elements and objects with forces of the universe.

The influence of calligraphy

The widespread use of calligraphic techniques in the contemporary painting of the literati greatly influenced the art of subsequent centuries. In a sense this marked a return to the sources, for many of the Chinese characters grew out of pictures. Even though in their long course of development the characters became a complex symbolical system, they retained some of their pictographic origin and character. The common technical media — the brush, ink and paper or silk — gradually brought painting and writing closer to one another, as can be seen by their juxtaposition on one scroll. The influence of calligraphy on painting was brought about by the artist's longing for freer forms of expression, a broader range of forms, and a musical rhythm which calligraphy had miraculously absorbed.

Calligraphy enabled the painter to improvise, allowing him unusual ease, freshness of treatment and 'enjoyment' from his painting — an essential condition of every spontaneous art form. The broader radius of movements of the hand that held the brush and the calligraphic swing of the whole arm brought about a new type of line and a new manner of expressing shape and area. This technique emphasized the uncommon beauty of the ink and the 'resonance' of all its miraculous values. The laws of calligraphy forced the painter to simplify the reality he saw in order to extract from it the hidden meaning, which the exacting spectator could 'read'. The typical rhythm of calligraphic inscriptions and texts also gave the painting a certain dynamic tension.

In the first period the artists used what is known as grass or conceptual style of calligraphy, characterized by its extreme freedom of rendering, a vibrant musical rhythm and dignified construction of the line. A certain irregularity in the arabesque of the line is typical of this style, with considerable contrasts of thin and thick lines, patches of dark and areas of light — media more akin to the construction of a picture. Likewise there are often

unbroken and flowing strokes which link individual characters and whole rows into a unified artistic form. The spectator receives the impression that in its mad dance the brush could not bear to part with the paper. We shall see later how important this manner of painting was for the 'hsieh-i' painters. The most important representatives of the grass style were Su Tung-p'o and particularly Mi Fei. In the later period other calligraphic styles were slowly introduced into painting, even the hard graphic 'chuan' style, known from archaic seals and stone steles.

The influence of Taoism

As has been indicated, the more independent scholars introduced boldness of expression into their painting and gave greater freedom to the painter himself. It must have been Taoism with its anarchic tendencies that influenced the literati in their thinking and social relations. It helped to spread the hermit's way of life among the scholars and their closer approach to nature. Taoism left its mark even on certain elements of meaning and form in the painting of the literati and in 'hsieh-i' painting.

Dangers of the literati painting

Literati who painted obviously lacked more solid training in art techniques and power of observation. Where the scholars relied on their own calligraphic skill they suffered from its limiting influence. For example Wên T'ung painted almost exclusively bamboo, which suited the principles of calligraphic brushwork in view of its structure of stem and leaves. This limitation in subject matter was quite common among the painters-literati and lasted into modern times. It is natural that such one-sidedness often led to mannerism. The painting scholars often had no experience of systematically observing nature, or of working in the open air; they encouraged memory and gave their subjects a purely artistic rendering. They often slipped into a literary or schematic approach. This free improvisation often led to unintentional freaks. During painters' meetings, for instance, verses of participants or famous poets were set as subjects for pictures. One such favourite verse, which even became an examination topic at the Imperial Academy, went as follows:

'The galloping horses stamped across the flowering meadow;
On return their hooves were scented.'

This sentiment used to be expressed by the artist depicting swarms of butterflies hovering around the hooves of galloping horses. Not even the mature Sung poetry — with its rich imagination and pictorial vision — could be externally grafted upon painting, an art form that differed so greatly in expression. The developing 'hsieh-i' trend managed to avoid this danger, and therefore cannot be identified with the painting of the literati. The great masters among the literati did manage to overcome this weakness and created a true painter's world in their pictures. They should not be spoken of as merely painting literati.

II Snow-covered branches of flowering plum and bamboo, detail of a scroll, Yang Pu-chih, Sung period

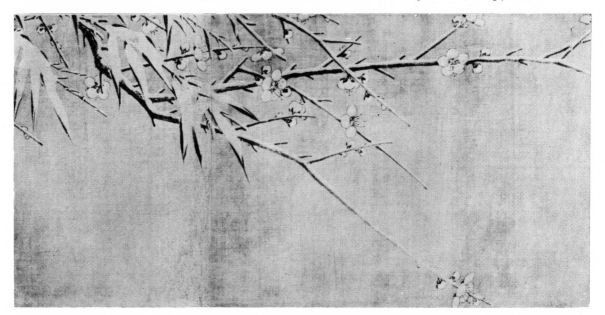

The danger of the influences of the literati painting was overcome by the artists who skilfully merged painting with a calligraphic inscription. This contained a poetical caption, original literary subject or any other sentiment, which could not easily be expressed in painting. The calligraphic inscription thus became an organic and unfailing component of the picture. It unobtrusively assumed a literary function without overburdening the painting. The 'hsieh-i' style played a considerable role in this interesting and unique development in Chinese painting.

'Hsieh-i' painting under the Southern Sung

'P'o-mo' method

Ying Yü-chien

Under the reign of the Southern Sungs 'hsieh-i' painting developed further in every genre and subject matter. It was applied very strikingly in the work of the monk Ying Yü-chien (middle of 13th century). His landscapes and cliffs rising out of the mists are painted in patches of ink dots, whose vehement rendering is a classical example of the 'p'o-mo' method, that of squirting or spilling ink. This method was further elaborated in the gestural aspect of 'hsieh-i' painting. It provided the best way of achieving expression in paint by sweeping movements of the arm, brush and ink, so that it readily served for fleeting emotions of the artist's ecstasy. Ying Yü-chien's landscape painting differs greatly from the work of the two masters of the Mi family, not only in brushwork technique, but in the overall tone of the picture. While Mi Fei's landscapes, despite their apparently dreamlike qualities and impressions, had expressive aims and were profoundly contemplative, Ying aimed at impression and tended to stress the decorative aspects of the picture. For Ying

Taoist white empty space

the empty white spaces were full of life — behind them we can sense the turbulence of winds and haze and the rent slopes of the mountains. Again we can feel the influence of Taoist philosophy: the empty space appears as an extreme, inexhaustible fullness. It recalls the white colourless natural light, which within itself hides all the colours of the spectrum and is, in fact, every colour. In the painted empty space on the picture the artist merely suggested things and events. He gave the spectator a stimulus so that he might fill it in his mind with full-blooded life. This culminating art of the empty space — prompting the viewer's intrinsic power of imagination — was adopted by 'hsieh-i' painting, enhancing its basic conceptual and expressive structure. Without regard to its symbolism and underlying philosophy the empty space in the picture is in itself full of brilliant colour. It forms an effective and most beautiful contrast to the values of black and grey of the ink, and gives the area of the picture a unique decorative accent. 'Hsieh-i' painting vacillated between these two poles — impression and expression — throughout its course of development. Perhaps only some Shanghai artists like Wu Ch'ang-shuo and Ch'i Pai-shih, were able to combine the two trends in their finest work. Under the Southern Sungs the two tendencies appeared evenly. When the reign of the Sungs ended, the expressive trend came to the fore, as it did after the end of the Ming dynasty three and a half centuries later.

Yang Pu-chih

To the period of the Southern Sungs also belongs Yang Pu-chih (first half of 12th century) who, like most masters with inclinations towards freer, non-conventional forms, did not belong to the official Court Academy. The Shanghai artists (and in particular Ch'i Pai-shih) regarded him as one of their patterns; they derived inspiration especially from the manner he used for painting flowering plums. The 'hsieh-i' method helped painters to seek suitable natural objects and invent the best forms of artistic expression for them. Yang Pu-chih introduced several motifs into ink painting — branches of the plum-tree, the flowers of the narcissus, and snow-covered bamboo — which later became very popular.

Ma Yüan, Hsia Kuei

The great landscape painters Ma Yüan (1190—1224) and Hsia Kuei (1180—1230) developed freer ink techniques in monumental landscapes, small scenes and figure painting set in landscapes. Although they cannot be considered direct representatives of the 'hsieh-i' trend, they contributed to its further development in landscape painting through a sense of realism and the high culture of their brushwork. Ma Yüan's little known 'Winter Landscape' in the Shanghai Museum is painted so economically and freshly that it might be taken as a starting point of the lyrical tone of 'hsieh-i'. Towards the end of the Sung period political events hastened its tragic end. The chaos and hopelessness of this period led to a relaxation of social relations and official philosophy, and likewise the inflexible canons of painting eased. Elements of romanticism, subjective ecstasy and even decadence prevailed. The Buddhist Ch'an sect became very popular in China. Its teaching, the word meaning 'meditation', is known in Europe better under the Japanese term 'Zen'. On

15

Chinese soil it developed into an independent current that derived a good deal from

Taoism. Stress was laid on direct contemplative perception and the enjoyment of nature. It contributed to the further refinement and greater individual variety of means of expression of different artists and this left indelible marks on Chinese and Japanese painting.

Liang K'ai, Fa Ch'ang (Mu Ch'i)

Well-known painters include the monks Liang K'ai (first half of 13th century) and Fa Ch'ang, known also as Mu Ch'i (1181—1239). Both can be considered direct predecessors of the 17th-century Individualists. The themes of most of their pictures had little to do with the customary Buddhist symbolism and iconography; they turned to the world of nature and came close to worshipping it. The universe (its highest principle) is fully contained in each single fruit or bamboo stem; every detail, even a pebble, contains more divine substance than the entire pantheon of gods. What a liberating conception for a painter! Through art one aspired to merge with the universal, forget oneself, and to touch the depth of the simplest of things. In this way painting became a means or training ground for the meditating person to reach the true consciousness of his substance. Both the philosophical systems — Zen and Taoism — discovered a new world of beauty for China in the depth of the insignificant and the simple. However much the two monks may have been philosophers and set out to find Buddha, Nirvana and Tao, to us they appear primarily as great painters. The laws of painting led them to a knowledge and shaping of nature's pure and secular beauty. Their style changed often enough, but in their best surviving works we can distinguish the spontaneous form of 'hsieh-i' painting, which used to be called 'wild, mad' in older Chinese literature. History ensured that 'hsieh-i' painting and the mission of the Zen sect merged naturally. The linking of the 'aims' and means was highly organic in this case. Sudden enlightenment came from profound meditation, requiring ready and simple media of painting: at moments of ecstasy the brush became the hand of the seismograph. What it recorded might be a message of a barely accessible region — the purest and most intimate touch of Man and the Absolute. This specific function of 'hsieh-i' painting served ecstasies of various degrees and origins for many centuries.

Liang K'ai's well-known majestic figure of Li Pê was painted in several strokes in true ecstasy, yet it depicts the indomitable and grand character of that great poet in exactly the way that generations of his readers imagined him. It does not appear, however, that this great work was inspired by Zen meditation. On Liang's scroll 'Three Scholars on a Walk' in the Peking Palace Museum we see the same certain strokes of the brush, but here the painter aimed at caricature and ridiculing irony, not unlike his predecessor Shih K'ê. It seems that the Shanghai figure painters, in particular Ch'i Pai-shih, learned Liang's style and emulated it.

Similarly, Mu Ch'i's works with a single apple, persimmon or bird on a pine tree are depicted in a few touches that are so simple, suggestive and direct that they recall the most modern forms of contemporary art. It could be said that they are the result of unmeditated vision of the substance of things, expressing their true depth and significance. From here a direct line leads to Hsü Wei, Chu Ta, Ch'i Pai-shih. And the Shanghai masters took the combination of black, cobalt and white from Mu Ch'i's persimmons. Ch'i Pai-shih added red to this combination of restrained colours.

The Yüan period

Escape from academic to freer and more individual painting continued during the subsequent period of domination by the Mongolian Yüan dynasty. At that time many of the learned men and officials sought safe refuge in painting. The 'hsieh-i' trend had no definite representatives nor did it undergo further development, but as the literati turned to art, work in monochrome ink began to spread widely and calligraphic principles were applied, especially in landscape painting. Ni Tsan (1301—1374), Wu Chên (1280—1354), Chao Mêng-fu (1254—1322), Huang Kung-wang (1269—1354), Wang Mêng (c. 1320—1385) demonstrated a grandiose style, in many respects derived from 'hsieh-i' painting; they produced works not only full of meaning, but also ciphers, allegories and symbols. Yüan painting reveals that the end of the national dynasty and the enthronement of the Mongolian dynasty were traumatic for the Chinese literati and artists. We can barely find those marks of simple human joys derived from beauty discovered, or the ecstasy brought about by truth found and secrets unveiled. Instead, we can sense a certain sadness, nostalgia, tension, fear and even hopelessness. It seems that from the Yüan period onwards a change occurred in official Court painting and that of the literati: the former certainties were warped, inventiveness declined, the ability to evolve new artistic symbols and a lively

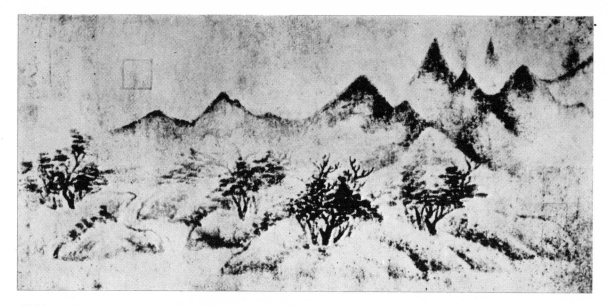

III Mountains in the clouds, scroll, Mi Yu-jên, Sung period

vision of reality diminished. The painters turned to the past and the pictures of their predecessors. Further development and progress in method and content hinged mainly on the 'hsieh-i' trend.

The period of the Ming dynasty

Under the Ming dynasty (14th—17th centuries), the majority of painters working outside the Imperial Academy continued in the style of the Yüan masters. Their work developed in opposition to the conservative Court or official painting, which tended to follow up older epochs in the form of precise miniature-type pictures with bolder colours. The painters who used freer forms with stress on content include Wang Mien (1335—1407); the versatile artist Shên Chou, known also as Shên Shih-t'ien (1427—1509), the founder of the Wu School at Su-chou; Wên Chên-ming (1470—1559); Ch'ên Tao-fu (1483—1544), a painter of magnificent landscapes, flowers and birds; Lin Liang (15th—16th centuries), who was restricted in his freedom by membership of the Academy; and the landscape painter Mo Shih-lung (16th—17th centuries). True representatives of 'hsieh-i' painting included painters Sun Lung (14th century) and Chou Chih-mien (16th—17th centuries). Sun Lung in particular was a master of exalted treatment, with rhythmical touches of a full brush, the almost brutal 'p'o-mo' method of splashing or, more precisely, pouring ink; in this sense he was a predecessor and teacher of the great Hsü Wei. Even Chou Chih-mien can be considered as a predecessor of Hsü Wei and the Yang-chou masters. Towards the end of the Ming reign 'hsieh-i' painting appeared in its most mature form in the work of Hsü Wei and of the famous group of painters known as the Individualists. One of the main representatives of the Shanghai School of Painting, Ch'i Pai-shih, said in his collection 'Poetical Studies of Lao P'ing', published in 1920, in which he dealt with the classics of 'hsieh-i' painting: 'The painting of the old masters, such as Ch'ing T'êng, Hsüeh Kê and Ta Ti-tzu, is bold and passionate. I shall never cease to admire it. I regret that I was not born three hundred years ago. I might perhaps have been allowed to grind ink for those masters and straighten their paper. Had they not accepted me, I would have waited on the threshold of their studies, and I would not have left even if I had died of hunger. And I would have been happy thus.'

The Shanghai painters modelled themselves on men who were not only brilliant painters but true heroes, who were all-round personalities with eventful lives. We do not know how much renown legends added to their names, but the chronicles, their surviving work, and even expressions of enmity or sympathy are convincing enough. The ruling gentry and their spokesmen among the painters and historians usually showed contempt with expressions like 'yeh', 'kuai', 'i', that is, wild, peculiar, exclusive. On the other hand, we can find boundless admiration and respect among their later followers.

The first of three masters on whose threshold painter Ch'i was willing to die, was

Hsü Wei, or Ch'ing T'êng as his best-known nickname sounds (1521—1593). Cultural history portrays him as the author of outstanding plays and poems, as well as a painter and calligrapher. He was a painter-literatus, and in the narrower sense of the word also a painter-politician or a painter-soldier. His eventful life was a woeful path to knowledge; and his struggles are reminiscent of those of Michelangelo, Rembrandt, Goya, Vincent van Gogh or Paul Gauguin. The basic theme of his life was somewhat Shakespearean. In his youth he studied military science and economics. Then he became an official in the Chêkiang prefecture where he excelled in defence operations. For his liberal behaviour and talents he won the favours of the prefect, who became, however, involved in certain intrigues and was finally assassinated. Hsü Wei was likewise faced with the threat of death and had to flee the province. Disappointment over the inability and baseness of the mandarin administration led him to the brink of madness; at that time he killed his own wife by an unfortunate accident and was imprisoned for eight years. Hsü Wei spent the end of his life in poverty and solitude, but he now produced his best literary works and paintings. He wrote thirty volumes of poetry and four plays, which were published under the title of 'Ssu-shêng yüan', 'The Monkey with Four Voices'. He also dealt with the theory of the theatre. In some poems and inscriptions on his pictures he attacked the powerful and even demanded equality between man and woman. In others he expressed freethinking ideas on art, which were revolutionary for his time. Some of the texts reveal bitterness that society disdained his talent; this lack of recognition together with his personal tragedy and political disappointment caused his insoluble inner conflicts and anger, apparent even in some of his pictures. After his failure in society Hsü Wei turned to the world of nature. Here he sought calm, beauty, harmony, and a refuge from the senseless world of people. He painted flowers, birds, fishes, beetles, landscapes and figures. His work is filled with passion, and at times even exultation. The majority of his pictures show the profound joy he derived from creative work, but on some scrolls or parts of them a tragic nervousness and anger manifest themselves.

On one of Hsü's most beautiful scrolls — 'Various Flowers' in the Shanghai Museum (length of scroll 10 m, ink on paper) — there are parts with a confusion of almost insane lines and dots, which in spite of the apparent ease of touch must have been painted with menacing strength, clenched teeth, perhaps in cramp. The painter's reason must have overpowered his emotions to keep the painting within the limits of comprehension. On such pictures or parts of them Hsü Wei amassed groups of dots and confusions of lines which remind one of the painting of present-day Tachistes. Perhaps it is here that the characteristics of the natural models are best exemplified with the expression of ideas that they rouse in man's soul. We cannot trace the creative development of Hsü Wei as a whole on the surviving pictures, but we can assume that periods of passionate exalted work alternated with calmer periods; then it would become finer and more impressive when the painter thought about the composition of the picture and each individual stroke of his brush. The various emotional trends identifiable in his painting clearly reflect the artist's character and the frequent changes in his mental states. His ready brush, the sweeping stroke of the arm and his perfect training in calligraphy were well suited to portray fleeting moods, unexpected inspiration and experiences gained in an ecstatic state. We recognize, of course, that the haste and tension of such exalted 'rising waves' prevented the painter from giving rational thought to the composition and from regularly dipping his brush into the ink. The brush spread apart and dried up, but it still served to depict the artist's intentions. The mixture of strength and haste, deliberation and ecstasy is characteristic of Hsü Wei. Most of the Yang-chou and Shanghai masters alloyed these elements. Their painting is dominated by calm, strength and balance — a form of expression that was called 'ta ch'i p'ai', the 'broad breath'. Hsü Wei used the calligraphic 'grass' style 'ts'ao-shu fa', which he probably derived from Mi Fei. This style with a free, written arabesque recalling tall grass bending in the wind suited Hsü's temperament perfectly. He adapted its abstract characters to the painter's needs for a sudden, spontaneous form and added some new elements. He made use of the highly decorative contrasting play of dots and lines, turned the touch of his brush into a real stroke and highlighted the emotional effect of the ink. The expression 'p'o-mo' is not exaggerated in the case of Hsü Wei; on the scroll 'Various Flowers' and some of his other works the ink was literally splashed on,

either in anger or pleasure, with a full and semi-dry brush. The end product consisted of dots and dashes in a delicate scale of values; it is velvety, warm, fresh and gay, but also sombre, nostalgic, sinister. Sometimes it is full of melancholy, kindled in the play of light and shadow and more colourful than truly bright colours. The Chinese themselves liked to personify these qualities of the ink. The artistic qualities which Hsü Wei sparked off in the ink and from the touch of the brush that almost 'lost the rein' were of great importance in the further development of 'hsieh-i' painting. Hsü's atomization of nature was a great novelty, which helped him create that special infinite space on the picture. He selected small subjects isolated from their material environment, then split them up or depicted them only in part — a little piece of the stalk, trunk or a few leaves to form a microscopic pattern of nature. Yet his miniature-like pictures give the impression of a living world that is fuller and more convincing than if it were painted in its entirety. This vision was also created by the telegraphic poems of the T'ang and Sung periods. However unrestrained Hsü Wei may have been in character, he had great respect for tradition. Though he was an innovator, he learnt painting from Ni Tsan, Shên Chou, Ch'ên Tao-fu, Wang Mien, Lu Chao and particularly Sun Lung, and studied the verses of the T'ang poets. He himself had no pupils or immediate followers, but the importance and originality of his work were recognised in later centuries.

The Survivors or the Individualists

The development of 'hsieh-i' painting culminated in the work of a group of masters known as the 'Survivors' ('yi-min', or 'hou-min') in Chinese literature and the 'Individualists' in western literature. Three of these Individualists are included among the Four Great Monks (Chu Ta, Hung Jên, Shih Ch'i, Shih T'ao). They were called the 'Survivors' because they remained faithful to the Ming dynasty, which fell after the peasant uprisings and the Manchu invasion in 1644. Most of the intelligentsia of the time accepted the Manchu and their Ch'ing dynasty, also because the semi-barbarian invaders from the north quickly adopted Chinese ways. The resistance of the Individualists, among whom were many monks, was directed against the Manchus as alien aggressors. The rebels refused collaboration, renounced social relations and often retired into monasteries. Such resistance also involved official culture and ideology; it was aimed against academic trends and conservatism in art. Conformism in painting showed as a rejection of reality and predominantly copying the old masters. It was natural that the Individualists turned to the 'hsieh-i' trend; it enabled them best to depict the world of nature where they had taken refuge from the world of people, and to express not only their feelings of indignation and passion, but also enchantment and romantic longings.

Ch'ên Hung-shou (Ch'ên Lao-lien)

The painter and famous illustrator Ch'ên Hung-shou (1599—1652), also known as Lao-lien, painted figures, landscapes and flowers and birds. He was close to 'hsieh-i' painting by his tense individualism and expressive work rather than the manner of painting. He used colour on a big scale and the 'shuang-kou' method of contour lines, which was closer to the laborious 'kung-pi' style of work. His pictures display a tone of ridicule and scorn, often accompanied by deformation of objects. Ch'ên's compositions are at times very eccentric, just like all his painting. Some motifs and faces are presented with such originality and fantasy that they are reminiscent of the work of modern Surrealists. In the arabesque of the strange lines we feel a satirical grimace or caricature. Fresh and certain in treatment, it is irritating art, with an almost barbarian strength. Little wonder that the masters of the Shanghai School — like Ch'ên's contemporary Chu Ta — found it imposing.

Chu Ta (Pa-ta shan-jên)

Chu Ta (1625—1705), known as Hsüeh Kê, and chiefly as Pa-ta shan-jên (shortened to Pa-ta), belonged to the imperial Ming family. Like Hsü Wei and Shih T'ao his personality was strikingly universal. Originally he devoted himself to literature, but later found refuge for his views and emotions in painting. At the age of twenty-three he renounced society and his career in defiance of the invaders and became a monk. He lived for more than twenty years in mountain monasteries in the Yangtze Basin and later led the life of a tramp. During his lifetime he became famous for his painting and calligraphy and also his patriotism. He painted landscapes, flowers, birds, fishes, beetles and stones, was a prominent calligrapher and poet, besides writing treatises and historical works. His work was based not only on the Late Sung masters, but also on Ni Tsan, Lin Liang and Ch'ên Hung-shou; his calligraphy was after the fashion of Wang Ta-ling and Yen Lu-kung. It is true that he saved himself from the Manchus by adopting a pose of insanity and monasticism, and he

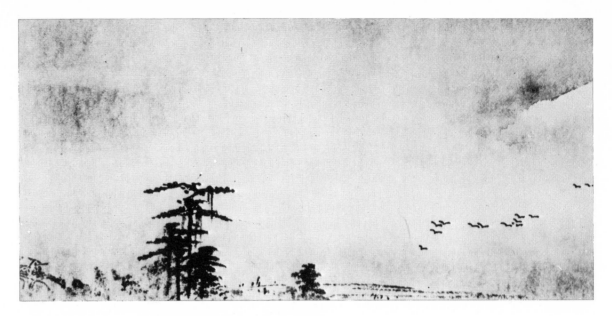

IV Winter landscape, detail of a scroll, Ma Yüan, Sung period

often pretended to be deaf. As a member of the defeated imperial family he did not have any other choice. At first the Manchus ruled with great cruelty and any spoken or written word of resistance meant certain death. Hidden meaning and allegory gained importance in Chinese painting at the time. This manner of resistance had little social effect, but it was a way of expressing anger and hatred for the intruders. It was not only a matter of this symbolism. These painters wished to express even simple human emotions and passions freely, including their enchantment with nature and personal concepts of beauty. The spontaneous 'hsieh-i' trend with its meaning was the only method in painting that could serve such needs.

Pa-ta is considered the greatest exponent of Individualism or Subjectivism in Chinese painting. Initially his paintings appear to highlight subjective feelings rather than objectively conceived nature. But Pa-ta's Subjectivism has a logic of its own and is not really removed from reality. Nature was not only the painter's political asylum, it was the chief source and inspiration of his work. Pa-ta clearly learnt to understand nature far better than the dogma of Buddhism. He studied the flight and nesting of birds and the growth of the flowers and trees which he himself planted and cultivated. Paradoxically, Subjectivists like Pa-ta were the only ones in their time who consistently studied nature and even painted in the open air. Their realistic approach is shown by the well-known statement of the painter Wang Lü: 'I learn from my heart, my heart learns from my sight, sight learns from the mountains of my homeland.' The extreme sensitivity of the Individualists was a reaction against the complete lack of personality in contemporary painting. That was true even later. Stress on the subject was mostly linked in Chinese painting with a heightened interest in the study of reality. At the same time it was a signal of changes in style and the penetration of new creative ideas which greatly upset tradition in art but maintained its vital development. Pa-ta, to a certain extent, personified nature. Perhaps this was the way in which he could get closest to its inner sources, and thereby to the hidden substance of humanity. According to his moods he stressed the cruder elements of nature by exaggeration and did so with exceptional fantasy. Pa-ta did not relate tales nor teach a lesson, but dramatized nature. He knew what a painter could afford to do, and just as he venerated the quintessence of nature, so he trusted his own feelings and ideas. The birds in his pictures are screeching or are tired to death, wretched with cold and hunger. They are persecuted creatures always on their guard, watching their surroundings with hatred and fright. On the other hand, Pa-ta's eagle symbolized cruelty, disdain and defiance; it is a striking example of anthropomorphism in Chinese art. Pa-ta brilliantly portrayed the eyes of crea-

tures as expressing human emotions. According to an old Chinese postulate the eyes are to be the centre of the painting, because they conceal the soul of the bird or animal. Pa-ta resorted to exaggeration, sometimes even caricature: his birds and fishes roll their eyes furiously, expressing terror and tension, or they mischievously look about 'with one little eye'. Stones overgrown with moss, rocks and cliffs breathe out great sadness. The atmosphere of Pa-ta's rugged and deserted landscapes is full of tension, struggle and decay. The minor distortions of nature that he employed may be interpreted as the artist's rejection of social reality.

Pa-ta's passionate nature did not defy the basic laws of nature and aesthetic principles of painting. It was corrected through the discipline of his brushwork, the careful layout of the picture and his knowledge of natural history. Pa-ta's depictions of nature were always made 'alive' and sensual by the lightness of a feather, the articulation of rocks, or the pulpiness of a plant. And when portraying the instinctive behaviour of persecuted creatures Pa-ta did not need to observe nature but himself. The Shanghai masters were most impressed by Pa-ta's manner of condensing his thoughts in painting, whereby he built up shape and space, matter and void. A few apparently chaotic patches and lines create a picture of rock overhanging with wild mountain vegetation. Below the ink dot of a feather one can sense the structure of the bird's body. This painter was very sparing with his ink and touches of the brush, but he was lavish with empty white space which shone out of his pictures with contrasting purity, depth and endlessness. We might call it a painter's void, but a Taoistic void which embraces all.

Certain scrolls depict only a small crouching bird, a single flower, a blade of grass or a little fish. A few strokes of the brush, however, create a tension which dominates the entire area of the picture. Pa-ta used a narrow range of shades of ink, mainly the darkest tone which was deep and velvety. By dousing the ink with water it became very different and served to distinguish specific structures of the objects depicted. The Chinese term for ink painting 'shui-mo hua' ('painting with water and ink') can be applied to Pa-ta's painting without reservation. Pa-ta created most objects with the aid of blots and blot-like lines, which he applied quickly and lightly. For some details — especially the eyes of creatures — he used firm ingenious lines drawn with a thin semi-dry brush. This technique he obviously derived from his own somewhat dry and calm, written calligraphy of a harder graphic style. The moist blotch and the contrasting dry line are given in equal ratio — a style every 'hsieh-i' painter wished to achieve.

Pa-ta's brushwork from the later period is regarded in China as passionate, grandiose and typical of the 'great hsieh-i'. Such touches of the brush were obviously executed at moments of excitement or ecstasy, when the painter literally 'poured out' his feelings within a split second. It is likely that he repeated his experiments in ecstasy until he achieved 'hsin-shên chieh pei', that is, 'harmonious fulfilment of shape and soul'. It is said that he used to undress for painting and liked to drink brandy while at work. At such moments he would throw himself at the paper with recklessness and brutality like a beast of prey. Even a few years ago one could observe such exaltation in some works of the modern masters of the Shanghai School, such as Li K'u-ch'an. Purity, spontaneity and the definite form of treatment reflected the fullness of the artist's feelings. These could be shown only in a given moment. It was a method of direct action, which guarded and maintained each stage in the process of creation; these marks then became an integral part of expression. Ch'i Pai-shih of the Shanghai School also formulated this method in his works: 'Slow circumspection and greatest prudence is required in thinking out the picture and its composition. But as soon as your brush touches the paper, you must show the greatest courage and directness'.

Expressive intensity, directness, purity and the sparing use of media were also characteristic of works by Pa-ta's contemporary, the monk Shih T'ao.

Shih T'ao

The painter Shih T'ao (1630?—c. 1714), originally called Chu Juo-chi, had many nicknames. Among the best known are Tao Chi, Ta Ti-tzǔ and Ch'ing-hsiang lao-jên. Like Pa-ta he became a monk after the fall of the Ming line. He lived mostly in the mountain monasteries of Eastern China. He painted landscapes, figures, flowers and birds, was an outstanding calligrapher and poet and one of the greatest art theoreticians in China. His best-known work in this field is a volume of essays 'Talks on Art by Monk K'u-kua'. He

achieved recognition during his lifetime and was considered 'the first to the south of the River' even by those who opposed him. This Individualist was much closer to the Shanghai masters in general character than Pa-ta. He was more balanced and matter-of-fact; he managed to control his anger and bitterness so that they did not consume him. Socially he was not as consistent as Pa-ta, but his work was more versatile and stressed the positive sides of life as well as the kinder face of nature. He strove to find pleasure and beauty in unattractive surroundings. This urge drove him from place to place and he was never content with any one type of landscape for long, nor indeed one form of expression. Few Chinese painters underwent such changes and were as universal as Shih T'ao. Even though he was influenced by the Sung and Yüan masters he did not copy anyone's style and always stressed his independence. He sought inspiration and instruction mainly from nature, according to the dictum 'The Yellow Mountains are my teacher'. His style was not only lyrical and intimate but dramatic and monumental. He painted noble and elegant landscapes as well as rough, primitive ones. In some he came close to 'kung-pi', the style of the 'laborious brush', while in others he applied the great 'hsieh-i' style; he changed from a dry brush to a wet one, alternating flowing ink with thick ink. There could not have been a single style of painting that he did not try. He spoke out sharply against copying the old masters and said of his contemporaries: '. . . they learn to paint pictures just like the old ones instead of learning to understand their hearts.' He declared that there is nothing static in the world, and everything is in constant change, therefore '. . . calligraphy and painting must change with the times'. He was against the mechanical use of established shading and schemes, because even these must be adapted to a concrete object. To curious questions he would reply: 'Where do I belong, to what School? I belong to myself, I use my own manner of painting.' Shih T'ao declared what is most vital for 'hsieh-i' painting — the right to individual expression and the necessity to carefully study nature, of which the painter himself forms a part. 'The mountains and streams in nature challenged me to speak for them. Nature comes out of me, I come from nature. What are we to seek in it? All its beautiful and typical qualities, that is what we are to paint.'

After decades of roaming about the country, innumerable types of landscapes were fixed in the painter's mind. These he composed in his pictures not according to their topographical forms but inner content. He learnt to understand himself and people's feelings through direct perception of nature because he knew that in his work he had to meet nature half way. He never escaped into the Buddhist state of Nirvana, nor depicted nature 'as such'. He humanized it in a manner similar to that used by Pa-ta: the crags and hill-tops are dramatic, mists suggest silence of a thousand meanings and rain resembles a shroud. In his pictures the trees are alive and have feelings like people. Shih T'ao was truly a poet of trees. He learnt to understand their silent life, the poses which they form by a special spread of their boughs, and the strange arabesques of their leaves. Even in his theoretical work he attributed human qualities to natural objects: the mountains can be kind, polite, friendly, wise or bellicose; water is seen as just, strict, courageous and loving. It is the constant changes in nature that make the evocation of human life possible. It seems that the painter was inspired by growth, movement, and the relation of individual forms of nature to space rather than by their external shapes and appearance. In this way he was able to keep his objects within the bounds of concreteness and realism. And so we can discern a rare balance: Shih T'ao's landscapes are decorative yet at the same time full of sensual feelings of life and contemplation. Devoid of sentimentality, Shih T'ao's landscapes always reflect a certain mood; festive, merry, sad or nostalgic, in harmony with the seasons. Whether it is an atmosphere of a fishing village or a landscape with hermits, the mood remains natural, and is never intrusive.

One of the artist's most beautiful landscapes 'Autumn in Wei-yang' (Nanking Museum) depicts the surroundings of Yang-chou after the town was looted by the Manchus. The region in the picture is deserted, the hills vanish into a broad horizon and the groves are lost in infinity. This solitude is also evoked by a fisherman on the lake. The inscription placed above the lake speaks of the curse that fell upon the once flourishing town. The artistic form of the inscription gives the impression of a heavy pall — a cloud whose waters drown all that is alive in that unhappy land. Here we see an artistic combination of literature, calligraphy and painting, in which the meaning of the words is enhanced by the

22

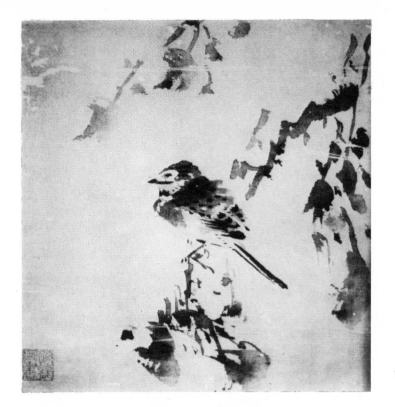

V Bird on a branch, album sheet,
Sun Lung, Ming period

artistic conception. This method became a part of 'hsieh-i' painting and was used both by the Yang-chou and the Shanghai masters.

Shih T'ao's calligraphy of the 'grass' or harder graphic style often changed, acquiring a different rhythm and function. The calligraphy of the inscription takes over the rhythm of the painting or perhaps harmonizes with it in slant or composition becoming linked in one organic whole. On some pictures the characters of the inscription assume the slant and rhythm of ducks in flight. Elsewhere the tops of mountains rise to unbounded heights and the characters rise with them. Shih T'ao liked to compose his inscriptions in square or rectangular blocks, which then appeared as an effective part of the whole composition. The artist's main calligraphic styles — the soft, swinging 'grass' style and the hard graphic style — were taken over by the Yang-chou (Chin Nung) and the Shanghai Schools of painting (Wu Ch'ang-shuo, Ch'i Pai-shih). Shih T'ao is also associated with the Shanghai masters for his use of light transparent colours. He was closest to them in the painting of flowers and fruit. On these small works — usually in albums — the area of the leaf is evenly divided between beautiful columns of calligraphy, the seal, and the picture of a fruit or flower. The artist's few light strokes form an eccentric composition which is both decorative and meditative — as if he concentrated that old Chinese world of the 'broad breath', the world of dignified simplicity. He applied himself to the Taoist principle 'Regard the great in the small'.

Shih T'ao influenced all creative endeavour in the subsequent development of Chinese painting and calligraphy. This pure painter, philosopher and humanist of a Renaissance type left a profound mark on the Yang-chou and Shanghai masters. He handed down to them the unique discovery of his brushwork and the moral qualities required of a thinker and painter.

Mention should be made of the three important landscape painters among the Individualists, or the Survivors: K'un Ts'an, Kung Hsien, Mei Ch'ing.

K'un Ts'an

K'un Ts'an, a monk (c. 1610—1693) also known as Shih Ch'i, painted panoramas of mountain landscape in a realistic and descriptive manner which at times is similar to the laborious 'kung-pi' style. The mountain slopes with rich undergrowth are often full of detail but expressed economically. Open-air painting was probably of strong influence here, being part of K'un's style. His scenes convey a slightly impressionist effect, caused by

lively, sketchy brushwork and light ink values. K'un's ink painting was usually complemented with thin transparent colours. Despite the influence of the early Sung painters and Shih T'ao one cannot overlook K'un's personal contribution to the Shanghai School. One of his most ardent followers was Huang Pin-hung, the leading landscape painter.

Kung Hsien

Kung Hsien (c. 1617—1689) was a 'rebel' in his style of Chinese landscape painting, his mountain panoramas dark with foreboding clouds. In stressing the plasticity of the mountains and the dark shadows of the valleys there seems to be a faint European influence. With one exception, no other artist produced these black phantom landscapes. Only in a few isolated works is the painter closer to Shih T'ao. He did not use the 'hsieh-i' method but was a rather tense Individualist.

Mei Ch'ing

Mei Ch'ing (active at the end of 17th century) is the painter of the Yellow Mountains. He knew Shih T'ao personally and is very close to him in his excited and rhythmic expression. Like the other members of the Yellow Mountain School Mei Ch'ing was led by the fantastic landscape to mighty exaggeration based on the realism of open-air painting, of which he is considered a leading figure. He had the ability to combine perfect knowledge of the object with subjectivity. The peaks of the mountains in his pictures toss about wildly and rise towards the heavens. Each crag appears as an individual entity. Apart from rocks there are magnificent pine groves — Mei Ch'ing was a poet of pines. Mei Ch'ing, a typical painter-literatus, had perfect command of his craft and of calligraphy.

The Eight Eccentrics of Yang-chou

A bridge between the great founders of 'hsieh-i' painting and the Shanghai School is formed by a group of painters known as the 'Yang-chou pa kuai', 'The Eight Eccentrics of Yang-chou'. The majority of the Yang-chou masters lived in the first half of the 18th century — more than half a century after the Individualists whom they followed. The chief influence was that of Shih T'ao, who lived in Yang-chou towards the end of his life. In this town he left behind a number of students and many pictures. The Eight Eccentrics of Yang-chou included Chin Nung, Chêng Hsieh, Li Shan, Lo P'in, Wang Shih-shên, Huang Shên, Kao Hsiang and Li Fang-ying. There were, of course, more artists in this School; in style the famous painter of flowers and birds Hua Yen (1684—1763) was one of them, also the founder of nail painting, Kao Ch'i-p'ei (1672—1734), and many others. According to old customs and for the sake of simplicity and popularity, some groups took the name of their most distinguished representatives, like 'The Four Wangs', 'The Eight from Ching-ling', etc. The link between the Yang-chou painters and the Individualists was an organic and logical one. Even the Eccentrics rejected official society and culture. Their situation was complicated by the fact that the reigning Manchus had used a clever policy to secure the co-operation of most of the Chinese intelligentsia. Yet the strong pressure of their immediate surroundings influenced the Eccentrics, or 'crazy' painters. The town of Yang-chou was again flourishing and had become one of the main centres of Chinese trade (note the similarity with the Shanghai School). Though civil servants and wealthy landowners settled there, the majority of the inhabitants were traders, especially salt merchants. The traders wished to be on a par with the aristocracy and gentry in their way of life, but at the same time they demanded more popular forms of artistic work. They enjoyed the stimulus of romanticism, colours and directness. Some of these demands were reflected by the external appearance of Yang-chou which, like the nearby Su-chou and Wu-hsi, boasted a lyrical atmosphere. The pavilions surrounded by splendid gardens with lakes and bridges showed the cultured tastes of the builders.

Popular artists, men of learning and professional painters moved here in large numbers. They were chiefly artists whose work was not approved of by the Court. Most of them lived in poverty and were constantly struggling against conservative views, but they managed to sell their works. Yang-chou gave rise to an original school of art which left profound marks on the development of Chinese painting. It formed part of the timidly growing opposition by the intelligentsia and artists to pedantic Neo-Confucianism, which considered the traditional idea of 'jên', humanity, an entirely empty phrase, synonymous with hypocrisy and shallow charity. The contemporaries of the Yang-chou Eccentrics were equally strange literati, like Ts'ao Hsüeh-ch'in, author of the famous novel 'The Dream of the Red Chamber'; Wu Ching-tzŭ, who wrote a satirical novel 'The Mandarins and the Literati'; the well-known story-teller P'u Sung-ling; and the enlightened philosopher Tai Chên.

The Yang-chou painters had brothers in distant Europe, among the 18th-century Dutch painters. What an analogy history offers here: opposition to academic forms and dissimulation drove countless painters closer to nature and truth. Similar passionate longing for directness and sensuality rose to the surface on their canvases.

The Yang-chou painters loved tradition. They studied the two great monks, Hsü Wei and the Sungs. They turned to the old calligraphy — especially that of the Han period — which they understood better than anyone else before them. But even more than tradition they loved nature, with which they identified the ideals of personality in revolt. For that reason they devoted their attention to basic shapes and individual elements in nature, which embody its basic matter and dynamics — grass, stones, bamboo poles, flowers and leaves, the resinous branches of the plum. From these studies the Yang-chou painters found their way to an understanding of the universe. They rejected the panoramic depiction of nature perhaps under the influence of the formal stiffness of landscape painting characteristic of the period.

The figure painting of Huang Shên, Lo P'in

Some of the Eccentrics, especially Huang Shên (1687—?) and Lo P'in (1733—1799), turned to depicting the human figure, which for them became a psychological and social object. They followed up the almost forgotten legacy of Ch'ên Hung-shou and certain Sung masters (Shih K'ê, Liang K'ai, etc.). The faces of their figures often have grimaces or show irony, and are undoubtedly a reaction to contemporary events. There was certainly much cruel irony in the fate of many of the Eccentrics. For instance, one of the most talented of Chinese figure painters, Huang Shên, had to study and paint in the temple below the eternal light because he did not have any oil for his lamp. And Lo P'in was forced to become a beggar in Peking to gain means for the journey back to Yang-chou.

Huang Shên was an outstanding draughtsman; he painted with quick, excited strokes — derived from his personal style of calligraphy — depicting old men with precise psychological characteristic. He used his skill at draughtsmanship and portraiture to evoke provocation: for example, he painted donkeys when it was the fashion in the Imperial Academy to paint horses. Lo P'in's figures have a diseased and depressing quality (the well-known portrait of Chin Nung in the Palace Museum). In his social satire he used subjects from popular New Year prints; he caricatured the state machinery with figures of evil devils.

It is interesting that Huang Shên and Lo P'in were equally outstanding painters of landscape, flowers and birds. In the latter genre their style was clearer and more attractive. Lo P'in learnt to paint bamboo from the Sung Masters; Huang Shên's flowers were inspired by Hsü Wei and left a clear mark on Ch'i Pai-shih.

Chin Nung

Chin Nung (1687—1764), called Shou-mên or Tung Hsin, one of the painters-literati, concentrated on bamboo and plum but also depicted landscape, figures, horses and Buddhist subjects. He became famous as a calligrapher. He was one of the direct predecessors of the Shanghai School and like Wu Ch'ang-shuo, turned painter when he was over fifty, having acquired a profound education and travelled through half the country. Chin's painting was preceded by highly cultured calligraphy, in which he created his own style: here strict graphic form and composition merged with the free rhythm of the brush.

This tension between freedom and discipline also applied to his painting: Chin Nung's pictures emit an almost childish joy from the certain strokes of the brush and those which are more volatile. They contain a sense of discipline and order, which checks the passion and holds the composition firm. This discipline is also typical of the other 'hsieh-i' painters. One of Chin's pictures in the Palace Museum is a good example of his individual style: a plum blossom with pure white flowers rises above a tiled wall, for all passers-by to admire. In this noble and refined treatment we often find intentional naivety in its exaggeration; Chin Nung enlarged the small plum flowers only to make them stand out and so that the brush could move about the petals in unconstrained elegance. Chin used such exaggeration — like Ch'i Pai-shih later — with complete spontaneity. He was a master of painting in thin semi-dark ink; he led his brush along the compact branches which resemble tributaries flowing into a mighty stream — the trunk — with a flat surface of ink. Another of the Eccentrics, Wang Shih-shên (17th—18th centuries), is close to Chin in style, but his treatment and compositions are freer and more decorative.

Chêng Hsieh

Chêng Hsieh (1693—1765), another of the painters-literati, was best known as Pan-

ch'iao. As a mandarin he spoke out in support of the rebellious peasants and was deprived of his office. He wrote his verses in almost conversational language. In calligraphy he created a special, new style, popularly called 'straying stones cover the streets'. Though Chêng based his style on the work of Hsü Wei and Shih T'ao, he strongly opposed the imitation of predecessors. His best works, which have survived in quite large numbers, were not produced until he was over sixty years old.

Like Hsü Wei, and later Wu Ch'ang-shuo, Chêng was a humanist and enlightened person who after his political failure turned to painting. In ink pictures of nature he sought the purity and moral values which he could not find in human society. He was also an unsurpassed poet of bamboo and the water orchid. In Chêng's view bamboo had a soul which men could comprehend: it creeps straight and unremittingly up towards the sun, then with its wise movements constantly wins back its own space. The wind and rain provide a voluptuous game for the bamboo, and its precise structure symbolizes perfection in a work of nature. Like Lady Li, the founder of bamboo painting, eight centuries earlier, Chêng studied the shadow of the bamboo stalk cast by the sun or the moon on paper in order to observe its jointed construction. On one of his pictures Chêng bears

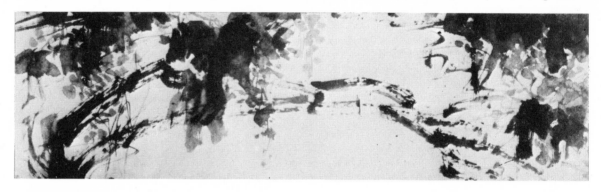

VI Flowers, detail of a scroll, Hsü Wei, Ming period

witness to his method:

'I lived in a pavilion above the river. It was a clear autumn, so I rose early in the morning and looked at the bamboo. Silver mist, shadows and dew slowly appeared through the dense foliage of the little grove. My heart was full of ecstasy — I had found the design of my next picture. In reality my own conception of the bamboo was not the same as the one I had before my eyes. I grasped hold of my ink and trough and spread out the paper. The brush began to flicker but the shapes changed. The bamboo that grew up under my hand was not the bamboo of my heart. It is always like that: the design in my mind has to pass through the brush in my hand; interest and feeling exist outside the law of painting, but the work does aim towards it.'

It used to be said about Chêng that 'He writes his characters like orchids and presents orchids like characters.' The link between calligraphy and painting is particularly striking in his case. Chêng's two favourite subjects — the bamboo and the orchid — must have presided over the birth of written Chinese characters. The knot of the bamboo or the grassy clump of orchids provide equal morphology for the painter or calligrapher.

Chêng Hsieh greatly influenced the Shanghai painters by his use of deep shades of ink, emphasizing the decorative beauty of contrasting black and white. The bamboo and the orchid are mostly painted in silhouette form, void of details, and with a suggestion of movement. Such renditions are symbols that are more true than natural reality. Chêng's form of expression is elegant and skilful. His brushwork is not only soft and supple, but also energetic with infinite finesse. The true secret of Chêng Hsieh's work lay in his ability to synchronize the rhythm of life perfectly with the rhythm of painting.

Li Fang-ying and the other Eccentrics

The other Eccentrics, Kao Hsiang, Li Shan and Li Fang-ying, each contributed something to the development of 'hsieh-i' painting. In particular Li Fang-ying (1695—1754) who mainly followed up Hsü Wei, left a strong mark on the Shanghai School. It is interesting that the work of the Eight Eccentrics of Yang-chou has so far been overlooked by Western literature. This is probably due to the belief in the complete decline of Chinese

painting after the Sung dynasty. But let us return to the real though irregular development in Chinese painting.

The Shanghai School of painting

The work of the Shanghai masters began almost one hundred years after the death of the leading Eccentrics, though during the interim period there were some painters who followed the principles of 'hsieh-i' painting. Works of art which appeared in Eastern China about mid-19th century constituted an important innovation in Chinese painting. One can trace the genesis of this new development to political and economic factors, as the major upheavals in society destroyed the calm surface of life in Old China. Initially the Opium Wars and the T'ai-p'ing Uprising changed the face of the patriarchal country. Yet in Chinese literature and art the results of these important events did not outwardly manifest themselves.

Shifts in social life

The sea, which China had taken little notice of in the last few centuries, assumed a new significance, no longer isolating the country from the rest of the world. When the English and French seamen started to break down this anachronistic isolation with salvos from their deck guns, a tragic and hopeless struggle ensued. At the same time Chinese merchants and financial capital began to move to the coastal towns, which had been

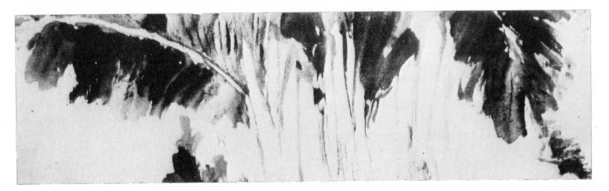

VII Flowers, detail of a scroll, Hsü Wei, Ming period

turned into bases of foreign expansion. These towns also attracted certain strata of the middle classes, bureaucrats, landowners and other sections of the new social conglomeration. From this new community emerged the first Chinese entrepreneurs and the first germs of an industrial proletariat.

Shanghai

As Shanghai's role expanded, it displaced Peking as the most important cultural centre of the country. The whole south and east of China had assumed cultural dominance over the north since the Chin invasion to the north in the 12th century. Apart from this, during the Ming and Ch'ing dynasties the north had been under the control of the conservative Peking Court, so that progressive artistic trends could barely penetrate — with the possible exception of woodblock printing and book illustration.

A broad spectrum of culture and art opened up in the new metropolis. The demands of the many rich consumers contained new stimuli which in turn attracted many learned men, artists and literati. And the reasons were not merely material ones. Newcomers sought the special atmosphere of the big coastal city, where innumerable contrasts inspired new emotions, unusual experiences and fresh ideas.

The result brought the unusual paradox. On the one hand, Shanghai became a busy cosmopolitan metropolis crowded with foreigners. Trade and modern industry grew along the lines of Western, capitalist societies. Yet on the other hand, with some exceptions in journalism and advertising, pure Chinese culture developed. The traditional south Chinese theatre thrived; novels were published in the old narrative style; scroll pictures, albums and fans were painted; and all kinds of folk art and Chinese antiquities were being sold. It was also a paradox that the first translations of Western literature were often transposed into classical archaic Chinese.

All these activities flourished as though the nation wished to protect itself through its unique cultural heritage which could counter-balance the alien products imported from

27

the West. In this manner China had managed to protect herself from various invasions, and so far always successfully. This self-preserving national culture, however, needed to be fresh and exciting, open to new demands and needs. In order to survive in such an untraditional milieu, it had to resort to inspiration other than that derived from the official culture of the ruling Ch'ing. Folk art played a very insignificant role here, as at grass-roots level it was not affected by the general decline. In art the decisive influence was the follow-up of 'hsieh-i' painting, especially that of the Individualists and the Eight Eccentrics of Yang-chou.

The town was inspired by the broad hinterland as well as the sea close by. For Shanghai lies in Kianghsu province, one of the most highly cultured regions of China. In previous centuries it had become famous for its great art from the Wu School, not to mention the Individualists and the artists from Yang-chou. The province also boasted renowned folk art, craftsmanship, woodblock printing, architecture and beautiful gardens. Shanghai was enclosed by a semi-circle of towns which hold places of honour in Chinese culture: T'ai-chou, Yang-chou, Nanking, Su-chou, Wu-hsi, I-hsin, Chia-hsing, and Hang-chou. From all of them artists, folk artists and craftsmen poured into Shanghai, bringing with them their work and their culture. And, conversely, new impulses spread out from Shanghai far and wide, either through the mediation of artists who returned or for a time left the city, or through their works, which attracted customers outside the metropolis. Educated men and the merchants from towns all over the country were frequent visitors to the town. The mouth of the nearby Yangtze linked Shanghai with the entire centre and west of the country — the richest parts of China.

The revival of traditional culture also occurred in other towns along the eastern and southern coast, where similar social conditions formed. For example, in the south lived Chao Chih-ch'ien, who is considered one of the founders of the Shanghai School. At this point we should briefly consider the name of this school of painting. The term Hai-p'ai is often used in specialist Chinese literature, meaning the 'Sea or Coastal School', but sometimes the term 'Hai-shang ming chia' is used, which means 'Masters of the Sea'. In Chinese literature and in colloquial speech the most commonly used term is the 'Shanghai School of Painting'. This is also frequently found in European history of art. Since the main founders of the School came from Shanghai, and that town was truly the focus of the School, the latter term is used in this publication.

Jên Hsiung

The Jên family, who came from the neighbouring Chêkiang province, were among the pioneering leaders of the new painting in Shanghai. Jên Hsiung (1820—1857), also known by the pseudonym Jên Wei-chang, painted figures, landscapes, flowers and birds. He followed up the expressive art of his fellow countryman Ch'ên Hung-shou, developing it to a greater decorative effect. His work is rather uneven; it shows his struggle to attain a freer form and the non-linear 'hsieh-i' style. He resorted to special dotted shading, washing the ink, and a broad range of colours — the main contributions of the Shanghai painters. Though Jên Hsiung died at an early age he had considerable influence on later painters, particularly Jên Po-nien. This was due to the fact that some of his figures were transposed to wood-block printing and appeared in painters' compendiums, which were then very popular.

Jên Hsün

His younger brother Jên Hsün (1835—1893), who also painted figures, landscapes and flowers, consistently adhered to the linear technique used by Ch'ên Hung-shou. His expressive colours, linear work in the 'shuang-kou' ('double hook') style, in flower pictures, were later taken over by Jên Po-nien. Jên Hsün developed a better style than his brother, slightly inclined towards mannerism; he was a skilled craftsman, precise and elegant in his work. The graphic hardness of treatment was balanced especially in landscape by eccentric composition, a certain naivety and fantasy in decoration, recalling Rousseau's work. At times excessive detail in drawing and colour — particularly on pictures of flowers — reveals his diligence in painting according to reality, which was not always in the order of things in China. Jên Hsiung's son, the painter Jên Yü, continued the family tradition and produced outstanding landscapes.

Jên Yü

Hu Kung-shou

Chao Chih-ch'ien

Ch'ên Hung-shou was also followed by landscape painter Hu Kung-shou (1823—1886), one of the founders of the School. In a sense Ch'ên Hung-shou inspired the work of the great 19th-century Chinese painter, Chao Chih-ch'ien (1829—1884), also known

as Pei-an (pseudonym Wei-shu), who came from Chêkiang province. He was one of the typical painters-literati, who passed his state examination and became an official. In his youth he lived in Peking, where he did a lot of painting. Later he became a prefect in the south of the country. Many of his paintings and calligraphic inscriptions have survived, and some were published in monographic almanacs. He was considered as good a calligrapher and carver of seals as a painter. Even here he maintained and passed on the tradition of 'hsieh-i' painting. Thanks to his good education and broad outlook Chao created a far broader framework for this style than his predecessors. He learnt as much from Ch'ên Hung-shou, the Individualists and the Eight Eccentrics of Yang-chou as from old calligraphy, in particular the flowing baroque-like style of writing on the stone steles from the period of the Northern Wei (4th—6th centuries). He used Ch'ên's strength of brushwork and Hsü Wei's elegance of ink marks and exaltation. His pictures mirror the restlessness of the artist upset by the events of the time in which he lived. The spreading cypresses, wistarias, lotus flowers, peonies and cinnamon bushes cover almost the entire area of the tall bands of the scrolls; these together with the archaic calligraphy of the inscriptions influenced his contemporaries in subsequent years. Chao rediscovered the sensual and spiritual significance of the nature motive and the ways of depicting it. Following the 'hsieh-i' trend he rediscovered the vivid colour effects of painting.

Hsü Ku

Another outstanding painter of flowers and birds, Hsü Ku (1824—1896), lived in Shanghai itself though he was a native of the neighbouring Anhui province. His colourful life recalls that of Hsü Wei or the Individualists. Originally Hsü Ku was an officer in the imperial army, but when he was sent to quell the uprising of the T'ai-p'ing he turned deserter and secretly aided the rebels from a monastery. He painted flowers, fruits, birds, fishes, squirrels, and sometimes a landscape on small square pictures. His broken and hard brushwork is striking; in it he showed a sense for rhythm and the picturesque. This sketchy brushwork slightly resembles the method used by the European Impressionists. There had never been such a style in Chinese painting before. Later perhaps we can detect certain traces of Hsü's influence in the works of Wu Ch'ang-shuo, Hsü Pei-hung and Wang Ch'ing-fang. The eventful life of a soldier, insurgent, monk and outcast was apparent in Hsü's pictures. While not lacking in lively decorative features, his work shows certain inclinations towards mannerism. We do not know if Hsü Ku saw paintings by the European Impressionists, like another painter, Wu Shih-hsien; but Wu did not enjoy the same renown as the preceding masters and tends to be an exception with the lesson he had learnt from the Western artists. We could name many other less well-known artists of the Shanghai School in the 19th century, each of whom contributed to the revival of Chinese painting, especially the 'renaissance' of flower and bird painting, the chief domain of the Shanghai artists. The School lived on, its ideas gradually spreading all over the country. They were developing in the course of the struggle for the freedom of the human personality and the right to depict the world of beauty in the correspondingly new manner. On the other hand the artist's style was attenuated by a one-sided stress on decorative feature, too much colour, exaggerated elegance of execution and imitativeness.

Further development of the Shanghai School

The Shanghai School did not close itself to the outside world, but was open to new influences, even those of European and Japanese painting. The ideas of 'hsieh-i' painting, which greatly influenced this School, would have scarcely allowed rigid dogma and formulae. In this manner it became attractive to young painters, who rejected schematic ways and academic plagiarism. It is interesting that the young painters of the national style known as 'kuo-hua' barely succumbed to foreign influences, even though Fauvist, Expressionist and Surrealistic oil paintings appeared in Shanghai during the twenties and some of the Impressionists' and academic work was available in Peking. According to painter Li K'u-ch'an, the younger generation's stress on national painting, particularly the 'hsieh-i' genre, was also due to the sudden and prolonged stoppage of deliveries of oil colours from Europe in the early thirties.

The culminating period of the School

In the second half of the 19th century and the first half of the 20th century the greatest painters of the Shanghai School were at work. The School's 'Golden Age', or culminating period, occurred between 1870 and 1957. Artists like Jên Po-nien, Wu Ch'ang-shuo, Ch'i Pai-shih, Huang Pin-hung, Hsü Pei-hung, and Ch'ên Pan-ting, who will be dealt with in the third chapter, were living and working at that time.

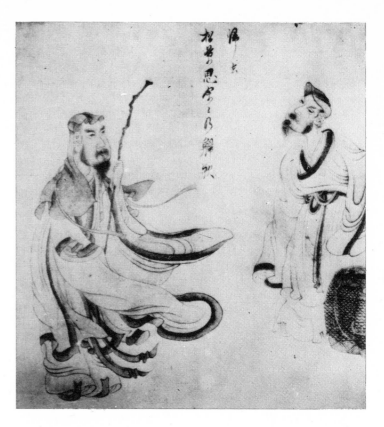

VIII Two figures from the scroll Picture of Vagrancy, Ch'ên Lao-lien, Ming and Ch'ing periods

New centres

Ch'ên Shih-tsêng

The Shanghai School of Painting gradually opened up new centres: first in Hang-chou, then Nanking and Su-chou, and finally, through the mediation of personalities like Ch'i Pai-shih, Huang Pin-hung, Ch'ên Shih-tsêng and Hsü Pei-hung, it penetrated even to conservative Peking. In Shanghai itself there did not appear any painters of the calibre of the founders and protagonists of the School, whose direct 'heirs' included especially T'ang Yün and Wang Kê-yi. While their painting of flowers and birds was fresh and lively, it was weakened by lack of description and an expressionless, garish colour scheme — shortcomings of the majority of the later Shanghai painters.

P'an T'ien-shou

Among the Hang-chou artists who perpetuated the Shanghai School great fame was reached by P'an T'ien-shou (born in 1897), who followed Chu Ta and Wu Ch'ang-shuo. This painter of flowers, birds and natural micro-scenery applied elegance and virtuosity in expressing the decorative beauty of nature. He used many media of 'hsieh-i' painting — such as the technique of the touch of the brush and asymmetric composition — to remarkable perfection. What is lacking in his work is a pioneering vision that derives from profound thought, emotional rapture and perhaps a certain naivety.

Wang Mêng-pai

In 1919 Wang Mêng-pai (1891—1938) came to Peking in search of a livelihood. Once a shop assistant, he was a pupil of Wu Ch'ang-shuo. This artist of revolutionary intent was one of the first adherents of the Shanghai School in the north. He painted flowers and birds, figures and genre scenes; in his work there appeared for the first time social themes from Peking streets. He was outstanding at painting animals, which he studied in the Shanghai zoological garden; in this he did not deny his major influence — Jên Po-nien. Later he chose the same patterns for his painting and calligraphy as his friend Ch'i Pai-shih. They based their style on that of the masters of the Yang-chou School, the Eccentrics. In Peking Wang was so successful that he became a professor at the Academy of Painting for a time. In flower painting he succumbed to the influence of Wu's decorativism and the exaggerated colours of his contemporaries in Shanghai. But he showed great inventiveness in his depiction of animals and small creatures, where he foreshadowed the

30 development of the Hsü Pei-hung School.

There is probably no need to stress the fact that the art of the one-time opposition group has become the leading trend in Chinese painting. In view of what has been said of the character of the art of the Shanghai masters, this development is entirely natural and logical.

Shortly before the war the style adopted by the Shanghai School had assumed a nation-wide importance, proof of which is in an almanac published on the occasion of the second National Exhibition of Art in Nanking in 1937. More than one third of the five hundred works reproduced in that large book derive from the tradition of the Shanghai masters. After the war the development of the Shanghai School reached its climax. Thanks to its leading figures this trend almost became an official one, and dangerously dominant. It prevailed over other artistic styles in any case by its quality. At that time the work of Ch'i Pai-shih, Huang Pin-hung, Hsü Pei-hung was reaching its peak, and the younger generation of Li K'ê-jan had made its entry; many students and young painters adopted the 'hsieh-i' trend. In the People's China this current of painting has been given the support of the ruling circles and enjoys great popularity among the masses. Ch'i Pai-shih and Hsü Pei-hung stood at the head of the Union of Artists of China and the Central Academy of Fine Arts — where other important artists like Li K'ê-jan and Li K'u-ch'an are working as professors. A vast number of reproductions and monographs have appeared and numerous exhibitions have been held. Events of recent years, however, have abruptly stopped the rise of this trend in painting. Whatever solution the future may bring, there is no doubt that the Shanghai School has promoted the rehabilitation of Chinese national painting. Artists of world renown such as Ch'i Pai-shih, Huang Pin-hung, Hsü Pei-hung, and Li K'ê-jan are proof of the power of the ideas of revival — ideas which more than a hundred years ago bold men worked out from their visions and the thousands of years of national traditions in painting.

The Shanghai School, however, was not the only one that was able to point the way ahead. Apart from several smaller groups and individuals of striking character (e.g. Fu Pao-shih or Chang Ta-ch'ien) there existed in the first place the 'Ling-nan hua-p'ai' School (the 'Painters School from South of the Mountains'), known in Europe as the Canton School of painting. It had a good deal in common with the Shanghai School, mainly its basis of realism and the endeavour to attain individual forms of expression. While it is doubtful that the Shanghai artists were influenced by European painting, Impressionism clearly left its mark on the Canton artists. The founders of the School — Kao Chien-fu (Kao

Lun, 1879—1951) and Ch'ên Shu-jên (1883—1948) — studied in Japan where they were able to examine the results of linking certain elements in European painting with modern Chinese and Japanese painting. On their return home they applied this knowledge to traditional techniques and created a new style marked by merger of ink and paint, the suppression of linear character and a specific choice of scenery.

In the works of the Canton artists appears the colourful landscape of south China and the scenery of the big coastal towns. Both the masters, like the Kao brothers, also painted figures, flowers and birds. Nor should the influence of European painting be exaggerated. The founders of the Canton School were pupils of the Kuangtung painter Chü Ku-ch'ien, who (like a number of other southern Chinese, mainly Canton painters) in the second half of the 19th century abandoned the principles of Chinese academic painting for the reality of nature. A similar development is noticeable in the work of a little known Canton painter Su Jên-shan (1814—1849?). In the first half of the 19th century this artist applied many new methods which were developed further by the masters of the Canton and Shanghai Schools. The weakness of the Canton masters was their overemphasis on impression and the picturesque, which in China was always disparagingly called 'sweetness'. As a result of insufficient roots in the progressive traditions of national painting they opted for naturalism. For that reason the Canton School did not rouse as great a response as the Shanghai School.

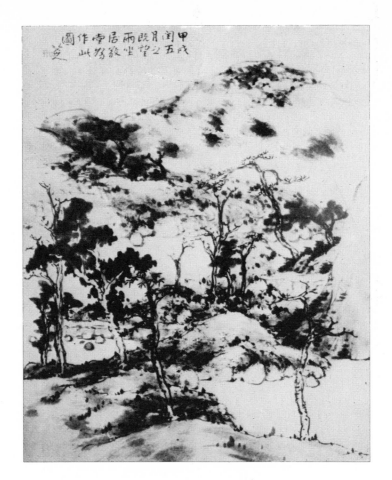

IX Mountain scenery, album sheet,
Chu Ta, Ch'ing period

II Media of expression

As in other spheres of creative work in China the basic technical media of 'kuo-hua' painting are very simple and plain: silk or paper, a brush, ink and an ink-trough and colour. It is perhaps because of this very simplicity — which these media have maintained over thousands of years — that the Chinese love it so much. For them these media are indispensable fellow-travellers of life. They personify them and call them the traditional term 'wen-fang ssu-pao', the 'Four Treasures of the Study', or also 'ssu-yu', 'Four Friends': pi, mo, chih, yen, i.e. brush, ink, paper, ink-trough. This attitude shows that the Chinese never regarded them as mere passive tools, but those which have a striking character and ethics of their own, contributing with their specific form to the master's success, though they are not to blame for the failures of an ignoramus.

The brush

The first of the four treasures is 'pi', the brush. Little is known of its origin, but it can probably be placed into the period of the Warrior States, perhaps even earlier. What is certain is that it was used during the Ch'in dynasty in the third century B.C., from which dates its present-day name 'pi' and the character with the radicle for bamboo, because at that time the brush handle was made from bamboo. The manner of production and the basic material has not greatly changed over the centuries. For the point of the brush nowadays the bristle of goat, hare, wolf, marten or deer is used, and the handle is made mainly of bamboo or reed. In the case of better brushes, the point of the brush itself is composed of two parts: the core, which is mostly of harder and more elastic wolf or deer hair and the outer part, usually of softer goat bristle. Each kind of bristle has different qualities and characteristics. For instance, thirty types of wolf hair alone can be distin-

guished. The quality of the brush is determined by the 'ssu-tê', the four virtues: *Pointedness,* which makes it possible to express the correct shape of the brush stroke and change the strength of the line to hair-thin threads. *Regularity* in expanding the bristles under pressure, which provides for a strong and regular line or patch. *Coherent roundness* of the brush, facilitating the precise strength of the lines in circular or rounded strokes. *Elasticity and strength,* providing for all possible strokes, touches and transformations of the brush. In addition to these qualities, the point of the brush must have sufficient volume and be convex, to absorb a maximum of ink or colour. Special hard brushes exist for 'dry painting', which is usually executed in thick dark ink. Though many different kinds of brushes are available, the individual painter tends to concentrate on only one or two sizes and qualities of the brush so that his style becomes more natural and unified in expression. Let us add that the best brushes have been produced for over two thousand years at Shang-lien in Chêkiang province and are known as 'hu-pi', the 'brushes from Hu'.

With the brush go several other implements which have been developed over the course of millenia. 'Pi-t'ao' is a cover for the point of the brush, usually made of the same material as the handle. 'Pi-chia' serves as a stand to prop up wet brushes, otherwise the brush can be hung up by a loop at the end of the handle. 'Pi-hsi' is a dish for rinsing the brushes; it is usually made of pottery, though sometimes of precious stone like nephrite. The last aid is the famous 'pi-t'ung', a big cylindrical case for holding brushes, usually made of wood, bamboo or pottery, and often richly carved or decorated. The 'pi-t'ung' has become a separate work of art. There exist many other terms with 'pi' as their basis, among them 'pi-hu', which means 'tiger brush', the expression used to denote an outstanding calligrapher.

Ink

'Mo', ink, is one of the most important inventions by the Chinese. Without it one can hardly visualize the traditional face of Chinese culture. It is a highly effective yet simple medium of painting and writing, and ink in the form of sticks or similar shapes, was in itself an interesting work of art. Many secrets and rules are connected with its production and usage.

The origin of ink has been ascribed to different periods, even far back into the Neolithic Age, when various minerals and types of black lacquer were clearly taken for ink. The predecessor of real ink was 'shih-mo', produced from graphite (black lead). Real ink probably replaced lacquer as the main medium of painting and writing in the period of the Western Han. The basic materials for its production have not changed: soot, glue and aromatic admixtures. The best ink was comprised of about twenty ingredients of which soot, the most important, was produced by burning pine wood. Deer glue was used as binding matter. To this were added musk, rhinoceros horn, crushed pearls, and sometimes crude lacquer which increased the hardness, gloss and durability of the ink. Later it was found that soot made from burning the oil of the tung-tree was far better than pine soot and finally that the best soot of all was gained by burning pork fat. Such ink was clearly very expensive. Pine soot continued to be used, but in the 19th century when western influences penetrated China, soot from petroleum became widely used.

The production of ink is not complicated, but the process is a lengthy one. The soot is sifted before the addition of glue and other ingredients, then this material is kneaded and pounded for a long time. The ink dough is poured into little moulds, left to thicken slowly and is dried thoroughly indoors. Finally it is gilded. As ink improves with age, good ink was often left lying for several years.

The external decoration of the ink stick played an important role. It was mostly composed of relief pictures moulded in the little forms and inscriptions, which tended to be gilded or printed in bright colours. The subjects of the relief decorations differed greatly — landscape, traditional symbolical objects, figures, historical events, genre scenes and didactic serials. The serials used to be divided into sequences because several sticks were usually placed in containers at a time. However beautiful the decorations on the sticks and covers may have been, the real connoisseurs were primarily interested in the quality of the ink itself, which they tested by sight, smell and sometimes taste. They worshipped good ink like a god. Which of its qualities did they value most? In the first place the brilliance of the black and its velvety depth, which were unequalled; also the ability to create very fine values up to the lightest nuances. No less important were the smooth surface of the

coating and its permanence, for we can see that ancient inscriptions or ink pictures over a thousand years old have not faded: Other vital qualities referring to the sticks alone were gloss, hardness and smell. Ink should not stick in the hair of the brush, nor soak through the paper, yet should combine well with the paper or silk. It must be added that coloured ink was also produced (mainly red), and that the best ink, 'hui-mo', was produced for over a thousand years in the Shê-hsien district of Anhui province. Even the imperial court purchased its ink there; the best-known firm producing ink is Hu K'ai-wên.

The ink-trough

Closely connected with the use of ink is the 'yen-t'ai', the ink-trough, since great importance was attributed to the act of grinding the ink. Most of the ink-troughs were made of stone, though some were made of precious materials like jade. The trough is smooth, and usually round with a groove to drain off the ink that is ground in it. Ink-troughs of more precious materials were often beautifully decorated with carved plastic.

Grinding the ink

At first sight the grinding of the ink appears to be a simple matter, but in reality this is not the case. The process is done in a little water, moving the ink stick with slow circular movements in a clockwise direction; even and gentle pressure is usually applied with the left hand so that the right hand can preserve its strength and agility for the work with the brush. It is a tiring process requiring infinite patience, for it takes hours before the ink thickens in the trough to form the brilliant depth. No wonder that in bygone days experienced servants and young novices at painting spent long hours grinding ink. Pupils often had to grind whole basins full of the substance before they were permitted to do any painting of their own, as though they were being schooled in infinite patience. If a painter wished to achieve special velvety shades of ink, he ground it the day before painting and let it stand overnight.

Ink boxes

Ground ink was carried around in 'mo-hê', ink boxes; they used to be of various shapes, often with decorations. Most were made of metal and inside had a silk pad of high absorption which held a considerable quantity of ink without overflowing. These boxes were used by pupils at school and by painters who liked to have them at their side when working in the open air.

Paper

Paper is the last of the Four Treasures of the Study, which, of course, does not mean that it enjoyed less popularity. Many Chinese would even place it first. Paper is one of their finest inventions with which they made a great contribution to the development of culture all over the world. Silk preceded paper, and was used for writing and painting on for

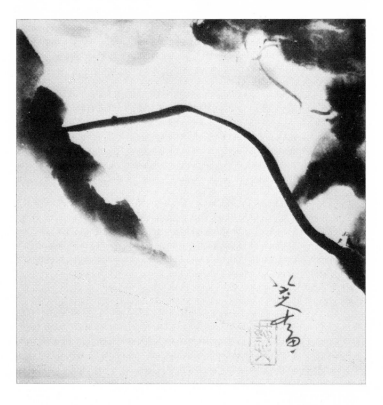

X Lotus leaf, album sheet, Chu Ta, Ch'ing period

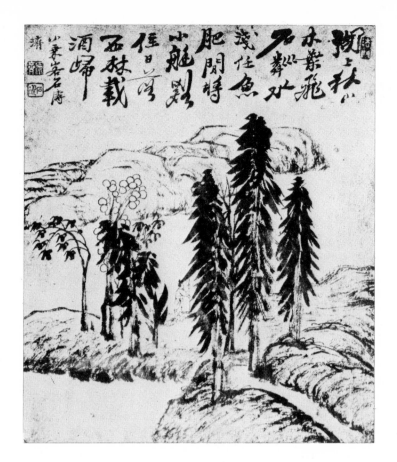

XI Landscape with a pilgrim, album
sheet, Shih T'ao, Ch'ing period

a whole millenium. After the discovery of paper, which was in fact a substitute for the comparatively expensive material, silk gradually lost its exclusive position, and in the Sung period began to take its place. Occasionally silk is used even nowadays. It should be added that not only is paper cheaper than silk but it is highly suitable for art. However, in view of our theme, 'hsieh-i' painting and the Shanghai School of Painting, no further mention will be made of silk. For among the Shanghai painters only Jên Po-nien occasionally used silk for smaller pictures in the shape of a round fan. Sometimes Ch'i Pai-shih did likewise in his earlier work. The other painters of the Shanghai School dealt with in this book painted on paper.

The history of paper is very old. It is assumed that a predecessor of paper made from hemp already existed in China by the third millenium B.C. The first attested record of paper in the Book of Han ('Han-shu') dates from the year 12 B.C. To judge by the character of paper in the first Chinese dictionary from the year 100 A.D., this material was evidently made — at least in greater part — from silk fleece, a waste product in the manufacture of silk fabrics. Let us add that this paper served mainly for wrapping medicaments. A milestone in the development of paper occurred in the year 105 A.D. when the well-known inventor Ts'ai Lun began to use more suitable plant materials — namely the bark of trees, linen waste, rags and fishermen's nets. Ts'ai Lun carried out the production with improved technology, which did not greatly differ from the classical manner. Under the T'ang dynasty paper of outstanding quality was produced, and at that time it was brought to Central Asia and Europe by the Arabs.

Paper was produced in small countryside workshops near the sources of raw materials, which varied from region to region. Sometimes this material was linen, in other places bamboo, mulberry bark, rice or wheat straw, even the cocoons of the silk worm and wistaria shoots were used. The material and the treatment varied according to the type of paper and its future function. In the case of woodblock printing and the production of books, a different quality was required than for calligraphy or painting. Among the best-

known papers is the so-called leather paper, 'p'i-chih', the so-called Korean paper, 'kao-li-chih' and 'hsüan-chih', which was chiefly used in painting and calligraphy.

The 'hsüan-chih' paper derived its name from the Hsüan-ch'êng district in Anhui province, where most of it was produced. This paper is ideal for painting, because it takes ink and colour well and keeps their original qualities. It is fine, has a silky sheen, is soft, yet firm, very resistant and lasting; it survives for centuries, if not whole millenia, as shown by surviving pictures that have come down from the period of the early Sung dynasty. Such paper was already produced under the T'ang dynasty and its quality improved steadily. There are two kinds of 'hsüan-chih' paper: single-layered and double-layered.

The chief material used in the production of this paper is the bark of the sandalwood tree. The production process is lengthy and rather complex. The sandalwood bark is first softened several times in steam, then soaked in milk of lime left to ferment, treated mechanically, washed, boiled in soda lye, then cleaned by hand and graded. This is by no means the end of the process. The bark has to be dried, whitened in the sun, boiled and cleaned again, then ground in a mortar before the fibres are cut. Finally the paper stock is mixed in vats in required solution, then lifted on to screens, and the end product is dried and finished. Sometimes the expensive raw material is partly replaced by rice straw, and the whitening is shortened with the aid of chemicals. Even so, the whole process of production comprises almost three hundred steps (many of them family secrets) carried out by hand. But this exacting work is not done in vain, as 'hsüan-chih' paper plays a vital role in the high professional standard of Chinese painting. We must add that the 'hsieh-i' technique is closely connected with the development of the production of paper for painting — paper which provided the bold brush and the beauty of the ink and the colour with an ideal medium of expression.

Colour
Colour does not belong to the official Treasures of the Study. It was used solely by painters, but plays a major role in the work of the Shanghai masters. Chinese colours are limited in number if compared with Europe, but they are of high aesthetic value. These traditional colours were of mineral, plant, or even animal origin. Tar dyes made from chemicals were commonly used in folk art (e.g. folk prints), but the masters of national painting shunned these. Minerals ground to powder produced opaque colours known by the common term 'ch'ing'; they contain shades of blue produced mainly from azurite and shades of green derived chiefly from malachite. 'Ch'ing' is a fine powder of brilliant 'kingfisher' tones, to which, before painting proper began, a fairly thick mixture of glue had to be added. Such powders are often sold in folded paper like medicaments. These colours — hardly used by the painters of the Shanghai School — are known mainly from the old 'green-blue landscapes' of the T'ang and Sung periods. White, usually made from lead, is more or less opaque and is sold in the form of hard crusted flakes which also need to be mixed with a little glue. Indigo is a well-known dark-blue colour, sold in the form of little scales; it contains a great deal of glue and therefore when warm was mixed with more water or other related colours. Since indigo is of plant origin it fades more easily, but to make it fast for painting and textile dyeing, another blue colour of mineral origin was added.

A considerable number of colours were red or reddish-brown, of which the best-known is vermilion, made in thin flakes; before use it was usually ground in a porcelain dish, or left to dry into a hard crust. The older the colour, the deeper it becomes. Seal colour was also made from vermilion. Cosmetic red is a brilliant shade of purple, sold in small pewter crucibles. Purple (i.e. the so-called true western red) is a very beautiful colour and is sold in small glass jars in powder form. The painters of the Shanghai School liked to use a deep red-brown colour made from haematite and also burnt sienna. Among yellows, the most commonly used in the last few centuries was the brilliant colour of gamboge, a resin of the tropical Garcinia tree. To make gamboge fast in light, gold pigment was added to it. These colours were mostly used in thin, transparent form, especially in 'hsieh-i' painting; a little or even no size was necessary so that in its application it resembled western water-colours. The Chinese painter mixed these colours with water in deep porcelain dishes. Some colours were already sold in such dishes; on paintings they usually appear in pure tones so that the Chinese artist does not require a palette like his European counterpart. The effect of the colour being broken with ink was achieved by dipping the brush twice: in this way

the colour and the ink became partly mixed on the brush and again once the brush touched the paper.

The basic forms of pictures

All that remains to be discussed is the actual form of the Chinese picture. In principle, three basic forms were used: fans, albums and scrolls. It is interesting that all three forms covered the picture so that it could be viewed only when the occasion arose. This fact corresponds to the different requirements of spiritual life in China. Fans can be folding ones, of oval or semi-circular shapes, which make a picture interesting both from its compositional and decorative aspects. The painting on a circular or oval fan — frequently made of silk — is usually mounted and fitted into a square passe-partout. Pictures of this type are often inserted in painters' albums. Similarly, whole concertina-folders were composed of small pictures. Series of pictures on identical or related themes were included in these albums and concertinas, each of eight or more leaves, including inscriptions.

The scroll is the most popular form of Chinese painting. When such scrolls are horizontal they are called 'makimono' from the Japanese; they are unrolled from right to left and 'read' on a table or in the hand. Vertical scrolls are called 'kakemono'. They are hung on the wall, but only on certain occasions. The painters of the Shanghai School concentrated mainly on the 'kakemono' form.

The size of the scrolls

The size of the scrolls was usually measured by the customary Chinese 'ch'ih' unit, which is equivalent to one foot, about 35 cm. This means that a vertical scroll measures roughly 32 to 35 cm in width and its height is a multiple of that measure, when it is not a square. The most common height of scrolls made by the painters of the Shanghai School was three to four 'ch'ih', i.e. a little over one metre to 1.4 m. This size related not only to the composition of the picture but also the fee, which was determined by the number of feet. In the fifties, for instance, Ch'i Pai-shih requested 6 yüan per foot, 12 yüan for a two-foot scroll, etc. Sometimes the painter indicated the length of the picture on the scroll by appending a seal, which plays an important function where the picture ends in a blank space at the bottom edge. This blank was often very effective in the painting. A shining red seal formed a colour accent on which the composition of the entire picture hinged, not to mention the fact that it served as signature.

The function of the seal

The mounting of the scrolls

The mounting of the scrolls in passe-partout is a special craft, which the painter seldom carried out himself. Though several methods of mounting exist, the most widely used is that of mounting wet. It is done on a big table with a varnished surface; the picture is placed on the table face downwards, the back is swabbed with thin size and glued on to thicker paper. Its edge is glued to a paper panel where it dries slowly and becomes stretched. The mounted picture is then taken off and cut to size before it is affixed to a scroll. In this work thick mounting paper with a smooth back is bandaged with strips of thin silk damask. Sometimes coloured mounting paper is used for the passe-partout. Many pictures by the masters of the Shanghai School are mounted simply with one kind of silk, occasionally dyed to match the colours used in the composition (e.g. pure ink pictures usually have a backing of light blue silk). Some scrolls have a matching brocade cover. Present-day collectors keep them in the drawers of a cupboard or, more traditionally, place them into a large cylindrical vase for scrolls, called 'hua-t'ung'.

How to look at Chinese pictures

Finally, a few words about how to look at Chinese pictures. Looking at pictures is not a ritual, and the Chinese were never inclined that way. They unfolded their scrolls whenever they felt the need — at moments of 'tê-i', fullness of heart and mental ease, or in honour of their guests. Naturally, the suspending of a scroll required the atmosphere of a cultured setting and, it should be stressed, the correct light conditions. An educated Chinese would have thought it barbaric to look at a Chinese picture in full daylight, or even in the sun. Sharp light decomposes ink and colour, lessening their brilliance and depth, and imprints upon the ink the dirty hue of ash. Only in deep shadow is the noble beauty of ink and colour revealed. The best time to study scrolls is dusk, when the colours are lit up and the ink gives forth its velvety deep and light values. This principle remains valid even for artificial light, though candles are recommended rather than electric light.

The craftsmanship of painting

The craftsmanship of painting and calligraphy at first sight seems easy. This apparent simplicity, however, conceals the demands on skill, experience, profound comprehension and also spiritual appreciation of the very act that is called painting. These qualities are part of intuitive knowledge rather than something which can be properly learnt.

We shall now deal with the basic techniques of painting which make up the training a Chinese schoolchild undergoes; this will bring us to the common starting-point of calligraphy and painting. The training is very long and exacting.

The first order a pupil is given is to sit up straight, relax his body and take a firm grasp of the brush. The brush has to be held very firmly, vertical to the paper, while the wrist must be entirely relaxed and may not touch the pad or any other support. A small hollow — sufficient in size to hold an egg — should form under the fingers that grip the brush. The firmness of this grip is sometimes tested by the teacher, who tries to snatch the brush away unexpectedly; if he succeeds in doing so, the pupil is punished by being splashed with ink. First, the pupil practises various movements of the hand with the brush to increase the mobility and elasticity of his hands. Later, the pupil learns to dip the brush correctly in the ink, which, long before, he has been taught to grind to the right consistency. When dipped the brush should be full of ink but retain a sharp point with which it ought to be possible to draw even a hair-thin line. Once the pupil has mastered these basic actions, he begins to learn the correct touches of the brush on the paper: he must recognize how much ink the paper can absorb and under what pressure, what marks the brush leaves, how a line and a patch are formed, how to achieve fluency of strokes. Even the way the brush is taken off the paper has special laws of its own. Advanced techniques of touches and strokes of the brush — when its traces assume meaning, rhythm and tension — follow later as part of the pupil's own creative work.

After this preparatory training the pupil learns — mostly by copying — to master the eight basic strokes needed for writing characters. These strokes have names, distinct appearance and are strictly divided into types. The pupil tries to apply them on the characters where the basic strokes are most often used (e.g. the character 'yung', which means eternal, permanent). He learns to write characters from patterns, and has to master the morphological principles of their composition, rhythm, proportions and shapes. In this manner he learns the primary though very solid ways of thinking required of an artist, including memory and imagination. Learning to write characters takes up the greater part of the training. It is not just a matter of learning thousands of characters by heart, but of understanding the inner structure of Chinese calligraphy and its artistic demands as well as semantic aspects. Almost every Chinese painter in the long history of the country underwent this basic training before he even began to study painting itself. It is typical that Wu Ch'ang-shuo, for instance, was very strict in training his pupils in these main principles of character-writing — especially the correct holding of the brush — as his former pupils are able to recall. For painting alone there exists an extensive system of strokes and touches, with a wide range of shading. In landscape painting trees, grasses, rocks, mountains and the water are executed in various types of strokes — ready-made building blocks as it were

XII Branch with fruit, album sheet, Shih T'ao, Ch'ing period

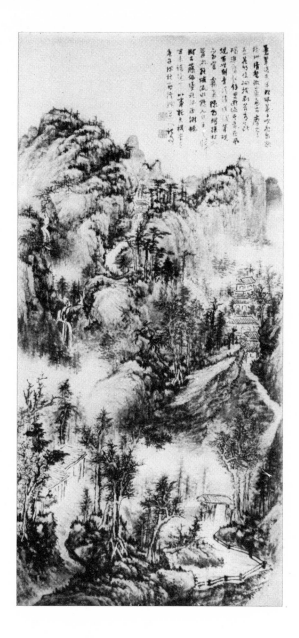

XIII Mountain scenery with hermits' dwellings,
 scroll, K'un Ts'an, Ch'ing period

— out of which the entire composition is built up. The painter had to learn these individual elements by heart, just like the Chinese characters. Artistic quality always depended on the depth of experience and the ability to express the whole, the rhythm, tension and what the painter would build out of the systematized strokes and touches. It should be added that the building-block structure is encouraged in the system of brush strokes because unlike traditional European painting, nothing can be altered in Chinese brushwork — each stroke is irrevocable and full of significance.

Equally difficult is the training in ink washes; that is, to create nuances of ink from the deepest black to the lightest shades of grey. The exact dilution of ink with water is usually carried out by dipping the brush twice. This technique is proof of the painter's skill to express the material or structure of objects with the relevant ink values. The wide range of ink values used by the Shanghai School is evident on traditional coloured woodcuts, by means of which the pictures of Ch'i Pai-shih and other painters were reproduced perfectly at the Jung-pao-chai workshops in Peking. Apart from a large number of blocks many of the values were added by hand during the process of printing. The transposition of ink values to specific colour treatment is by no means a simple task for the painter.

39

III The Artists of the Shanghai School

Note to the Third Chapter
This chapter includes the founders of the Shanghai School of painting (Jên Po-nien and Wu Ch'ang-shuo), the masters of the culminating period (Ch'i Pai-shih, Huang Pin-hung, Hsü Pei-hung etc.) and outstanding painters of the third generation (Li K'ê-jan, Li K'u ch'an and others). They are given in chronological order. The illustrations were selected from material to be found in public and private collections in Czechoslovakia.

Jên Po-nien Jên Po-nien (1840—1896), whose real name was Jên I, came from Chêkiang province. As a young man he went to Shanghai and became an apprentice in a workshop that produced fans. Few reliable dates of his career have come down to us, but many anecdotes and humorous stories are told about him. He made the acquaintance of his first teacher of painting, Jên Hsiung, under somewhat unusual circumstances: the young Jên was forging pictures by popular masters, and out of curiosity, Master Jên Hsiung went in person to meet his skilful imitator.

Jên Po-nien was a versatile painter, depicting flowers and birds, animals, figures, portraits and landscapes. He was an outstanding draughtsman and used colours skilfully; he even discovered a new range of colours in Chinese painting. In some of his works he showed strong leanings towards the traditional woodblock illustrations by the graphic sharpness of the drawing and the monochrome tones of the ink. Jên devoted great attention to preparatory work and usually made many sketches of nature. His favourite motif was bird-life.

Jên Po-nien is rather an exception in the current of Chinese painting under consideration: he became a well-known master at a very early age. He arrived in Shanghai without much education, but full of vitality, creative ambitions, and an almost divine talent. He had no desire to imitate other artists nor did he greatly respect tradition. Jên Po-nien was a painter who scarcely worried about literary associations or philosophy, and least of all, traditional education. He quickly mastered the technical principles of traditional painting and the entire painter's craft. Endowed with great perception and an excellent memory, he was determined to look at the world surrounding him, not merely into painters' textbooks. His main shortcomings — lack of literary and calligraphic education and a limited knowledge of tradition — proved an advantage to him at the outset of his career. Jên Po-nien managed to see his subjects more directly than his contemporaries, and since it was his nature to practise bold experiments which the stiff canon prohibited, he contributed a great deal towards the revival of painting figures, flowers and birds.

Jên Po-nien was not so entirely cut off from tradition as his critics make out. He studied the Individualists, particularly Ch'ên Hung-shou and Chu Ta. Amongst the numerous collections in Shanghai he also saw quite a few of the smaller works by Sung masters, to which official art collecting had paid little attention. He learnt most from Ch'ên Hung-shou's expressive form and stylization in drawing. He developed the elements of characterization and caricature in drawing, as they kept re-appearing in 'hsieh-i' figure painting during his century. He soon perfected the two main styles of painting which he alternated or combined on his pictures — the linear manner of contour drawing called 'shuang-kou' ('double hook'), derived from Sung flower and bird painting, and partly from pictures by Ch'ên Hung-shou; and the freer, contourless 'hsieh-i' style, which he learnt mainly from Chu Ta. He enriched the latter with striking colours executed in original patches and special broken, half-veiled tones, which he gained by adding ink to the paint. He achieved superb mastery of the non-descriptive colour scheme, slightly Art Nouveau in character, and the 'shuang-kou' brushwork. He naturally used the linear style most in figural painting, which he enhanced with mythological themes adopted from New Year folk prints and contemporary figures of the common man.

Jên Po-nien's excellent visual memory and secure knowledge of all he painted gave him virtuosity and facilitated light, playful improvisation. Without this speedy brushwork it would be impossible to imagine the freshness and visual stimulation of his pictures. The structure of the flower or the spontaneous movement of the bird arose in a brief fragment of time, without speculation or hesitation, as a sensitive record of the artist's keen imagination. The result is, in the first place, enjoyment, be it enjoyment from an encounter with

a person or a minor event in nature. We might say Jên's work is like a small poem in painted prose, or a minor musical suite on the touches of the brush. The full-blooded poetry and musical rhythm of his painting is clearly one of the reasons why he seldom wrote little poems on the margin of his pictures.

Apart from the usual scroll format Jên Po-nien liked to use both small square album leaves and the circular or oval format derived from fans, which he had once learnt to produce. On such pictures of rounded shape he created unusual compositions on a horizontal or vertical layout, which strongly contrasted with the round margin and divided the picture into irregular parts.

One characteristic of Jên's pictures is contrast. He contrasted the movement of a bird with the calm surroundings, a contracted or condensed arabesque of the painting with the empty white area, or a straight line with curved ones. Equally effective were his different colours, even colour and noncolour, the contrast of the linear drawing and free ink patches, the light density of fine drawing and brutal dark accents, and 'dry' and 'wet' brushes, etc. This wide range of values was perfectly harmonized by Jên into an organic whole, thus retaining the rhythm and tension that always accompany contrast. In Jên's work this tension is heightened by the typical 'cutting off' of scenery along the margin of the picture, which nevertheless continues beyond that margin in the inner eye of the beholder. This method, based on hints and the effective alternation of media, is reminiscent of the classical Chinese theatre. It was brought about by the contemporary demand — voiced most strongly in Shanghai — for greater stimulation in art.

Jên Po-nien was no philosopher of painting; he was not a nervous and over-sensitive person nor did he show any inclination towards being a rebel. He was less of an intellectual than his predecessors, contemporaries and those like Ch'i Pai-shih and Huang Pin-hung who followed him. But he was an outstanding observer of life, who knew nature as well as the environment of the literati, the hermits, officials, merchants, craftsmen and the poor. He loved his friends - most of all his pupil and companion Wu Ch'ang-shuo, whom he used to visit in Anhui province. He also liked coachmen and horse-dealers. He would observe the goat market and paint the butcher standing over a bound kid without sentimentality. Nor was he too lazy to climb onto a roof to have a look at cats mating. He was a painter possessed with curiosity.

As a great Chinese portrait painter of the nineteenth century Jên divested his models of the usual corrupt dignity. Usually he did not paint them from life but from memory after a friendly chat at home, or from sketches. He did not, however, take away their human warmth and hints of natural weaknesses. The face of his friend, the painter Sha Fu, is a smiling one — indeed, how many such faces could we find in the whole of Chinese painting? The confused and sorrowful face of Wu Ch'ang-shuo fell victim to Jên's friendly malice. Finally, half a millenium after Liang K'ai there appeared unfalsified human feeling in Chinese figure painting. It should be added that if the time had then been ripe, Jên Po-nien would have become an outstanding caricaturist.

The customers among the new strata of Chinese society were not trained to recognize the finest nuances of ink or mysteriously hidden symbolism. They demanded more sensuality and spontaneity from the artists. Jên Po-nien responded to these demands better than any one else in his time, though sometimes he overemphasized them. He aimed at making art entirely secular, more popular and simplifying the painter's ethics. He worked in the fitting style of contrasts, with rhythm, tension and a striking brushwork.

It is a little puzzling that Jên's work shows almost no development. From the beginning it had the same high level. Many pictures, which he painted for casual customers, 'dirt-cheap' and while they waited, showed him also to be a trader. For that reason some of the literati called him a 'vulgar craftsman'. Despite such criticism, Jên Po-nien's versatile work became representative of the Shanghai School of Painting in the nineteenth century, and has influenced countless Chinese painters in the twentieth century.

Wu Ch'ang-shuo

Wu Ch'ang-shuo (also Wu Ch'ang-shih, 1842—1927), whose original name was Wu Chün-ch'ing — had many nicknames, the best-known of which were Fou-lu and K'u-tieh. He came from an old Chêkiang family of literati. In his youth he experienced the terror of war during the T'ai-p'ing Uprising, in which almost his entire family were killed. For five years the young Wu roamed all over the devastated land. These horrors influenced his

whole life. He would often return to them in his poems, and they undoubtedly contributed to his growth as a great humanist. He worked on the land for some years but managed to pass his first state examination at the age of twenty-two. He did not, however, continue in the career of an official and devoted more and more time to literature and calligraphy. He went to Shanghai before he reached the age of thirty and later moved to Su-chou. He was given the position of a minor official and it was not until he was fifty-three that he was named prefect of a district in Kiangsu province. Wu resigned from this office after only a month because he could not bear the hypocrisy and oppression of the people and settled in Shanghai. He had studied calligraphy and carving of seals from his childhood, but he took to painting only after he was over forty; he would copy the old masters, whose works he found in friends' collections. Only after Wu had passed the age of fifty did he begin to take painting seriously and appeared in public as a painter. He learnt the rudiments from Jên Po-nien, whom in return he taught calligraphy, but in style he was a follower of Chao Chih-ch'ien. For subjects he tended to concentrate on flowers or boughs with blossom or fruit — chrysanthemum, peonies, lotus, gourd, vines, wistarias, peaches, and plum blossom; these he often set among little fences, stones or crags. In his early period he painted only a few landscapes and figural pictures, but a series of small landscapes are known from his last year of life, suggestive of a new grandiose period in his work.

Wu Ch'ang-shuo is said to have lived very simply and in poverty. He began to sell his pictures only at the end of his career, when they were passionately sought after by the Japanese. Over five hundred of his pictures have survived. Many of them, together with calligraphy and seals, are in the Wu Museum on the banks of the Western Lake in Hang-chou.

Wu's life is not unlike that of Hsü Wei, but his encounter with official society did not take place with such drama. His work does not have the same pathos of anger and struggle, but turns explicitly to the positive sides of life. Wu's portrayal of nature does not serve to express his inner pain and conflicts, but to form a harmonious picture of beauty combining the sensual values of painting, calligraphy and the seal. Perhaps Wu chose to ignore the worrying problems of his time, or he followed the original Buddhist parable but changed it into a positive philosophical standpoint: 'The lotus grows out of the mud and slush and unfolds a royal blossom, full of tenderness and splendour, purity and beauty.'

This standpoint only affected Wu's painting. In his poetry he openly expressed his bitterness, hatred of all oppression and hypocritical moralizing and drew pictures of the destructiveness of wars. His literary work also includes poems describing natural scenery to be used on inscriptions, where he was greatly influenced by the lyrical Wang Wei of the

XIV Rock cliffs in the Yellow Mountains, album sheet, Mei Ch'ing, Ch'ing period

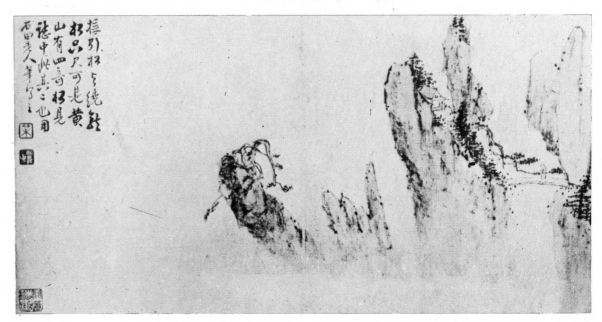

T'ang period. His epic historical poems are based on the monumental style of Tu Fu. Wu's style was classical, though simple and comprehensible, and he was highly thought of by the literati and painters among his contemporaries. At one time his poetry was published in separate collections. It strongly influenced the poems of Ch'i Pai-shih among others. Wu Ch'ang-shuo learnt a great deal from the works of Hsü Wei, Li Shan, the Individualists and the Eight Eccentrics of Yang-chou. He developed the impressive aspects of the 'hsieh-i' style, stressing more realistic enjoyment of nature; and like his teacher Jên Po-nien he did not suppress the decorative beauty in the object himself. For that reason he ranked colour and ink equally and in much of his work gave preference to colour. As a typical painter-literatus he set out to achieve a harmonious link between painting and calligraphy, and poetry and the art of seal-carving, which he considered an essential part of a picture. Indeed we can find few works by Wu which were not accompanied by several verses applied in magnificent flowing calligraphy.

Calligraphy interested Wu from his youth and was always in the forefront of his studies. At that time a new slogan was being coined: 'pei-hsüeh' — 'study the steles'. It sounded like a commandment and had the effect of a gold rush. As Mohammedans go to Mecca, calligraphers made pilgrimages to Hsi-an to find the famous Wood of Steles. They looked for steles in the mountains and at burial places. The thousand years old lettering with its patina and scratches, at times barely recognizable, was duplicated by countless transfers and published in almanacs and catalogues. Old stone masons carved every tremble of the hands of the ancient calligraphers and after twenty centuries people were amazed to read the strokes of the writing which spoke about the character and feeling of the creators far more clearly than the textual contents, which were not often very important in themselves. This study of the steles had a very beneficial effect on Chinese calligraphy and other arts, which it helped to revive, as the passion of collecting turned to inspiration. The beautiful inscriptions on the granite and marble slabs invited thoughts on the mystery of the line and its rhythm, and the infinite possibilities of expression.

Wu Ch'ang-shuo learned a great deal from the old writing, which he studied and copied for dozens of years. The ancient style taught him to appreciate the decorative effect of the inscriptions on Chou bronzes, the decisiveness of characters on stone drums, the grandiose simplicity of Han and Wei steles, and the 'grass' style of the Sung artist Mi Fei. Gradually Wu mastered all the archaic and contemporary styles in calligraphy and demonstrated this unique ability on some of his pictures and inscriptions. At the beginning, archaic shapes were dominant in his calligraphy, but gradually he developed his own characteristic form of expression on the basis of his studies. The hardness of the lettering became more moderate, acquiring a more natural rhythm of writing. The composition of the inscription likewise changed, and was now largely executed in long vertical rows adjusted to the vertical format of the scrolls. Wu's final calligraphic style combined elements of the ancient monumental writing with modern sensuality, simplicity and sophistication. The result was a stimulating tension between the desire for unlimited freedom and the terse order of discipline. He himself said: 'The place of the flourish must be bound by law, the details in the small places must be carried out in a grandiose manner.' Many later calligraphers aimed at such a form of expression because it involved a creative approach to tradition and promised further development. It is no wonder that a number of Shanghai masters followed Wu in calligraphy, especially Chi Pai-shih, who studied Wu's rhythm of execution and his ability to master the tension between contradictory values.

Wu Ch'ang-shuo was as great a master of seal-carving as calligraphy. As a young boy he had learnt to carve stone seals, and he spent more than fifty years in perfecting this art. He studied the stone drums and seal lettering from the time of Chou and Ch'in but also paid attention to the work of his predecessors and contemporaries. His typical rhythm in drawing and composition appears even on those small, mostly square pictures. The engraving is energetic but soft and here too, the design reveals eccentricity. His virtuosity in handling the carver's knife enabled him to carry out various experiments, like adapting the free 'hsieh-i' style to seal-carving. In 1904 Wu and his friends founded the Seal Society of Hang-chou, which did a great deal to encourage the study, collecting and teaching of the art of seal-making.

Calligraphy left a strong mark on Wu's painting; it even became its basis. We can find

identical, concise strokes on his plum branches, on the painted veins of leaves, on stone shading and the contours of flower petals. The drawing has an energetic rhythm corresponding to a calligraphic inscription. The picture is, in fact, a written one. The brushwork is certain and grandiose; it shows delight in painting and gives a broad range of touches, including spontaneous and accidental ones. Wang Kê-yi in the foreword to a monograph by Wu describes the manner in which his teacher worked: 'First he turned the picture over in his mind for a long time; in so doing he would walk about, looking at old pictures or reciting old poems, but once he was inspired, he began to concentrate and painted the picture itself in a moment. His brush moved rhythmically and often like a flash.' Painting, calligraphic inscriptions and seals are inextricably linked in Wu's pictures; though each is original, they have common features which add to the wealth and unity of the work.

Wu's technique marks the culmination of the Shanghai School's attempts to rehabilitate colour in Chinese painting. Colour often took prevalence over ink, adopted some of its values and became an equivalent bearer of expression. Wu used mainly pure and bright colours — red, yellow and blue — to depict fruits and flowers. He presented leaves, branches and stone in broken tones with an admixture of ink. His famous greenish-yellow and blue-green shades with a grey hue, previously unknown in Chinese painting, were later imitated and altered by his pupils. Wu did not like to work with opaque colours which destroy any lighter hues of the painting. One tendency we can find in his work is that of placing varied colour dots side by side, a little reminiscent of the techniques used by the European Impressionists. Wu's favourite colour, sienna, began to appear on his pictures, from the very beginning, sometimes pure, elsewhere broken with ink. The last landscapes Wu produced are magnificently composed in sienna and cobalt alone — a colour scheme which influenced the work of modern landscape painters, especially Ch'i Pai-shih.

Wu also set an example in composition. He made maximum use of contrasting patches of paint with empty space on his little pictures and album leaves. His most frequent format was that of a long vertical strip, whose composition was later copied by

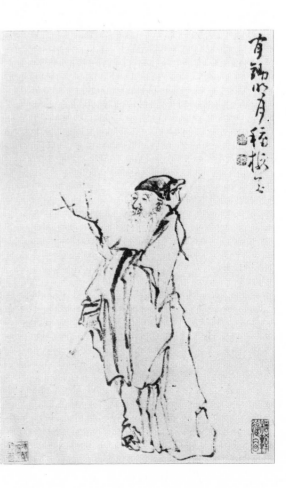

XV Figure of a plum grower, album sheet,
Huang Shên, Ch'ing period

44

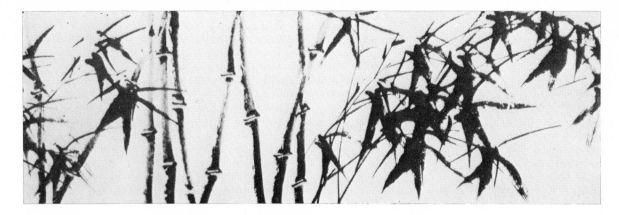

XVI Bamboo, detail from the scroll Orchids and Bamboo, Chêng Hsieh, Ch'ing period

a number of other painters. It was a kind of slanting cut, forming two triangular areas, which gave a picture more dynamic impact and made its format appear less elongated. This compositional division was carried out from the top left-hand corner of the picture downwards to the lower right-hand edge and was achieved with the aid of a diagonal tree trunk, branch or flower.·

An important feature here was that of transposing the vital rhythm of nature to the picture. For Wu the white part of the picture is a stage on which the flowers and branches appear like actors. (An analogy can be found in Pa-ta's fishes and birds.) Their appearance is very important, as a great deal depends on where and how these strange actors enter the stage, when they show part of themselves and what they have to hide behind the curtain. These fragments made the curtain, or margin of the picture a very exposed place, full of tension, encouraging the spectator to continue the play he was watching on his own. Let it be added that the 'actors' — the flowers or branches — on these scrolls did not need wings, in conformity with the actors in the Chinese theatre, because they kindle an idea of space by the specific rhythm of their movements and the hidden trends of growth or decay.

Wu's work showed few changes or major reversals. His life's achievement is unified and well balanced with a noticeable growth in quality. Like many other 'hsieh-i' painters, Wu reached his peak in the last decade of his life. In that period the decorative aspects of his work and the elegance of treatment partly gave way to expression and contemplation. According to the Chinese the 'ta ch'i p'ai' period had started, that of the 'broad breath'. Wu's most beautiful pictures were of flowering plums, chrysanthemums and lotus blossom. In the last year of his life Wu produced his most interesting work — little pictures of square format with series of sprightly birds, done à la Pa-ta. The soft contours included monochrome flowers, stones, tufts of grass and scenery with branches and birds; one might call it a modern improvisation of a Sung theme.

A series of beautiful small landscapes influenced by Shih T'ao and Pa-ta indicate that just before his death Wu Ch'ang-shuo was depicting volume and space in the typical manner of 'hsieh-i' painting. In that endeavour he reached almost monumental simplicity and strength. Thus used to depart many of the truly great artists of China, who lived to a ripe old age. Their last words referred to strength, ideas and youthfulness.

Ch'i Pai-shih Ch'i Pai-shih (1863—1957) is the pseudonym of a painter renowned all over the world. His real name was Ch'i Huang, and among his many nicknames the one often used is Pai-shih lao-jên, which means 'Old Man Pai-shih'. He was born in the Hsiang-t'an district of Hunan province into a peasant family, so from an early age he had to work. He grazed the family buffalo, collected fuel wood, helped in the fields, and in the household at his mother's loom. At the age of seven he started going to the village school, but poverty forced him to leave after less than one year. In his childhood Ch'i knew a great deal of drudgery, poverty, illness and disappointment. Nonetheless, it became the main source of inspiration throughout his life and influenced his work both in poetry and the visual arts. A life of hard work, deep affection for his loved-ones, the traditional atmosphere of family life, encounters with nature and the small adventures of children — all these returned

many decades later in Ch'i's verses and on his scrolls in the form of gentle poetical pictures with clear-cut shapes, colours and scent. Ch'i's culminating work developed in his search for the soul of a child and for the lost home.

Ch'i Huang was physically weak and unable to carry out peasant drudgery. He learnt to be a cabinet-maker, which at the time involved carving. In this craft Ch'i became a master and his fame spread over the entire region, which brought him another nickname: Mu-jên, the 'Wood Man'. He devoted himself to cabinet-making for fifteen years; it sharpened his power of observation and expression and directly affected his later seal-carving. In that period he spent most of his evenings learning to paint, using the famous textbook 'The Garden of the Mustard Seed', which he copied from the beginning to end. The scope of the down-to-earth folk art became an important source of inspiration to him, for it accompanied the life of the people around him in every facet.

When he was twenty-seven years old Ch'i 'broke his fate'. He abandoned his craft and embarked on the career of a professional painter. He managed to support his family by doing a variety of paintings for cult purposes and decoration, fashioning traditional portraits of the living and the dead (death masks). Through the help of educated local people and friends he acquired a solid classical education; he studied history, literature and particularly poetry, calligraphy and painting. He spent whole nights reading the verses of T'ang poets by the light of a pine torch, and they became the pattern for his own poetry. He founded a poetry society and as its most talented member was appointed chairman. For a number of years the literati of the region knew Ch'i mainly as an excellent poet and essayist. Over the course of his life he composed about three thousand poems, and two collections were published in the thirties.

At that time Ch'i developed another passion, seal-making. Over the years he had copied countless seal books. Into stone that he himself had gathered from the river bed he carved hundreds of his own seals, and then he re-polished them and carved anew. After many years of study he created his own inimitable style in seal-making, for which he adapted certain elements from painting, such as eccentric composition and soft lines. The several thousand seals he produced are generally considered the best in this century. They were published in almanacs from the thirties onwards. The artist regarded himself as more successful in seal-making than in painting and calligraphy. He expresses this evaluation in one of his most popular nicknames used on pictures: 'The Old Man opulent in his three hundred stone seals'.

In 1900 Ch'i Pai-shih suddenly abandoned his friends, earnings, bohemian way of life and promise of a good career — moving to a remote mountain retreat with his whole family. There he built the famous 'Pavilion of Poetry by the Rented Mountain', a term that appears on thousands of Ch'i's pictures as a nickname. Like his predecessors he sought an environment of true nature and tranquillity for profound contemplation. The broad panorama of the landscape and the direct contact with flowers and birds later became his main source of inspiration in painting. He spent years observing birds, insects, fishes, crabs and other 'tens of thousands of creatures'. He even studied the growth of the bamboo, flowers as they bloom, and ripening fruit. He planted his own pear and plum trees, and kept crickets, tadpoles and chickens. He observed all their shapes and characteristic movements with a sketchbook in his hand, gradually amassing his basic capital as an artist — the living shapes of nature, which he securely stowed away in his miraculous memory.

He continued this close contact with nature when he moved to a new abode 'The Hall of the Settled Chickweed', where he settled some years later. He tilled a few pieces of land and kept a small orchard which he cultivated himself. It can be seen that his attitude to nature was not one of a passive admirer, since he approached it as a peasant, gardener and orchard-keeper. He planted, weeded and dug with his own hands. The life of the plant would pass through his hands from seed to fruit; it passed through his entire mind and heart, forming the awareness of self-sustaining nature and its meaning for humanity. Working and living in the countryside naturally influenced Ch'i's choice of subjects, which never included anything unusual or exotic. He discovered beauty in simple things — an ordinary wicker-mat, a rake, a cabbage-head or a burning torch.

Ch'i spent almost twenty years systematically studying nature on the mountain slopes

of Hunan. He says in his essays: 'The good painter must first imbue the picture of things

that he has seen with his own eyes. Only then can he grasp hold of the brush and will with certainty beget the spirit of the objects depicted in his work.'

Besides nature's microcosm Ch'i also passionately studied its macrocosm: the sky, mountains, lakes, vast distances, the beautiful landscape in his country. He grew into a major landscape painter. In the year 1902 he set out on his first great journey to the north-west, and then in the following eight years undertook four other journeys to all corners of China. He earned his living by painting and carving seals, but he concentrated on sketching the landscape, visiting monuments, looking at collections and seeking out new friends. The immediate gain from these journeys was the famous collection 'Pictures from Chieh-shan', largely produced from the countless number of sketches he had made during his travels. He depicted the most beautiful parts of the Chinese landscape on several dozen leaves. For the first time Ch'i's great 'rough' and monumental style appeared — something entirely new in Chinese landscape painting; basically it foreshadowed his great 'hsieh-i' style in other genres. This collection and hundreds of later landscapes suddenly ranked Ch'i among the greatest of modern Chinese landscape painters.

At an age when other artists were happily reaching the climax of their work Ch'i Pai-shih began to feel restless and dissatisfied. In his mountain retreat he had painted thousands of pictures of flowers and birds, landscape and figures; he had carved countless seals, written whole collections of poetry and become well-known far beyond the borders of his province. But it seemed to him that 'he painted in too descriptive a manner, that he had not emancipated himself from the bonds of triviality'. He felt the urgent need for greater scope in his work and firmer anchorage in the national tradition of painting. His travels undoubtedly contributed to all this. Impetus for leaving his native Hunan came almost immediately, with the wars which affected this province in 1917. He escaped with his bare life. But even in Peking, where he took refuge from the onslaught of soldiers, there was war, and so after a few months he returned home again. Wars and looting in the Hunan countryside continued and drove Ch'i to a deserted mountain region where he hid for a long time and nearly died of hunger. After a year of suffering he once again fled to Peking, this time to settle permanently. He spent more than forty years of his life in the city but he returned to his native province over and over again in his pictures and poems. The cruel experiences of these years had a profound influence on shaping Ch'i's humanist feelings and resistance to all tyrants and militarists. He expressed his love and hatred in his pictures by very characteristic symbols (e.g. parasites in nature), satire (a stand-up doll), and even more openly in his poems and inscriptions on the pictures. He set out to prove how low the brutal world of despots and warriors is when compared with life-giving nature and harmonious co-existence. The garden and the orchard appear as symbols of peace and dignified human activity.

Ch'i's renowned 'pien-fa', the 'great change in style', occurred during his first years in Peking, roughly 1919 to 1925. This change concerned mainly the genre of flowers and birds, which now became the centre of Ch'i's work. On the basis of lessons learnt from the Shanghai Masters, the Eight Eccentrics of Yang-chou, the Individualists and Hsü Wei, and on the advice of his friends, the painter abandoned the style of miniature-like painting in which he had created his well-known pictures of beetles. He turned to the vigorous and condensed 'hsieh-i' style. This 'change at the end of life' must have been a difficult and painful process. Ch'i Pai-shih had by then turned sixty and had gained fame with his former style. However, he set out on the new road with immense enthusiasm, because it ideally suited his nature, his 'broad breath' and the agitated period in which he was living.

Ch'i's art reached its maturity during the late twenties, when it assumed unimaginable breadth and scope. Hundreds of monumental and lyrical landscapes came from his atelier, with mountain crags, lakes, sailing boats, the setting sun, huts, and trees with ravens. Variations on the theme of the stand-up doll appeared, as did pictures of strange old men close to satire. In the first place Ch'i produced thousands of pictures of fishes, shrimps, crabs, eagles and sparrows, chickens and herons, lotuses and bindweed, wistaria, chrysanthemum, flowering plum, peonies, and flowers of the tea bush, wicker mats and vegetable hoes. Almost the entire spectrum of the countryside and man's labour penetrated into Ch'i's painting: all fruits of the field, garden and orchard; spring and autumn flowers; creatures of the fishponds and streams; the inhabitants of village homesteads; climbing

47

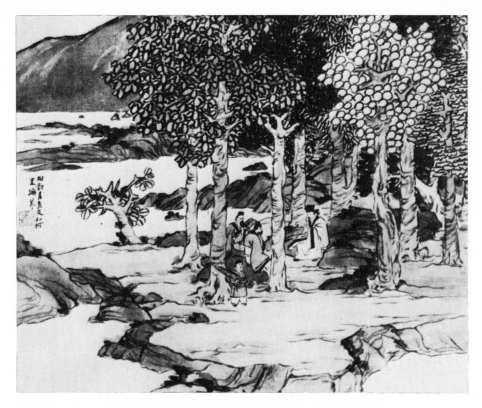

XVII Picture on a theme in a poem by Yao Hsieh, Jên Hsiung, Ch'ing period

creepers on fences and arbours; animate and inanimate inhabitants of the groves, field boundaries, mountains, rocks, and even peasants' sheds. No artist in the history of Chinese painting has achieved such breadth of genre and subject. The models themselves were unpretentious — all that was needed was a mouse, a spider's web, a tadpole or a withered leaf — but under Ch'i's brush their hidden dignity and unexpected charm came to the fore. Nothing remained common or indifferent; nature in its entirety appears in each of Ch'i's subjects. The painter even managed to find beauty and grandeur in decay and waste, in a toppled pine or a thicket of withering lotus blossoms, where the giddy dance of the brush endowed them with the promise of new life. In a very subtle manner the painter was drawing a parallel with human fate and existence, without any pathos or external literary association — and did so throughout his work. It is remarkable how close Ch'i Pai-shih came in his work to the conception of modern European art.

In all his paintings Ch'i attempts to express the hidden order of things, to depict their substance as a general symbol and to catch the rhythm of life in nature. That is the secret of the profound truthfulness of his work. The life force of his bindweed is centred on the struggle for light and space, the vermilion lamps of the flowers reaching out without restraint for the sun. The shrimps sink clumsily to the bottom as the column of water descends. The insects hide under the leaves and the bees hover in mid-flight: you can almost hear their humming. Ch'i Pai-shih was truly the first painter of sound. He managed to express the quality of the elements, the structure of matter, and the rhythm and dynamics of movement. In his pictures we feel the brilliance of light, the current of air; we hear sounds when all we have before us are picture-symbols which are a mixture of 'likeness and unlikeness', yet they are more true than the world in front of our imperfect sense organs and their ultimate records.

Ch'i's art is a synthesis of the concrete and the spiritual; it is an expression of balance between the objectivity of the world and the subjectivity of the creator. There is perfect cooperation between idea and formal medium, as Ch'i did not permit elegance or uniqueness to surmount the inner meaning of his work. He did not copy or describe the reality of the world, but merely suggested it, leaving the spectator sufficient scope for his own imagination. Ch'i himself said: 'Good painters seek their picture of the world on the border

48

of the similar and the dissimilar. He who paints with too much likeness succumbs to vulgarity, but the painter with too much dissimilarity deceives the world.'

In his work Ch'i Pai-shih gave the full meaning to the ancient motto of developing the old tradition, under whose 'banner' he had taken his place. He had learnt a great deal from his predecessors, the masters of 'hsieh-i' painting, but managed to overcome some of their limitations. Unlike some of the Individualists he did not lapse into bitter expression. His love was stronger than his hate, his passionate joy and optimism helped him overcome all worries in life. The radius of his thinking and emotions was more universal than that of the Eight Eccentrics of Yang-chou. By nature he was more of a philosopher than most of the Shanghai masters; he overcame their too decorative trends by using more spiritual expression, which reflected his thoughts on man's relation to the world and to his own soul. He enriched the media of 'hsieh-i' painting by new discoveries in handling ink, composition and colours, which he gradually reduced to a few brilliant tones with maximum colour effect. Together with seal-carving he brought his calligraphic style to its zenith, incorporating the experiences of his predecessors with new elements derived from painting. Thus he created a new energetic rhythm in the slant of the characters and in their composition. What distinguished Ch'i Pai-shih most from other artists is the glimpse of ingenious simplicity and directness contained in every stroke of his brush. On looking at Ch'i's pictures we often recognize a certain primitiveness, discovering that the painter, in fact, looked around him with the fresh and direct eyes of a child, devoid of the surface layer of prejudices and the banality of habits. At the same time the artist thinks with the brain of a philosopher and his immense erudition enables him to generalize and pass judgment. We might say that Ch'i Pai-shih, like Picasso in Europe, 'understood that our age demands directness, immediacy and strength'.

At the beginning of the thirties the fame of the Peking artist spread all over the country and soon began to penetrate far beyond the borders of China. Ch'i became professor at the Peking Academy of Fine Arts and gathered around him many pupils, some of

XVIII Lotus and wagtail, Jên Hsün, Ch'ing period

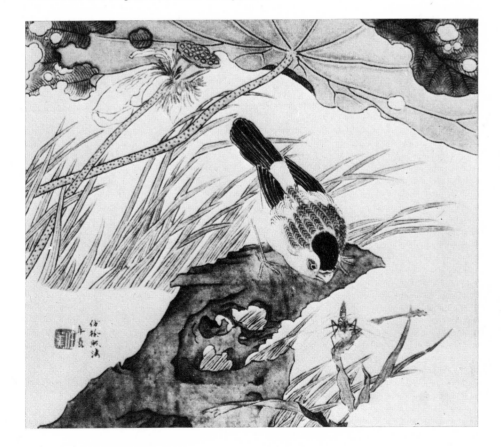

whom later became well-known artists themselves. In Peking collections of his pictures, seals and poems were published. People used to go straight to Ch'i Pai-shih's famous atelier in the western part of Peking for his pictures. But the artist never made a secret of his opposition to despots, bureaucrats and militarists. To avoid the obtrusiveness of those in power he even had a false news item of his death printed. When the Japanese aggressors came, he gave up his professorship and refused to cooperate with state institutions; he forbade the Japanese soldiers to enter his house and symbolized them in his pictures as voracious crabs. Ch'i Pai-shih lived to a great age and was able to see his country enjoy better times. He received honours at home and abroad as no Chinese artist has ever done before. In 1953 he was named the first National Artist of China; he was made chairman of the Union of Chinese Artists; and in 1956 he was awarded the International Peace Prize. In the fifties people from all over the world made pilgrimages to see Ch'i Pai-shih as once they had visited Tolstoy or Tagore. Ch'i never for a moment ceased in his work. Even in his last year of life, at the age of ninety-five, he painted several hundred pictures. It has been estimated that altogether Ch'i painted about thirty thousand pictures in his lifetime. His last works are filled with the flowers of the bindweed, tea plant, lotus, chrysanthemum and peonies. Sometimes a couple of doves appear among them which he painted as symbols of peace and actually kept in his home. Ch'i Pai-shih's last works show no traces of infirmity. His hands had been shaky for some time, but as soon as he gripped the brush, the deliberate motion of the arm produced firm lines. He put down shining patches of vermilion with verve and certainty; each stroke of the brush reveals the ideal 'broad breath' of the creator. He painted his models simply and concisely; though free of details they were enhanced with dignity. The pictures of Ch'i's last years — particularly those of the last few months of his life — are considered the finest of all his work. In them he consummated the heritage of 'hsieh-i' painting to the last dot.

In the last four years of Ch'i's life there appeared pictures that differ greatly from the rest of his work. Their effect is dramatic: they were painted in agitated, baroque-like brushwork, and extremely fluid. The lotuses are depicted in broken blue and brilliant red, the tea flowers in harsh contrasts of black and orange. He went back to the theme of the shepherd and the buffalo and the return of an old man to his native hut, from which a child runs out to meet him. The master himself is both the old man and the child; they represent the circle of life that has run its course. On Ch'i's last pictures beautiful peonies — the royal flower of China — toss wildly about in the wind which tears at the leaves and carries them off in the air. The flowers seem to be struggling for the right to open up their beautiful blossoms to the sun and give forth their scent. Perhaps these flowers symbolize the life of their creator.

Ch'i Pai-shih died on 16 September 1957. He was buried in the presence of countless mourners at the Hunan cemetery near Peking. Not only China, but the whole world felt his loss.

Huang Pin-hung

Huang Pin-hung (1863—1954) is rightly considered the most important Chinese landscape painter of the twentieth century and one of the greatest modern masters. He was born in Chêkiang province but always thought of Anhui province, from where his family originated, as his home. In that province are to be found the Yellow Mountains, which became the chief inspiration of his work. In his youth Huang acquired a classical education, passed the state examinations, but instead of taking up the career of an official devoted himself to painting and taught at many schools of art in different places around the country. He also found employment as an editor and became a theoretician and historian of Chinese art. He was a passionate collector and a good poet. In the years 1937 to 1948 he taught at the Peking Academy of Fine Arts, then moved to Hang-chou, where he was to remain until his death as a teacher at a branch of the Peking Academy. A Huang Pin-hung Museum was later opened in Hang-chou, displaying the master's most important works.

Huang Pin-hung revived landscape painting, which for almost three hundred years had been executed according to the ossified rules of the Yüan masters and the Four Wangs of Ch'ing. Originally Huang Pin-hung had belonged to the conservative school of Huai, but a prolonged stay in Shanghai helped him to overcome this passive approach and apply the liberating principles of the Shanghai artists to his work. But first he had to

conform to the basic prerequisites of those principles — direct study and true knowledge of the landscape. Huang was one of the few Chinese landscape painters of his time who travelled over large parts of his country. He observed many types of mountain regions and hilly lands, which for him always represented the essence of diversity in nature. He loved the sweet picturesque mountains of Kui-lin in the south and above all the imposing Yellow Mountains in Anhui province.

Huang made countless sketches when climbing all those mountains. In this manner he joined Ch'i Pai-shih and the Canton masters in reviving *plein-air* painting. The sketches served only as records; however lively they may seem from our point of view, for Huang they were no more than a preparatory stage in his work. In this he did not abandon the rules of the Chinese tradition. He painted his landscapes from memory, freely, to suit his own fancy. He gave them the atmosphere and meaning that had taken form in the subconscious of generations of painters and the nation as such over the centuries.

The direct study of nature and the need and courage to show his own feelings form the basis that linked Huang with the Shanghai masters. Like them his style was characterized by freshness, directness and novelty of brushwork, sensuality and a concrete approach. Even if Huang's method of painting cannot be considered typical of 'hsieh-i' and of the classical manner of a broad, all-embracing gesture — as used by the Individualists and the majority of the Shanghai masters — it does reflect spontaneity of expression, the 'written' character of the work done under great pressure. With agitated touches of the brush Huang set down a whole stream of painter's characters, aiming to reveal their significance. He himself gave a fitting comparison to his method: 'Brushwork must resemble the determined struggle of the porters on crowded city streets. They are all hastily jostling, and forcing their way, yet they do not knock into one another, never damage the cargo hung from their yokes nor make any unnecessary steps or movements. In fact, they do not get into one another's way.' This is similarly true of the composition of his lines and patches.

Huang's landscape is not static, but full of movement. In contrast to Ch'i Pai-shih's compressed landscape Huang's is more descriptive and elaborate. The painter paid fastidious attention to each detail; his panoramas comprise clumps of trees, stones, grasses, various dwellings, even human figures. Such sensual detail, less generalized than on Ch'i's pictures, forms an essential part of the picture. It helps to create the outline relief as well as the tension between the multiplicity and the singular. This living tension is the result of the many-sided study of reality. Painters who invented landscapes in their studios were never able to achieve this. Climb the summits of mountains to get panoramic views, walk along the road and over the hills, touch the stones and trees, the soil and the grass — those were the main orders of the founders of Chinese landscape painting. Nature has a thousand faces; it is infinite in its transformations and likenesses. For that reason each encounter with nature stimulates the senses and emotions and provides new concepts of depiction. Huang's work serves as an example of this communion with nature. The realization of these postulates in landscape was one of the main reasons why some of Huang's contemporaries bore a grudge against him, particularly the landscape painters from the north; for they were working in their ateliers and based their subjects on preconceived patterns out of reference books.

Huang Pin-hung was an expert on old painting, about which he wrote thousands of pages of highly knowledgeable text. He had great respect for tradition and was keen to promote its continuity; throughout life he studied the old masters. He recommended the detailed study of ancient inscriptions on bronzes and stone steles for the training of strokes and the brushwork of the line. Huang considered Shih Ch'i (K'un Ts'an) as his main influence. He had immense respect for that master's work and theory. But he wrote with pride on many of his pictures: 'The Yellow Mountains were my teacher.' The priority of this great theoretician and art historian was to seek inspiration from immediate reality. However much of a philosopher Huang may have been, he was not concerned with illustrating his philosophy in his work — such ideas would have contradicted the very basis of 'hsieh-i' painting. He was not interested in a neutral, indefinite landscape. If we were to journey through the Yellow Mountains, we would search in vain for the concrete scenery on Huang's pictures. Instead we would recognize how he unravelled the core of that immense

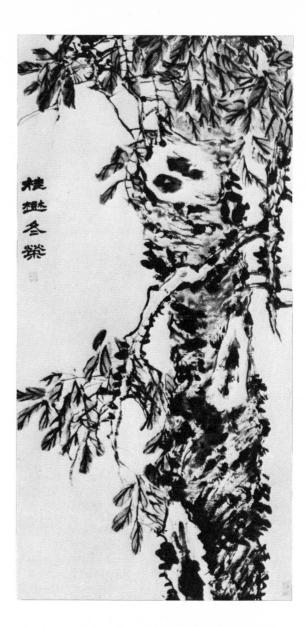

XIX Cinnamon tree, Chao Chih-ch'ien, Ch'ing period

confusion of natural miracles and caprices, to create a dignified yet simple landscape core which does not confuse our vision. Huang created a picture of the Yellow Mountains in their sensual and spiritual character out of thousands of views and thousands of experiences.

Huang Pin-hung painted coastal scenes and pavilions in the mountains on small square pictures. In these he applied a more lyrical tune. But he is primarily known for his robust panoramas of wild mountain crags and lake shores. The monumental space on these landscapes and the inertia of the mountain ranges is stressed especially in the later period, by extreme plasticity of relief, modelled in dots and lines. The brushes combined the touch of the point with full application, attention to detail with compactness, thick and dark inks with light and thin ones. Such plasticity had perhaps never been seen in Chinese landscape painting before. The surface of the landscape is tempestuous, baroque; it is filled with large and small dramas of mountains. There are dark, thick modelling inks — 'bitter' landscapes, as Huang himself called them — in contrast to the more pleasing colours by other landscape masters. But the broad white areas of water, the mists, the sky, and the calming touches of blue on the distant mountain ranges suggest that the agitation in the landscape are not absolute, but only one aspect of the infinite, grandiose flow of events. This contradiction of forces resounds in Huang's pictures by the uncommonly effective contrasts which are highly decorative in character.

Huang Pin-hung regarded landscape painting as the highest form of art. He believed — in common with other great Chinese landscape painters — that landscape is an event, an aimless river bed whose current sustains the struggle for the balance of forces, otherwise space would close and movement, the main force of life, would cease. Such a concept of the landscape precludes all disinterested approaches on the part of the creator and spectator, for the spectator cannot possibly feel indifferent towards a painting in which the parable of human life is so consistently applied, and nature and man become inseparably linked. In Huang's view the artist might succeed in that genre only after he had reached the age of forty, because it was impossible to understand nature without a profound knowledge of life. One of his well-known beliefs is that landscape is the domain of human and artistic maturity. In this connection Huang liked to repeat and stress the principles of the painter Shih Ch'i, his model. They concern his three famous regrets: 1. regret or shame that his two legs did not climb all the mountains under the heavens; 2. regret that his two eyes did not read ten thousand volumes; 3. regret that his two ears did not listen to the teaching of all wise men. It appears that these notions of the famous Individualist exemplify the principles of the painters-literati whom Huang Pin-hung represents.

Like Wu Ch'ang-shuo and Ch'i Pai-shih Huang produced his best pictures at an advanced age. The climax of his work is usually placed in his ninety-first year, the last year of his life. Following a happy tradition he worked till almost his dying hour. A day before his death he painted the countryside in a snowstorm from the door of his study in Hang-chou. Towards the end of his life he painted not only his 'bitter' landscapes but also smaller pictures full of colour, as though he had become tired of the dramatic landscapes and was seeking a contrast in a new synthesis, free from tension and despondency. These landscapes have light and restless lines outlining the basic shapes of things, and, what is most important, rich and lively colours. While formerly the colours were complementary in character, they now became substitutes for the plastic effect of the ink. By alternating the contrasts of warm and cold shades they suggest plasticity and space in the landscape. Sienna, cobalt and green tones form an unbroken cover over nearly whole areas of the picture. Their full colour effect is not subdued by ink values; on the contrary, the individual colours stand out in mutual confrontation. At the same time the colours mitigate the hardness of Huang's traditional compositions made up of dominating points, set asymmetrically, and triangles. They raise the tension between the space depicted and the actual flatness of the picture. The works are slightly reminiscent of Cézanne's landscapes in

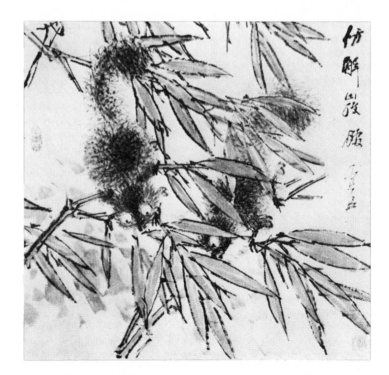

XX Squirrels and bamboo, Hsü Ku,
Ch'ing period

water-colour. In his preoccupation with colour Huang revived and developed the ancient Sung rules on colours known as 'the red dot in the green sea', by which a picture can become saturated in colour. He liked to use a striking yet economical colour accent, which was decisive for the composition and, at the same time, endowed with playfulness. Did those bright and shining landscapes hold the promise of a new period in Huang's work? Ch'i Pai-shih's last pictures were full of rapacious brushwork commemorating spring in a dramatic tonescale, the final work of his fellow-painter Huang Pin-hung boasts brilliantly pure and merry colours which evoke poetry and the freshness of youth.

Ch'ên Pan-ting

Ch'ên Pan-ting (1875—?), like so many of the painters of the Shanghai School, came from south-eastern China. He was a pupil of Wu Ch'ang-shuo, whose style and scope of subjects he adopted without major changes. Later he went to Peking. He also learnt a great deal from Ch'i Pai-shih, in particular composition and the conception of some of his subjects such as fruits and vegetables. He chiefly painted flowers and birds, and also some landscapes. Like Ch'i Pai-shih, he followed the graphic style of Chin Nung in calligraphy; but he alternated it with the 'grass' style. He developed the colour palette of the Shanghai masters in a very sophisticated manner. Here too, however, he lacked the courage to achieve a more independent technique so that his painting represents a mature and sensitive elaboration of the style of his two great models — Wu and Ch'i. While Ch'ên Pan-ting's work is not new in itself, it is highly proficient and expresses joy derived from the elegant touches of the brush, the restrained colours and the decorative beauty of the flowers.

Ch'ên Shih-tsêng

Another of the School's protagonists was Ch'ên Shih-tsêng (1876—1923), whose real name was Ch'ên Heng-chüeh. He came from the town of I-ning in Kianghsi province. He was a painter, engraver of seals, calligrapher, poet, pedagogue, theoretician and art historian. Ch'ên wrote a history of Chinese painting. As the son of a well-known poet, Ch'ên San-yüan, he acquired a great classical education at home. He studied museum science for a number of years in Japan and is also said to have studied European painting. He worked as professor at Peking University and at the Academy of Art, and was also employed in the editorial department of the Ministry of Education. Ch'ên was one of the most interesting artists in China at the beginning of the century. With his many talents and receptiveness to new trends he stood apart from the conservative, mediocre artists that dominated the north of the country. He painted with very sparing media producing landscapes of small size — consistent and successful applications of the 'hsieh-i' style within the intentions of the Shanghai School. They were executed in broad, energetic brush strokes, with green predominating the noble colourscale. Ch'ên applied the grandiose compactness of his landscape to painting flowers and birds, in which the lyrical tone became even more striking. Somewhat different are his figures, painted mostly from models. Almost miniatures, they are pleasant and a little naive in expression, often with a touch of satire. We can detect the influence of European post-Impressionist painting as interpreted by Japan. The best-known of these miniatures were published under the title 'Pictures of Peking Customs and Habits'. Ch'ên also painted fans exquisitely; he became widely known for seal engravings and calligraphy, and executed his grandiose calligraphic style in his painting. Ch'ên was a very close friend of Ch'i Pai-shih's; he was the first to recognize Ch'i's talent and took an interest in him on his arrival in Peking. He also suggested Ch'i's 'great change of style at the end of the years'. Ch'i Pai-shih remained grateful to his teacher to the end of his days and spoke of his memory in many poems and inscriptions. The benefits of that great friendship were mutual. Ch'i expressed it concisely in one of his inscriptions on Ch'ên's picture: 'Were it not for the Master, I would not have moved ahead; were it not for me, the Master would have gone back.' As the Chinese say — 'The heavens envied Ch'ên his age' — his early death was always considered in China one of the saddest losses of modern Chinese painting.

Hsü Pei-hung

Hsü Pei-hung (1895—1953) is better known in the West as Jupeon. He grew up in the town of I-hsin in Kiangsu province, from where he set off for Shanghai. In 1919 he went to Paris on a scholarship. He returned home in 1927 and soon became professor at the art school of Nanking. Apart from teaching he devoted his time to organizing Chinese exhibitions abroad. During the war against Japan he fled to Chungking; in 1939 he travelled to India and other countries in southern Asia to organize collections for the fighting

Chinese. After the war he worked in Peking, where in 1949 he became Rector of the Central Academy of Fine Arts.

In Paris Hsü Pei-hung learnt the European manner of realistic painting with clear marks of Art Nouveau Symbolism, and also the solid craft of painting in oil. After his return to China he continued to paint in oil for many years and produced large pictures with historical and patriotic subjects. Realistic classical portrait and figural studies, drawn by pencil or charcoal, accompanied his work throughout his life. Concurrent with this work in the European tradition he began to experiment in the national 'kuo-hua' painting. He was not concerned with an eclectic blending of the two different traditions — there had been a number of such attempts in China during the twenties and thirties. The traditional basis of Chinese painting — the principles of composition, motifs, colours, treatment, media and materials used — remained unchanged. What Hsü tried to do was to enrich this basis with some rational media of painting: precise study in the form of drawings, anatomy, perspective foreshortening, and the expression of plasticity by means of shading. The artist endeavoured to broaden Chinese national painting in content and theme as he wished to place this at the disposal of the revolution taking place at the time. He was convinced that the existing traditional media were not sufficient for the new needs, especially in figure painting.

Hsü's work in the last twenty years shows how successful this experiment was. He hoped that Chinese national painting could develop if it was enriched also by certain elements from an entirely different, European tradition. The experiment succeeded as a result of Hsü's thorough knowledge of the European art traditions, as well as the proverbial lack of dogma in style and the open-minded approach of 'hsieh-i' painting interpreted by the Shanghai School of painting.

His novel method made him and Jên Po-nien the best portrait and figure painters in contemporary China. His monumental figure compositions have, unfortunately, found no follower. He was likewise the best painter of animals, especially lions, buffaloes and cats, and in the dynamic depiction of horses he became a worthy heir of the Sung artist Li Lung-mien. His well-known pictures of cocks, cormorants, ducks and other birds are highly decorative, as are those with plant subjects — bamboo, flowers and blossoming branches. Many of his landscapes have exceptional charm and reveal the influence of the Impressionists more than his other genres. On the other hand, strength and terseness of expression appear on certain scenes of trees — particularly cypresses and pines — and also on bird paintings of eagles, vultures, and sometimes even cocks. Everywhere Hsü Pei-hung applied a symbolism connected with topical events.

Hsü's courage and creative honesty greatly impressed Ch'i Pai-shih, who became his closest friend. On numerous occasions the two painters worked on one and the same picture; e.g. Hsü would paint the water flora and Ch'i the shrimps. The friendship of the two men was so deep that no one had the courage to inform Ch'i of his friend's death.

Even this brief survey makes it clear that Hsü's work is not entirely unified in expression, which was perhaps due to his blending of different traditions. Hsü's broad scope of interests, immense work as pedagogue and organizer, his social activities and too short a life-span did not enable him to give sufficient depth to his discoveries. Despite his vitality and creative approach, it would appear that the generalization of reality and the rate of contemplation did not reach their utmost limit. One might say, quoting Ch'i Pai-shih, that there was still too much likeness with outer reality, perhaps too much decorative beauty. The term was short, the risk too great, and one cannot but speak of the lack of finish in Hsü's work. Even so he possessed great talent, courage and moral values. His work forms a milestone in Chinese painting.

Kuan Liang

Kuan Liang was born in Canton in 1901. He studied for a long time in Japan where he learnt European methods and techniques of painting. After returning to his country he worked as professor of painting at a number of Chinese art colleges. Kuan Liang became known at home and abroad through his pictures of scenes taken from classical Chinese opera. The Japanese woodcut — which often portrayed actors — is considered as the original inspiration of his theatre paintings. There was even a greater influence of Chinese folk prints, which not only have a wealth of theatrical subject matter but are very close in colour to Kuan's work. In traditional painting the subject of opera seldom appeared, so

that Kuan's application of it to the 'kuo-hua' media of expression was a worthwhile undertaking. The world of the classical opera is endowed with rhythm, dynamics, contrasts, brilliant colours and inner tension; all of these qualities can be found in Kuan's pictures, which are lightning records of his theatre experience. He painted in the 'great hsieh-i' style, reminiscent of Sung Shih K'ê's work and that of the Eight Eccentrics of Yang-chou. One can find similar, primitive figures which evoke children's drawings, in the paintings of Ch'i Pai-shih. A leaning towards caricature and expressiveness is also evident in Chinese woodblock illustrations, while folk New Year prints display similar colours. Kuan's painting is built up from the rhythmic play of contrasts: lightly sketched lines and flat dots, thin and deep, thick inks; the faces of the actors form brilliant accents in colour. Here too, the adaptation of the rhythm of life to pure painting is the secret of the artist's success.

Lin Fêng-mien Lin Fêng-mien (b. 1901) comes from the province of Kuangtung in South China. After the first world war he studied in Paris and Berlin. Back in his country he taught painting at the Academy of Arts in Hang-chou and together with that school retreated inland during the war to escape from the Japanese. This period of refuge had a considerable influence on his work, and was probably the reason why he later showed leanings towards national painting. After the war he settled permanently in Shanghai. For many years after his return from France Lin was inspired by the post-Impressionists and adopted European techniques of painting. Later he applied these principles to traditional Chinese techniques and continued the two traditions side by side. He painted still life, figures including nudes and landscapes often in the European style. We can recognize the influences of Vlaminck, Derain, Matisse and Marquet in Lin's work, even his Chinese painting which is akin to water-colours by contemporary Western artists. Nonetheless, Lin's Chinese work is considered to be traditionally 'hsieh-i' in style. It is highly valued both in China and abroad. Lin chose attractive and traditional subjects — actors of the traditional Chinese theatre, lakes, rivers and waterfowl. He used thin and thick values of ink, and broad, thin brush strokes which he often placed in the European manner. His colours too, especially blue and sienna, are broken with ink. The format of his pictures is almost exclusively square. Lin's experimental technique differs from that of Hsü Pei-hung. Hsü enriched the Chinese national style with certain media of European painting, while in Lin's work the two traditions meet roughly at the same functional level. But they created a new expression of poetry in Chinese painting, which was equally organic and effective.

Wang Ch'ing-fang Wang Ch'ing-fang (b. after 1900 — d. 1956) spent most of his life in Peking, where he studied at the Academy of Painting. He was a pupil of Ch'i Pai-shih and Hsü Pei-hung; originally he was known as a xylographer and carver of seals. He made a series of woodcuts with figures from Chinese history. Wang studied the European tradition in woodcut techniques, but the freer style of his seal-carving reveals the influence of Ch'i Pai-shih. He was a good calligrapher and also a poet, whose poetic inscriptions on pictures even appeared in print. The main core of his work lay in painting, and his lively, realistic form learnt from the two great masters, ranks him among the Shanghai School. In painting plants, animals and birds he followed the Hsü School most closely. He appears far more original in landscape, undoubtedly inspired by *plein-air* work. He painted secluded parts of Peking — subject matter which forced him to abandon ready-made landscape formulae and seek new ways of expression. The lightly veiled colour schemes of these little scenes recall the Peking School of landscape painting, which expressed the atmosphere of the ancient metropolis in a like manner. Wang Ch'ing-fang was primarily a poet of fishes, which became the chief domain of his art. He established his own School in that genre. His picture of the ink carps and small fishes, or golden aquarium fishes in bright red, were made with an understanding of the creatures' rhythm of movement and the resistance of the invisible element, water. Boldness and elegance of expression are the result of Wang's immense patience as an observer. Countless little fishes took their place in the aquarium in Wang's study, and his Peking courtyard boasted many generations of bindweed, chrysanthemums and gourds. All these fishes and plants were examined in great detail before they were given their unique likeness on Wang's scrolls.

Li K'u-ch'an Li K'u-ch'an was born in 1903 in Shantung province, from where he went to Peking to study European oil painting at the Academy of Painting. He was also taught by the Czech Professor Vojtěch Chytil, who guided the young Li to paint in the local tradition and ac-

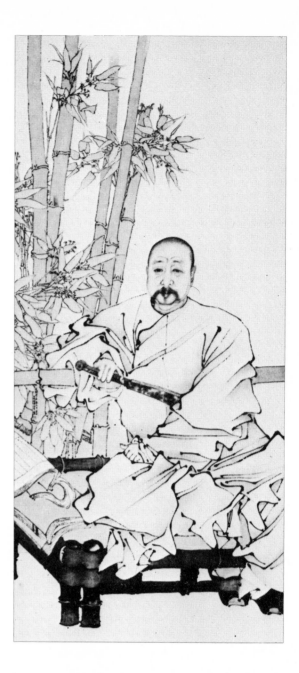

XXI Portrait of a man. Jên Po-nien, Ch'ing period

quainted him with his friend Ch'i Pai-shih. As we already know, the lack of oil paint in Peking imposed a certain pressure upon Li's generation, directing them towards national 'kuo-hua' painting. Li K'u-ch'an became one of Ch'i Pai-shih's pupils. His main genres were flowers and birds. He also chose Pa-ta shan-jên (Chu Ta) as a pattern. The wealth of colour and the decorative beauty of some of Li's flowers — in particular chrysanthemums and lotuses — reveal that he had also studied Wu Ch'ang-shuo's work. Under the influence of Ch'i he began to paint even fishes, frogs, and cormorants, and Ch'i Pai-shih personally signed some of these little pictures for him. The dominant creatures on his scrolls are quail and herons, set against a background of cornfields, pines or other trees. There is nothing new in this theme, which had been used long ago by the Sung painters. Li's originality lay in his close observation of nature; his realistic execution did not preclude the decorative effect. Following the 'hsieh-i' trend the painter did everything spontaneously and 'in one breath'. The specific rhythm of the painting and rapid flow of the brushwork evoke the living character of creatures and plants and the vibrating structure of matter and surface. As a member of the Shanghai School the artist paid great attention to colour. It is again typical that in Li's work blue and sienna, placed in broad patches on a basis of ink, prevail.

The bodies of Li's quail and herons — and likewise eagles and cormorants — are modelled simply in a few strokes of the brush, dipped alternately in thin and in thick ink. There is nothing superfluous here, perhaps because the painter works at moments of ecstasy. Li K'u-ch'an works spontaneously: many of his pictures — perhaps his finest — were produced during meetings with friends, merry conversation, or over a glass of brandy. The painter would have a ready pile of cut paper and sufficient ink and paint, before he literally hurled himself at the white paper that was lying on the floor. He would then select one or two from the dozens of pictures and destroy the rest. This manner of painting is rather typical of the Shanghai masters, even though it was not practised by all of them.

Li K'u-ch'an also used to paint landscapes and figures according to the expressive, European tradition. In figure painting he applied a strong social note. In both genres, however, Li did not display such a sense for beauty and sensuality of expression as with his bird and flower paintings. He knew his favourite subjects well: he kept eagles and cormorants in his home and frequently visited the zoological gardens west of the Peking wall. He made many sketches and studies to which he gave much thought before carrying out the final work.

In the fifties Li worked as Professor of National Painting at the Central Academy in Peking. This artist can be ranked among the modern representatives of the classical school of 'hsieh-i' painting in view of his leanings towards real nature and his individuality.

Li K'ê-jan

Li K'ê-jan (b. 1907) comes from the town of Hsü-chou in Kiangsu province from a poor family of market gardeners. At an early age he showed interest in painting and began his career as a painter in the orthodox manner: he ground ink and washed brushes for the traditional painters in his town. From the age of fifteen he studied at the art school in Shanghai and then progressed to the well-known Academy of Painting in Hang-chou. He became a member of the progressive movement in art led by Lu Hsün; from 1937 he was one of the many cultural workers taking an active part in the anti-Japanese struggle around the Yangtze river basin, mainly in Hunan. He painted pictures, posters and leaflets, and even made large frescoes with anti-Japanese and anti-collaborationist topics. From 1943 onwards Li taught painting at the art school in Chungking. The beautiful setting of Ssŭch'uan guided him at that time to his favourite group of subjects: landscapes, bucolic scenes and figures of poets, old men, pilgrims and hermits. Li relates how opposite his Chungking home there stood a big cowshed; at that time he developed a great liking for cows and buffaloes and never ceased to paint them. Soon after the war he was offered the post of professor both at Hang-chou and in Peking. Li decided to go to Peking. As he himself said, the reason for his choice was that two of the greatest painters of China, Ch'i Pai-shih and Huang Pin-hung, lived in that ancient city. Li K'ê-jan considered it his good fortune that he could learn from both these painters, who were then at the height of their creative powers. Ch'i took a great liking to Li, and they became close friends. Apart from the influence of these two teachers Li also studied the Individualists of the seventeenth century, in particular Shih T'ao. He then developed his style in a lyrical direction, following the Shanghai School in the use of richer colours and the novel significance of paintings. In his autobiography Li called this New Realism. He began this trend about the year 1949, and clearly linked it with the revolutionary events of the time. It is founded on the traditions of the national 'kuo-hua' painting, but Li added some of the rational elements of European art traditions. Interestingly, Li's New Realism has a good deal in common with the Neo-Realism then developing in Europe. Similarities include the deep regard for reality, the stress on the standpoint of the creator, and the general optimism and joy derived from observation and execution.

At that time Li K'ê-jan became professor at the Central Academy of Fine Arts in Peking. He began as a figuralist, and figure painting forms part of his work to this day. The painter considers the transition to landscape a higher stage in his own artistic development. In figure painting he used the age-old themes — shepherds with buffaloes, hermits, poets admiring the beauty of nature, court ladies, exorcists of the devil and the like. The bucolic scenes and those of the poet meditating in nature mainly filled Li's work in the forties. Their lyrical and romantic atmosphere reveals that the artist originally found his patterns in Sung pictures of this genre. These subjects are presented in a modern manner, with all the *noblesse* that 'hsieh-i' painting is capable of in its contrasts of line and patch

and the typical lively rhythm of the brushwork. Other masters of the Shanghai School worked in a similar manner as for example Hsü Pei-hung in pastoral scenes with buffaloes. In Li's work it seems that the segmented and lightly sketched outlines of the figure reveal the influence of political caricature, to which Li devoted himself during the war and for which the Chinese media of painting and the techniques of 'hsieh-i' painting are eminently suited. In the rustic scenes depicting the world of children Li upheld the poetry of the bucolic setting. There appeared many humorous, playful, almost frolicsome scenes, but they do not aim at caricature by contrast to the pictures of exorcizing the devils, which are clearly caricature. However charming these idyllic little pictures with buffaloes and children may be, their infinite transformations involved a certain danger of mannerism. Li K'ê-jan avoided this danger by turning to landscapes. Hints of this appeared already in figure paintings, not only in the form of trees, stones and rocks, but in the equally important white space of water, mists and sky. On the pictures with figures done in sparing colour (ink and skin colour, or at times brilliant red, sienna and blue) Li applied his interesting calligraphy in the form of large inscriptions which often filled up the empty space.

Landscape became dominant in Li's work from about 1953 onwards. It is typical that the direct contact with reality became the chief stimulus of this creative development. *Plein-air* work gained new significance. From 1954 Li regularly went on long journeys to the most beautiful regions of his country, which included the Yellow Mountains, Hang-chou, the vicinity of Su-chou, Lake T'ai-hu, the Fu-ch'un River and Ssŭch'uan. He also painted in Peking and its vicinity. Li considered the Yellow Mountains the most beautiful part of China, because of their rapid and endless changes, like the changes on a human face. He sought 'i-ching' in the landscape, the soul of the scenery, which reflects the specific qualities of a place and Man's spiritual attitude to it. He had learnt this from small Sung landscapes, which interested him both for the emotional attunement of the scenery and the fleeting changes in weather. These qualities merged with human activity and movement to form the original core of the landscape. For that reason Li K'ê-jan advised his

XXII In a mountain town, Wu Ch'ang- shuo, 1927

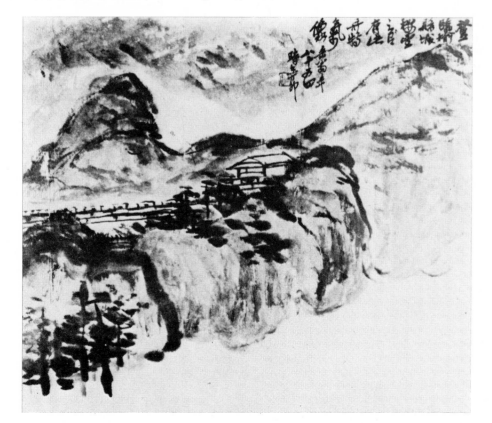

59

pupils to meditate and gain insight into the landscape they saw, before painting it. Li learnt to understand the poetry of the landscape from T'ang verses. He derived inspiration from music and folk songs, in which he always found the lyricism and spaciousness of country scenes. He brought back hundreds of *plein-air* pictures from his travels, which are slightly reminiscent of Utrillo's work. For Li they represented raw material; he painted the definitive pictures at home, using the method 'from nothing to something' and 'from something to nothing'. He would paint each subject many times over, making the landscape less varied in order to achieve greater simplicity. Conversely, he added subjective images to a bare scene, enhancing the significance of individual elements of the work. He acknowledged the need for exaggeration even in colours, which he reduced to one dominant tone, such as blue, green, ochre or golden-brown. His *plein-air* pictures are different. They stirred immense interest in China because of their rich colours, directness, concrete form and fresh handling. They were exhibited on many occasions and published in large works. Li depicted the towns of Su-chou, Shao-hsing, Hang-chou and Chungking from a bird's eye perspective, using the traditional method of the scattered focus in a vertical direction. He usually moved the horizon to the upper margin of the picture, whose format often came close to the typical format of European pictures. Li enlivened his landscapes with figures and barge traffic. His manner of merging the traditional style of painting with transferred elements was bold, effective and highly sensitive. Again it was the principle of 'hsieh-i' painting according to the interpretation of the Shanghai School which not only made Li's innovatory work possible but even encouraged it.

Wu Tso-jên

Wu Tso-jên (b. 1908) comes from Anhui province. He studied European painting in France and Belgium and also spent some time in Switzerland and Italy. Since the fifties he has been professor at the Central Academy of Fine Arts in Peking. Wu is one of those modern Chinese painters who works both in the traditional style and the European manner (oil painting), applying techniques in oil to some of the Chinese principles of art. For portraiture he also makes use of water-colours and studies in charcoal and pen (taken from the European tradition), using oil techniques chiefly for landscape. Wu Tso-jên is known at home and abroad mainly for his technique of 'kuo-hua' painting. To a large extent this artist's work is characterized by his specific subject matter — the world of the western Chinese steppes and upper plains. Wu is primarily a painter of animals (in particular yaks and camels) which inhabit that region. The immense plains are a most fitting subject for the empty white spaces on the Chinese picture. This empty space contrasts well with the heavy, yet vibrating matter of the washed ink spots, which in graded values form the bodies of the mighty animals. The free conception of the subject and the fresh, grandiose treatment in contrasting ink values reveal that Wu had studied the work of Hsü Pei-hung, especially his animal pictures.

Wu paints on coarse yellowish paper called 'kao-li-chih' and 'mei-nung-chih'. This represents a suitable basic colour for the ink, into which Wu sometimes mixes a little sienna. Otherwise his use of colour is very sparse. Other subjects from natural history include galloping horses, bears, elephants, and at times even bamboo. Wu also paints isolated figures of Tibetans, Mongolians and other nationalities, which gained general popularity in Chinese art in the fifties.

Ch'ên Ta-yü

Ch'ên Ta-yü (b. c. 1910) comes from the province of Kuangtung in southern China. Though he originally belonged to the Canton School of painting, he later applied some of the methods of the Shanghai painters after his contact with Shanghai and Peking. In landscape painting, in the fifties, he clearly learnt from Li K'ê-jan (as did a number of other painters, like Lo Ming and Chang Ting). For flower, bird and insect painting Ch'ên's examples were Wu Ch'ang-shuo and Ch'i Pai-shih.

Chronological Table of the Dynasties

Shang (Yin) c. 1550—1028 B.C.

Chou .1028—221 B.C.

 Warrior States 481—221 B.C.

Ch'in . 221—206 B.C.

Han . 206 B.C.—220 A.D.

 Western (Early) Han 206 B.C.—9 A.D.

 Eastern (Late) Han 25 A.D.—220 A.D.

Three Kingdoms 221—280

Six Dynasties 386—589

Sui . 581—618

T'ang . 618—906

Five Dynasties 907—960

Sung .960—1279

 Northern Sung960—1126

 Southern Sung 1127—1279

Yüan (Mongolians) 1260—1368

Ming . 1368—1644

Ch'ing (Manchurian) 1644—1912

Chinese Republic 1912—1949

Chinese People's Republic 1949—

List of Illustrations

Ink and paint on paper
Loose sheet, 34.5 × 34.5 cm
c. 1930
National Gallery in Prague

20 Ch'i Pai-shih: Huts in a Bamboo Grove
Ink and paint on paper
Hanging scroll, 38 × 137.5 cm
c. 1930
National Gallery in Prague

21 Ch'i Pai-shih: Sitting Monk
Ink and paint on paper
Lengthwise scroll, 91 × 48.5 cm
c. 1930
Náprstek's Museum in Prague

22 Ch'i Pai-shih: Drinker (The Robber and Thief
Prime Minister)
Ink and paint on paper
Hanging scroll, 34 × 67.5 cm
c. 1935
National Gallery in Prague

23 Ch'i Pai-shih: Bird on a Magnolia-Tree
Ink and paint on paper
Loose sheet, 27 × 33 cm
c. 1930
National Gallery in Prague

24 Ch'i Pai-shih: Branch with P'i-pa Fruit
Ink and paint on paper
Hanging scroll, 34 × 132 cm
Summer 1931
National Gallery in Prague

25 Ch'i Pai-shih: The Return Home
Ink and paint on paper
Hanging scroll, 43 × 74 cm
February 1931
National Gallery in Prague

26 Ch'i Pai-shih: Chrysanthemums and Mantis
Ink and paint on paper
Hanging scroll, 33 × 100 cm
c. 1935
National Gallery in Prague

27 Ch'i Pai-shih: Basket with Persimmons
Ink and paint on paper
Hanging scroll, 34 × 68 cm
c. 1936
Private Collection in Czechoslovakia

28 Ch'i Pai-shih: The Retiring Prime Minister (in the
likeness of Ch'i Pai-shih)
Ink and paint on paper
Hanging scroll, 52 × 95 cm
c. 1940
National Gallery in Prague

29 Ch'i Pai shih: Still-Life with Peaches
Ink and paint on paper
Hanging scroll, 34 × 98 cm
August 1938
National Gallery in Prague

30 Ch'i Pai-shih: Birds of Paradise on a Cinnamon-
Tree
Ink and paint on paper
Hanging scroll, 48.5 × 35.5 cm
c. 1940
National Gallery in Prague

31 Ch'i Pai-shih: Still-Life with the Festivities of the
Autumn Equinox
Ink and paint on paper
Hanging scroll, 35 × 103 cm
c. 1944
National Gallery in Prague

32 Ch'i Pai-shih: Bamboo Shoots
Ink and paint on paper
Hanging scroll, 33.5 × 104 cm
c. 1945
National Gallery in Prague

33 Ch'i Pai-shih: Autumn Sailing on the River
Ink and paint on paper
Hanging scroll, 32.5 × 95 cm
c. 1945
National Gallery in Prague

34 Ch'i Pai-shih: Gourds
Ink and paint on paper
Hanging scroll, 34.5 × 103 cm
1946
National Gallery in Prague

35 Ch'i Pai-shih: Still-Life with Cherries
Ink and paint on paper
Hanging scroll, 34 × 103 cm
1946
National Gallery in Prague

36 Ch'i Pai-shih: Plum Blossom
Ink and paint on paper
Hanging scroll, 34 × 100 cm
1947
National Gallery in Prague

37 Ch'i Pai-shih: Withering Lotus
Ink and paint on paper
Loose sheet, 34.5 × 34 cm
c. 1948
National Gallery in Prague

38 Ch'i Pai-shih: Plum Blossom
Ink and paint on paper
Loose sheet, 34 × 34 cm
c. 1948
National Gallery in Prague

39 Ch'i Pai-shih: Pomegranates
Ink and paint on paper
Hanging scroll, 34 × 103 cm
1948
National Gallery in Prague

40 Ch'i Pai-shih: Vine
Ink and paint on paper
Hanging scroll, 34 × 101 cm
1948
National Gallery in Prague

41 Ch'i Pai-shih: Withering Lotus
Ink and paint on paper
Hanging scroll, 34 × 102 cm
1948
National Gallery in Prague

42 Ch'i Pai-shih: P'i-pa Fruit
Ink and paint on paper
Hanging scroll, 32 × 97 cm
1948
National Gallery in Prague

43 Ch'i Pai-shih: Crabs
Ink on paper
Hanging scroll, 34 × 103 cm
1948
Private Collection in Czechoslovakia

44 Ch'i Pai-shih: Brood-Hen and Chrysanthemums
Ink and paint on paper
Hanging scroll, 52.5 × 114 cm
1950
National Gallery in Prague

45 Ch'i Pai-shih: Chrysanthemums and Locust
Ink and paint on paper
Hanging scroll, 35 × 105 cm
1950
Private Collection in Czechoslovakia

46 Ch'i Pai-shih: Blossoming Plum Tree
Ink and paint on paper
Hanging scroll, 34 × 103 cm
1950
Private Collection in Czechoslovakia

47 Ch'i Pai-shih: Feast at Night
Ink and paint on paper
Hanging scroll, 37 × 97 cm
c. 1950
National Gallery in Prague

48 Ch'i Pai-shih: Crabs and Arrow-head
Ink on paper
Hanging scroll, 33 × 100 cm
1953
Private Collection in Czechoslovakia

49 Ch'i Pai-shih: Magpies on a Blossoming

Plum Tree
Ink and paint on paper
Hanging scroll, 33.5 × 101.5 cm
Private Collection in Czechoslovakia

50 Ch'i Pai-shih: Withering Lotuses
Ink and paint on paper
Hanging scroll, 35 × 137 cm
1953
Private Collection in Czechoslovakia

51 Ch'i Pai-shih: Bindweed
Ink and paint on paper
Hanging scroll, 36 × 37 cm
1954
Private Collection in Czechoslovakia

52 Ch'i Pai-shih: Flowering Tea-Shrub
Ink and paint on paper
Loose sheet, 34 × 34 cm
1955
Private Collection in Czechoslovakia

53 Ch'i Pai-shih: Lotuses
Ink and paint on paper
Hanging scroll, 34.5 × 98.5 cm
1955
Private Collection in Czechoslovakia

54 Ch'i Pai-shih: Vine
Ink and paint on paper
Hanging scroll, 34 × 34 cm
1956
Private Collection in Czechoslovakia

55 Ch'i Pai-shih: Lotuses
Ink and paint on paper
Hanging scroll, 34 × 66 cm
1956
Private Collection in Czechoslovakia

56 Ch'i Pai-shih: Peony in the Wind
Ink and paint on paper
Hanging scroll, 35 × 70 cm
1956 (mistakenly dated 1957)
Private Collection in Czechoslovakia

57 Huang Pin-hung: Landscape with Pavilions
Ink and paint on paper
Hanging scroll, 32.5 × 88 cm
1925
National Gallery in Prague

58 Huang Pin-hung: Mountain Landscape with
Hermit Settlements
Ink and paint on paper
Hanging scroll, 33.5 × 77 cm
Winter 1943
National Gallery in Prague

59 Huang Pin-hung: Landscape near Ch'ing-ch'êng

Ink and paint on paper
Hanging scroll, 31.5 × 76.5 cm
c. 1943
National Gallery in Prague

60 Huang Pin-hung: Landscape with a Sailing-Boat
Ink and paint on paper
Folding fan, 69 × 23 cm
c. 1945
National Gallery in Prague

61 Huang Pin-hung: Dusk in the Western Mountains
Ink and paint on paper
Hanging scroll, 42 × 78 cm
c. 1945
Private Collection in Czechoslovakia

62 Huang Pin-hung: Coastal Scenery with a Boat
Ink and paint on paper
Hanging scroll, 25 × 27 cm
c. 1950
Private Collection in Czechoslovakia

63 Huang Pin-hung: Evening Scenery with the Banks of a Lake
Ink and paint on paper
Hanging scroll, 31.5 × 83.5 cm
c. 1950
Private Collection in Czechoslovakia

64 Huang Pin-hung: Landscape near Chih-yang
Ink on paper
Hanging scroll, 33.5 × 33 cm
c. 1950
Private Collection in Czechoslovakia

65 Huang Pin-hung: Rocky Coastal Landscape with Dwellings
Ink and paint on paper
Hanging scroll 33.5 × 101.5 cm
c. 1952
Private Collection in Czechoslovakia

66 Huang Pin-hung: Landscape with a Waterfall
Ink and paint on paper
Loose sheet, 34 × 34 cm
c. 1953
Private Collection in Czechoslovakia

67 Ch'ên Pan-ting: Chrysanthemums and Orchid
Ink and paint on paper
Folding fan, 53 × 25 cm
1945
Private Collection in Czechoslovakia

68 Ch'ên Pan-ting: Autumnal Evening on the River
Ink and paint on paper
Loose sheet, 52 × 43.5 cm
1930
National Gallery in Prague

69 Ch'ên Pan-ting: Melon and Chinese Cabbage
Ink and paint on paper
Hanging scroll, 40 × 33.5 cm
c. 1945
National Gallery in Prague

70 Ch'ên Shih-tsêng: Landscape in the Rain
Ink and paint on paper
Hanging scroll, 27.5 × 37.5 cm
c. 1915
Private Collection in Czechoslovakia

71 Ch'ên Shih-tsêng: Mountain Stream with Bridge (based on a poem by Ch'i Pai-shih)
Ink and paint on paper
Hanging scroll, 28 × 37.5 cm
c. 1920
Private Collection in Czechoslovakia

72 Hsü Pei-hung: The Legendary He-he Brothers with a Frog
Ink on paper
Hanging scroll, 47 × 82.5 cm
c. 1920
National Gallery in Prague

73 Hsü Pei-hung: Pines on a Cliff
Ink on paper
Hanging scroll, 33.5 × 102 cm
1932
National Gallery in Prague

74 Hsü Pei-hung: Grazing Horses
Ink and paint on paper
Hanging scroll, 39.5 × 95.5 cm
1948
National Gallery in Prague

75 Hsü Pei-hung: Lonely Ferry
Ink and paint on paper
Hanging scroll, 118 × 111 cm
1932
National Gallery in Prague

76 Hsü Pei-hung: Cocks and Hens
Ink and paint on paper
Hanging scroll, 55 × 110 cm
1948
National Gallery in Prague

77 Hsü Pei-hung: Running Horse
Ink and white paint on paper
Hanging scroll, 55.5 × 103.5 cm
1950
National Gallery in Prague

78 Kuan Liang: Scene from the Chinese Opera
Ink and paint on paper
Hanging scroll, 33.5 × 66 cm
June 1944
National Gallery in Prague

79 Kuan Liang: Scene from the Chinese Opera
Ink and paint on paper
Hanging scroll, 42 × 66 cm
c. 1950
National Gallery in Prague

80 Kuan Liang: Scene from the Chinese Opera
Ink and paint on paper
Hanging scroll, 38 × 65.5 cm
c. 1950
National Gallery in Prague

81 Kuan Liang: Scene from the Chinese Opera
Ink and paint on paper
Hanging scroll, 34 × 66.5 cm
1953
National Gallery in Prague

82 Lin Fêng-mien: Heron above the Reeds
Ink and paint on paper
Loose sheet, 65 × 67 cm
c. 1950
National Gallery in Prague

83 Lin Fêng-mien: Hamlet below the Mountains
Ink and paint on paper
Loose sheet, 66.5 × 67 cm
c. 1950
National Gallery in Prague

84 Lin Fêng-mien: Herons in the Reeds
Ink and paint on paper
Loose sheet, 32.5 × 33.5 cm
c. 1950
Private Collection in Czechoslovakia

85 Lin Fêng-mien: Actor in the Classical Opera
Ink and paint on paper
Loose sheet, 33 × 33 cm
c. 1955
Private Collection in Czechoslovakia

86 Lin Fêng-mien: Landscape with Yellow Trees
Ink and paint on paper
Loose sheet, 32.5 × 32.5 cm
c. 1955
Private Collection in Czechoslovakia

87 Lin Fêng-mien: Female Nude
Ink and paint on paper
Loose sheet 32.5 × 32 cm
c. 1955
Private Collection in Czechoslovakia

88 Lin Fêng-mien: Fishermen's Houses in the
Harbour
Ink and paint on paper
Loose sheet, 66.5 × 66.5 cm
c. 1955
National Gallery in Prague

89 Lin Fêng-mien: Actor in the Classical Opera
Ink and paint on paper
Loose sheet, 32.5 × 32 cm
c. 1955
Private Collection in Czechoslovakia

90 Wang Ch'ing-fang: Fishes (Inscription by Hsü
Pei-hung)
Ink and paint on paper
Hanging scroll, 34.5 × 69.5 cm
c. 1950
National Gallery in Prague

91 Wang Ch'ing-fang: Pavilions above the Water
Ink and paint on paper
Hanging scroll, 37.5 × 67.5 cm
c. 1952
National Gallery in Prague

92 Wang Ch'ing-fang: Three Fishes
Ink on paper
Loose sheet, 41 × 32 cm
February 1956
Private Collection in Czechoslovakia

93 Li K'u-ch'an: Quail
Ink and paint on paper
Loose sheet, 34.5 × 35.5 cm
1956
Private Collection in Czechoslovakia

94 Li K'u-ch'an: A Pair of Fishes
Ink on paper
Loose sheet, 41.5 × 86 cm
1956
National Gallery in Prague

95 Li K'ê-jan: Pilgrims in a Mountain Landscape
Ink and paint on paper
Hanging scroll, 44 × 66 cm
c. 1943
Private Collection in Czechoslovakia

96 Li K'ê-jan: Woman under a Banana-Tree
Ink and paint on paper
Hanging scroll, 33.5 × 98 cm
1947
National Gallery in Prague

97 Li K'ê-jan: Shepherds with a Buffalo
Ink and paint on paper
Hanging scroll, 38 × 65.5 cm
1947
National Gallery in Prague

98 Li K'ê-jan: A Walk in the Mountains
Ink and paint on paper
Hanging scroll, 34 × 75 cm
March 1948
Private Collection in Czechoslovakia

99 Li K'ê-jan: Poets under Trees with Falling
Leaves
Ink and paint on paper
Hanging scroll, 34 × 70 cm
Autumn 1948
Private Collection in Czechoslovakia

100 Li K'ê-jan: Listening to Rain by the Lotus Pond
Ink and paint on paper
Hanging scroll, 41 × 53 cm
c. 1948
Private Collection in Czechoslovakia

101 Li K'ê-jan: Chung Kuei, the Exorcist
Ink and paint on paper
Hanging scroll, 34.5 × 70.5 cm
c. 1956
Private Collection in Czechoslovakia

102 Li K'ê-jan: Autumnal Wind on the Pasture
(based on a poem by Shih T'ao)
Ink and paint on paper
Hanging scroll, 46 × 70 cm
c. 1952
Private Collection in Czechoslovakia

103 Li K'ê-jan: Return from the Pasture in Wind and
Rain
Ink and paint on paper
Hanging scroll, 51 × 82.5 cm
c. 1950
National Gallery in Prague

104 Li K'ê-jan: By the River in the South of the
Country
Ink and paint on paper
Loose sheet, 45.5 × 53 cm
c. 1954
National Gallery in Prague

105 Li K'ê-jan: Southern Chinese Landscape in
Spring Rain
Ink and paint on paper
Hanging scroll, 34 × 65.5 cm
c. 1954
National Gallery in Prague

106 Li K'ê-jan: Spring Rain in the Southern Land-
scape
Ink and paint on paper
Hanging scroll, 47 × 50 cm
c. 1954
National Gallery in Prague

107 Li K'ê-jan: Red Leaves (based on a poem by

Tu Fu and Shih T'ao)
Ink and paint on paper
Loose sheet, 45 × 63 cm
1955
Private Collection in Czechoslovakia

108 Li K'ê-jan: Shouting into the Clouds
Ink and paint on paper
Hanging scroll, 27 × 56.6 cm
c. 1955
National Gallery in Prague

109 Li K'ê-jan: Spring Walk to the Chi-ch'ang Park
Ink and paint on paper
Hanging scroll, 27 × 56.5 cm
c. 1955
National Gallery in Prague

110 Li K'ê-jan: Fishing Village in the Mist and Rain
Ink and paint on paper
Loose sheet, 52 × 80 cm
1955
Private Collection in Czechoslovakia

111 Li K'ê-jan: Gorge with Coastal Village
Ink and paint on paper
Hanging scroll, 46 × 69 cm
1964
Private Collection in Czechoslovakia

112 Ch'ên Ta-yü: Wasps and Wistaria
Ink and paint on paper
Folding fan, 52 × 24 cm
c. 1954
Private Collection in Czechoslovakia

113 Wu Tso-jên: Yaks
Ink and paint on paper
Lengthwise scroll, 103 × 42.5 cm
c. 1953
National Gallery in Prague

114 Wu Tso-jên: Shepherds' Tents on the Tibetan
Uplands
Ink and paint on paper
Hanging scroll, 54 × 66 cm
Winter 1953
National Gallery in Prague

115 Wu Tso-jên: Two Elephants
Ink and paint on paper
Loose sheet, 41 × 51 cm
1953
Private Collection in Czechoslovakia

Selective Bibliography

1 Chie-shan jin-kuan shih ts'ao (Poetical Studies in the Pavilion of Poetry by the Borrowed Mountain), Peking 1926

2 Ch'i Pai-shih hua-ts'ê (Ch'i Pai-shih's Collection of Painting), Peking 1928

3 V. Chytil: Či-Bai-ši, největší čínský malíř, Salon 1931 (in Czech: Ch'i Pai-shih, the Greatest Chinese Painter)

4 Pei-hung hua-chi I. — III. (Collection of Pictures by Hsü Pei-hung), Peking 1932

5 Hsien-tai shu hua chi (Collection of Contemporary Calligraphy and Painting), Shanghai 1937

5a Chu Ta shu hua he-ts'ê (Collection of Calligraphy and Pictures by Chu Ta), Shanghai, in the thirties

5b Tao Chi shu kuo hua-ts'ê (Collection of Pictures of Vegetables and Fruit by Tao Chi), Shanghai, thirties

6 Huang Pin-hung hsien-sheng shan-shui hua-ts'ê (Collection of Pictures of Mr Huang Pin-hung), Shanghai 1943

7 Li Ching-hsi: Ch'i Pai-shih nien-p'u (Ch'i Pai-shih's Biography), Shanghai 1949

8 L. Hájek: Čínské uměni (Chinese Art), Prague 1954

9 Ch'i Pai-shih ti hua (Ch'i Pai-shih's Pictures), Peking 1955

10 Chung-kuo k'ê-hsüeh chi-shu fa-ming he k'ê-hsüeh chi-shu jen-wu lun-chi (Collection of Chinese Scientific and Technological Inventions and Inventors). Edited by Li Kuan-pi, Ch'ien Chün-hua, Peking 1955

11 Hua yüan tuo ying (Jewels of Chinese Painting), Shanghai 1955

12 Ch'en Shih-tsêng hua-ts'ê (Pictorial Collection of Ch'en Shih-tsêng), Peking 1955

13 Wu Ch'ang-shuo hua-chi (Collection of Pictures by Wu Ch'ang-shuo), Peking 1957

14 Chung-kuo hua lun lei pien (Collection of Chinese Theories of Painting by Types). Edited by Yü Chien-hua, Peking 1957

15 Hsieh Chih-liu: Shui-mo-hua (Chinese Water Colour), Shanghai 1957

16 T'ang, Wu-tai, Sung, Yüan ming chi (Famous Works from the T'ang Period, the Five Dynasties, Sung and Yüan), Shanghai 1957

17 Jên Po-nien hua-ts'ê (Collection of Pictures by Jên Po-nien), Tientsin 1958

18 Chung-kuo chin pai nien hui-hua chan-lan hsüan-chi (Selection from the Exhibition of Chinese Painting of the Last Century). Introduction by Cheng Chen-to, Peking 1959

19 A. Hoffmeister, L. Hájek, E. Rychterová: Současné čínské malířství (in Czech: Present-Day Chinese Painting), Prague 1959

20 Wang Mêng-pai hua-hsüan (Selection of the Pictures of Wang Mêng-pai), Peking 1959

21 Li K'ê-jan shui-mo shan-shui hsieh-sheng hua-chi (Collection of Li K'ê-jan's Plein-air Pictures of Landscapes in the Traditional Form of Painting), Peking 1959

22 Pai-shih lao-jên tzü-chuan (The Autobiography of Old Mr Pai-shih), Peking 1959

23 Lung Kung: Ch'i Pai-shih chuan-lüeh (Brief Biography of Ch'i Pai-shih), Peking 1959

24 Ch'i Pai-shih tso-p'in hsüan-chi (Selection of Ch'i Pai-shih's Works), Peking 1959

25 Ch'i Pai-shih yen chiu (Studies on Ch'i Pai-shih). Edited by Li Ch'ün, Shanghai 1959

26 Shih T'ao hua yü-lu (Shi T'ao's Notes on Painting), Peking 1959

27 Lu Kuan-chao: Li-tai hua-chia ku-shih (Stories about Old Painters), Peking 1959

28 Yang-chou pa-chia hua-chi (Collection of Paintings of the Eight of Yang-chou), Peking 1959

29 J. Hejzlar: Ch'i Pai-shih (Article in Czech in the journal Výtvarná práce), 1959/20—21

30 Ch'in Chung-wen: Chin-tai chung-kuo hua-chia yü hua-p'ai (Painters and Schools of Painting of the Modern Era), journal Mei-shu yen-chiu, 1959/4

31 Li K'u-ch'an hua-hsüan (Selection of Pictures by Li K'u-ch'an), Peking 1959

32 Wu Tso-jên shui-mo hua-hsüan (Selection of the Traditional Pictures of Wu Tso-jên), Tientsin 1959

33 Shih T'ao hua-chi (Collection of Pictures by Shih T'ao), Shanghai 1960

34 Li Sung: Hsü Wei sheng-p'ing yü ch'i hui-hua ch'eng-chiu (The Life of Hsü Wei and his Success as Painter), Wen-wu (Memories), 1961/6

35 E. Rychterová: Li Kche-žan, (Li K'ê-jan — in Czech), Prague 1963

36 J. Hejzlar: Sto let Chuang Pin-chunga (in Czech: One Hundred Years of Huang Pin-hung), journal Výtvarné uměni, 1964/5

37 M. Sullivan: A Short History of Chinese Art, University of California 1967

38 Masters of the Shanghai School of Painting, exhibition catalogue, introduction by J. Hejzlar, Prague 1968

39 M. Sullivan: Trends in Twentieth Century Chinese Painting, Stanford University 1969

40 J. Hejzlar: Čchi Paj-š (in Czech: Ch'i Pai-shih), Prague 1970

Index of Names

70

Table of Chinese Characters

1 蔡倫 2 張大千 3 張仃 4 趙之謙 5 趙孟頫 6 鄭燮 (板橋) 7 禪 8 陳洪綬 (老蓮) 9 陳半丁 10 陳師曾 11 陳樹人 12 陳大羽 13 陳道復 14 齊白石 15 周之冕 16 朱耷 (八大山人) 17 法常 (牧溪) 18 范寬 19 傅抱石 20 海派 21 海上名家 22 后民 23 胡公壽 24 華嵒 25 黃 26 黃公望 27 黃賓虹 28 黃慎 29 齊吉爾 30 楊州八怪 31 楊補之 32 遺民 33 螢玉澗 34 高其佩 35 高翔 36 高劍父 37 髠殘 (石谿) 38 關仝 39 關良 40 龔賢 41 李方膺 42 李可染 43 李苦禪 44 李龍眠 45 李思訓 46 李鱓 47 梁楷 48 林風眠 49 林良 50 嶺南海派 51 羅銘 52 羅聘 53 馬遠 54 梅清 55 米芾 56 米友仁 57 莫是龍 58 牧溪 (法常) 59 倪瓚 60 潘天壽 61 夏珪 62 虛谷 63 徐悲鴻 64 徐熙 65 蘇東坡 66 徐渭 67 蘇仁山 68 孫龍 69 石谿 (髠殘) 70 石恪 71 石濤 (道濟) 72 沈周 (石田) 73 道濟 (石濤) 74 唐雲 75 荊浩 76 金農 77 巨然 78 董源 79 王青芳 80 王个簃 81 王蒙 82 王夢白 83 王翬 84 汪士慎 85 王維 86 文徵明 87 文同 88 吳作人 89 吳鎮 90 吳昌碩 91 吳道子 92 任頤 93 任伯年 94 任熊 (渭長) 95 任薰 96 榮寶齋

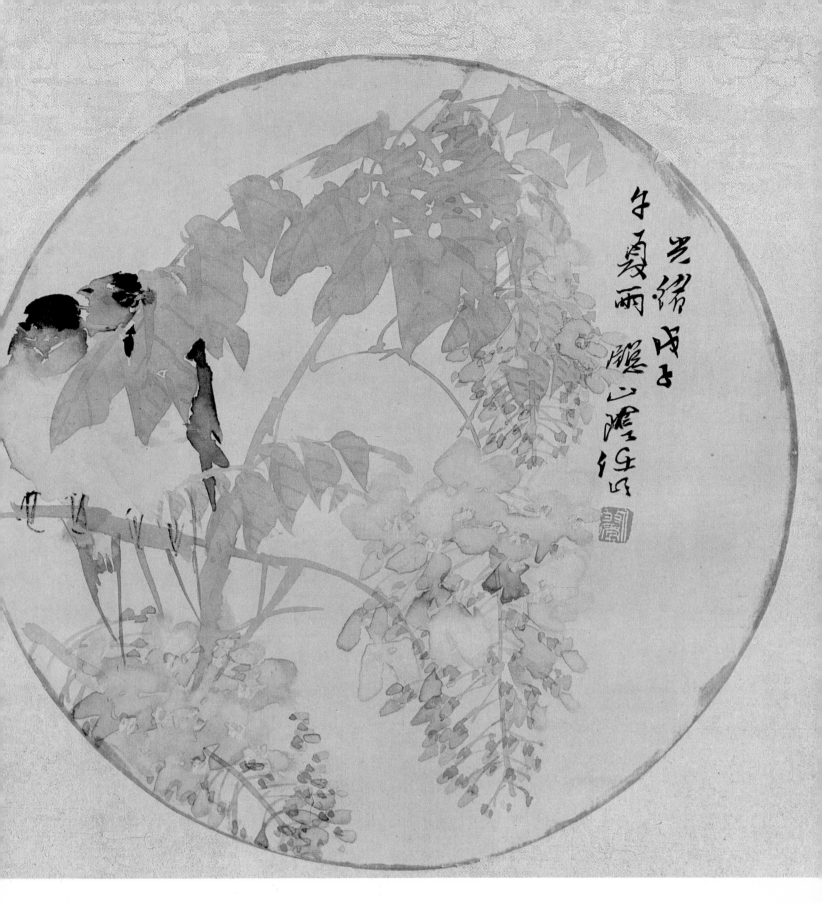

1 Jên Po-nien: Swallows on a Wistaria

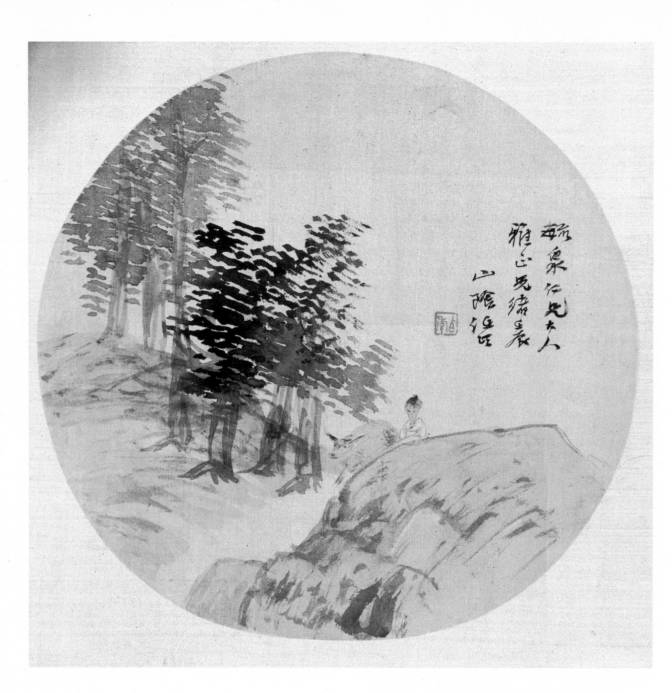

2 Jên Po-nien: Return from the Pasture

3 Jên Po-nien: Crane and Pine

4 Wu Ch'ang-shuo: Meditating Poet under a Cliff

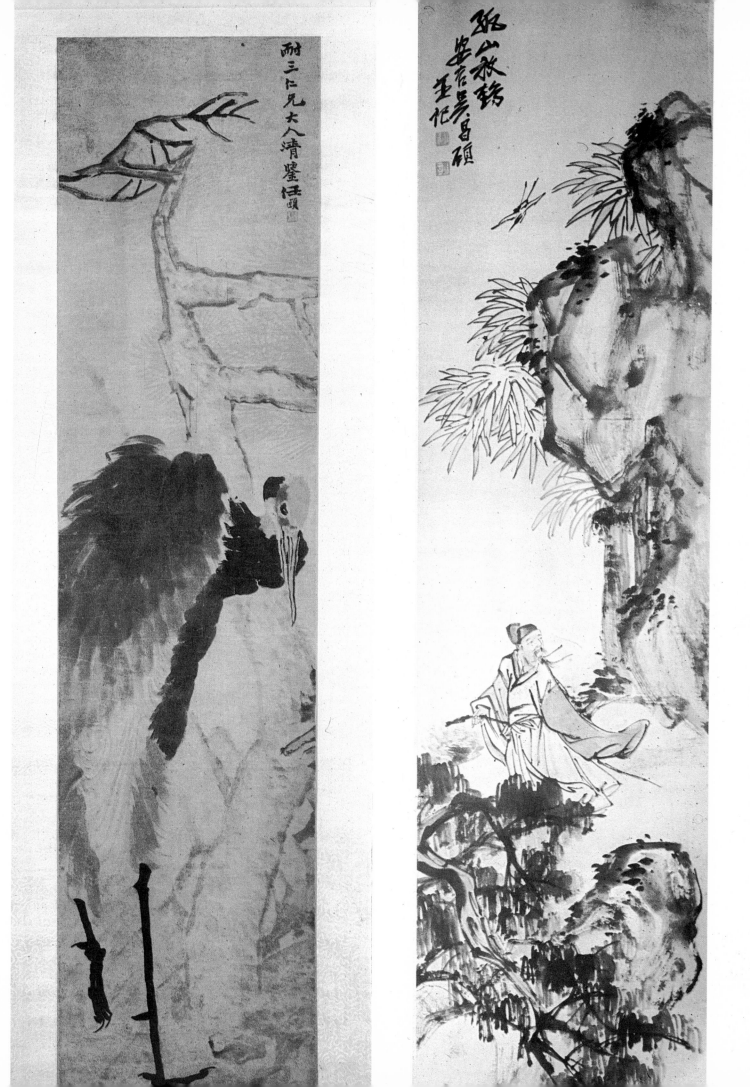

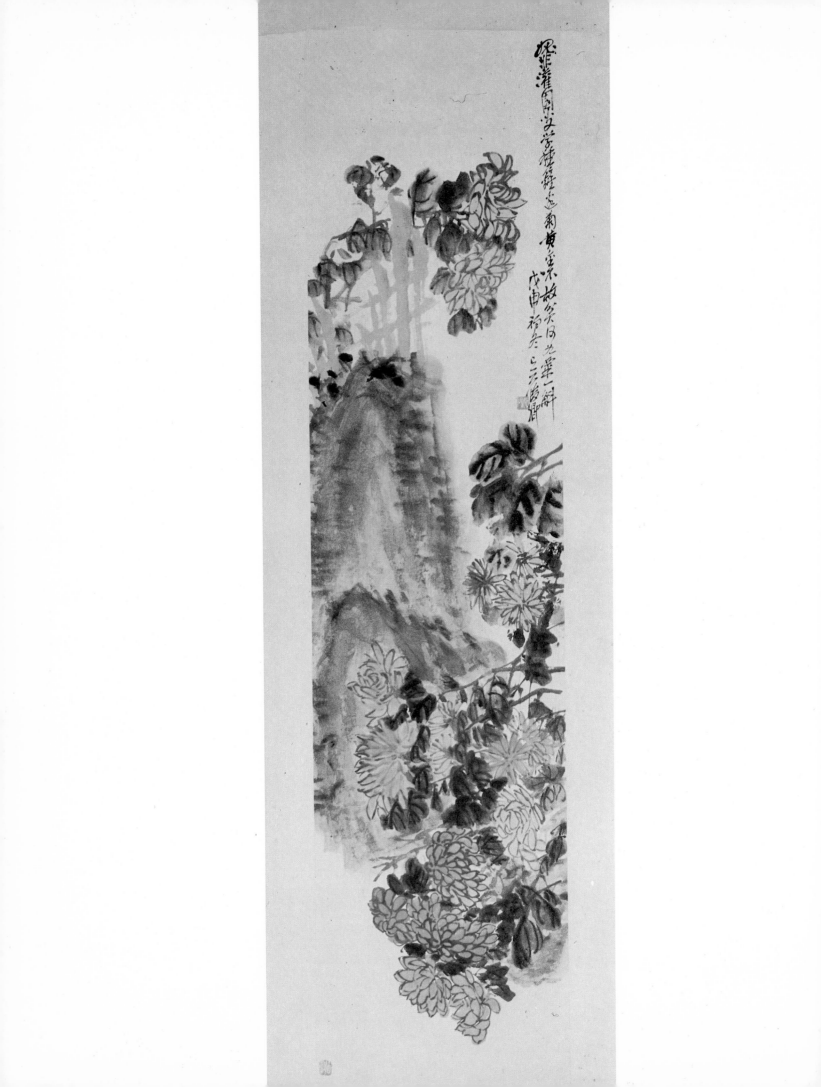

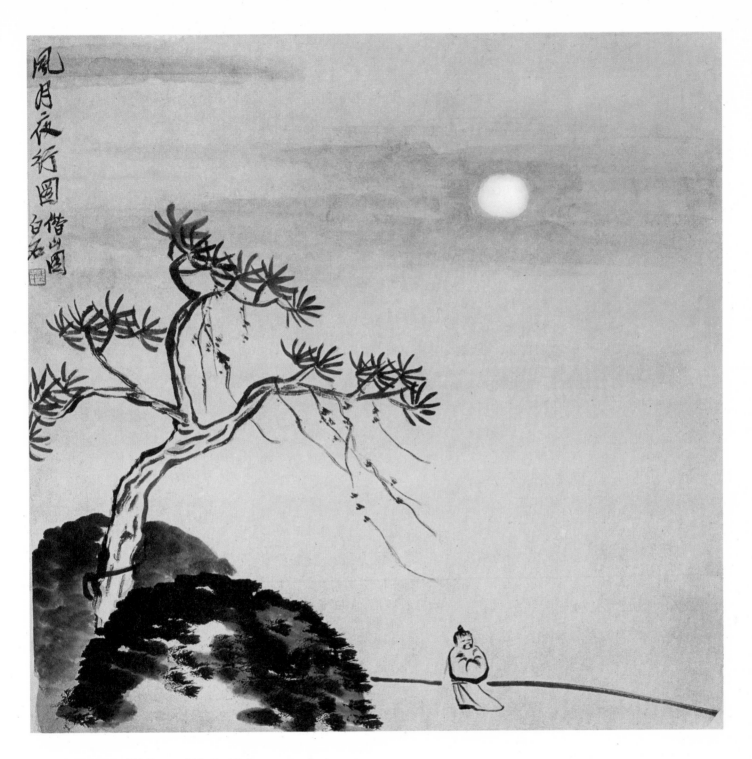

6 Ch'i Pai-shih: Walk on a Windy Night

5 Wu Ch'ang-shuo: Chrysanthemums

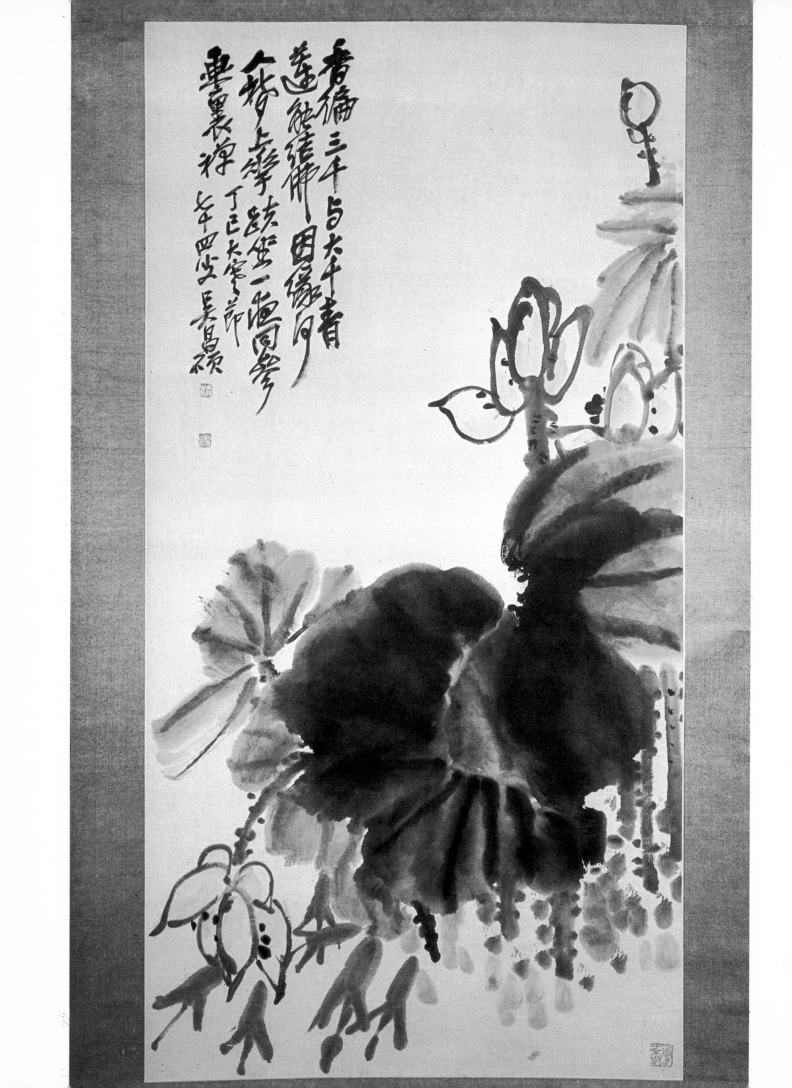

7 Wu Ch'ang-shuo: Lotus-Flowers

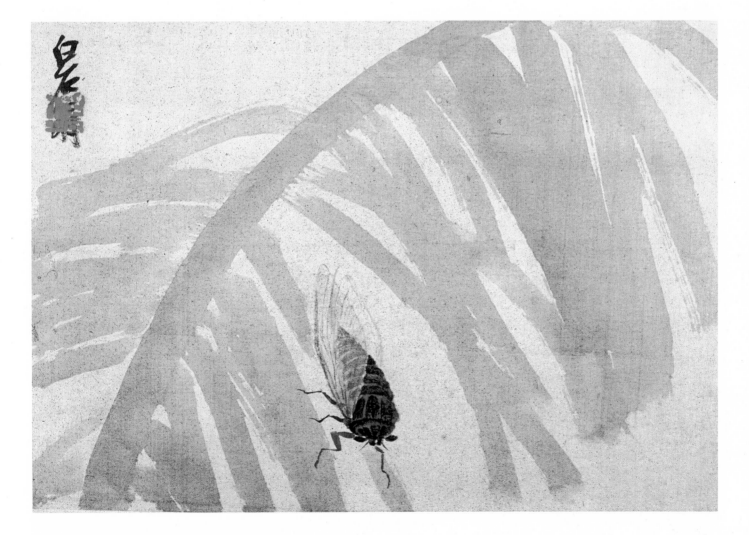

8 Ch'i Pai-shih: Cicada on a Banana-Tree

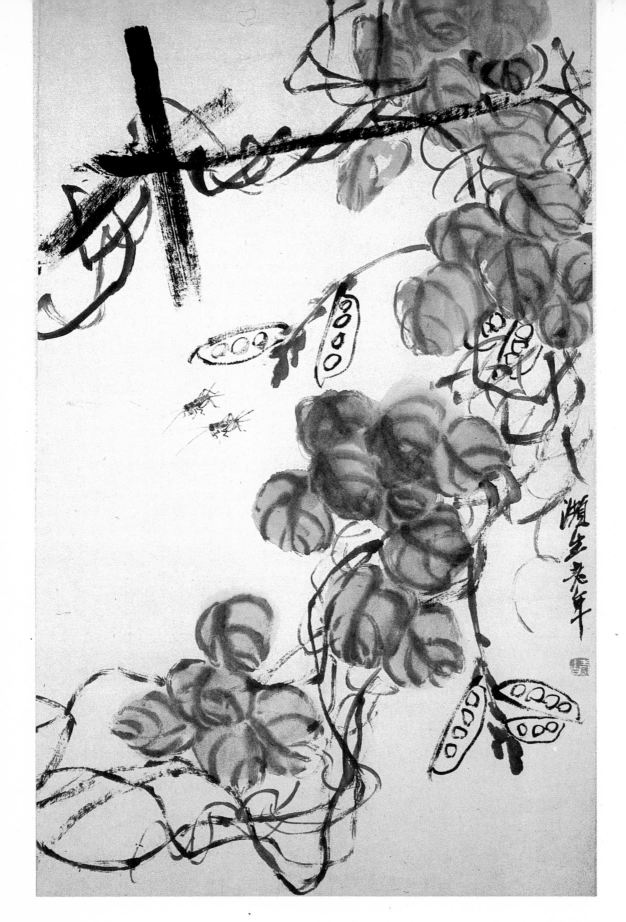

9 Ch'i Pai-shih: Beans and Crickets

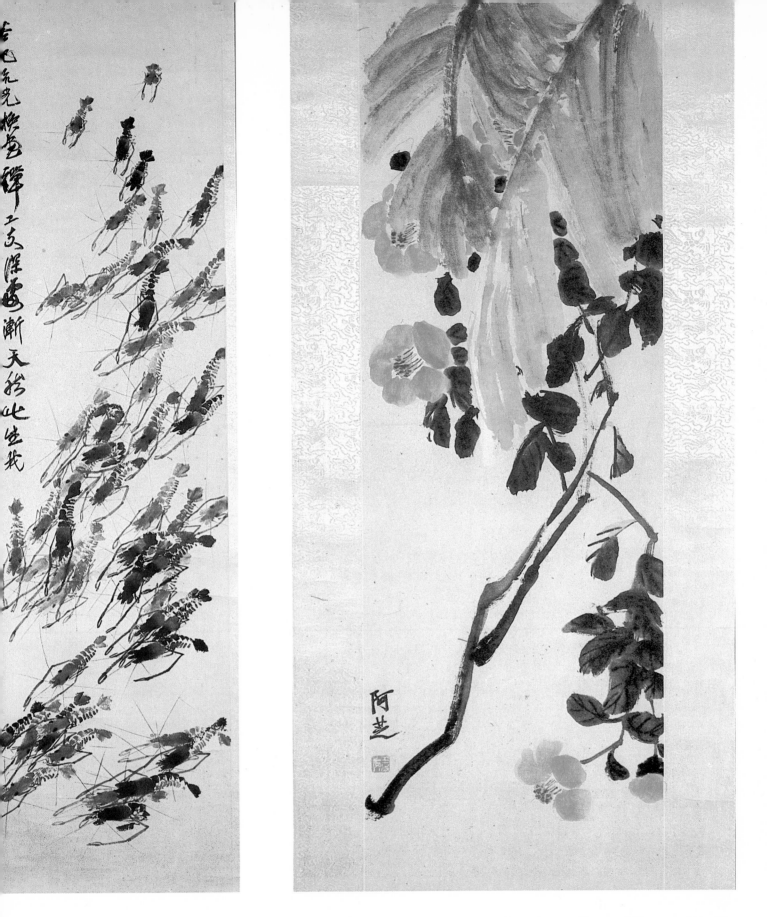

10 Ch'i Pai-shih: 'Fifty Years Prisoner of the Shrimps' 11 Ch'i Pai-shih: Leaves of the Banana-Tree and Flowers of the Tea

12 Ch'i Pai-shih: Rejected Beverage

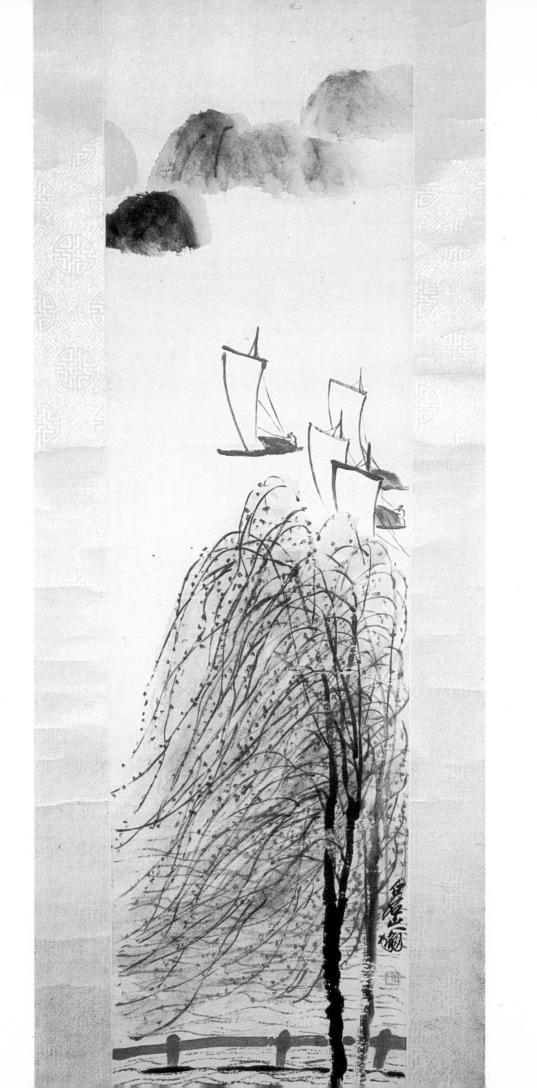

千株松樹萬陰山生長
清年湘水間天気已涼寒
未到此台無事數風颿

齊璜白石山翁並題

14 Ch'i Pai-shih: Sailing-Boats
on the River Hsiang

15 Ch'i Pai-shih: Bamboo and
Plum Blossom ('Spring'
in the Cycle of the Four
Seasons)

16 Ch'i Pai-shih: Pine ('Winter'
in the Cycle of the Four
Seasons)

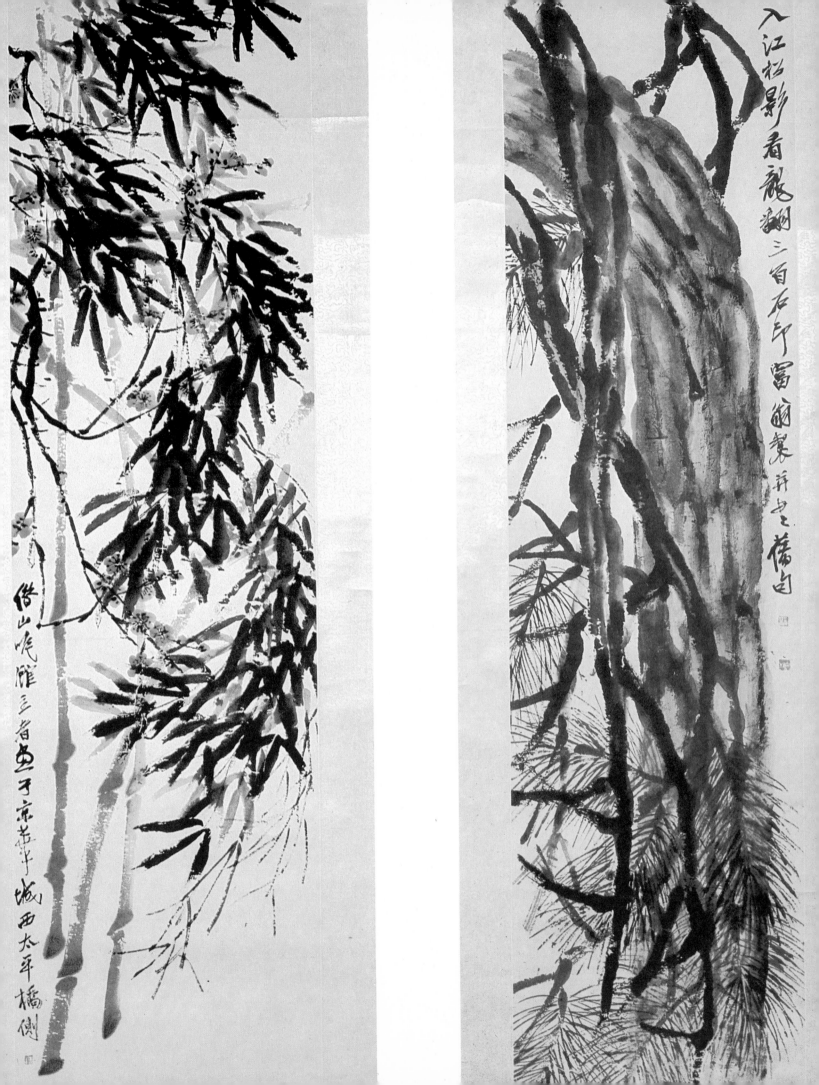

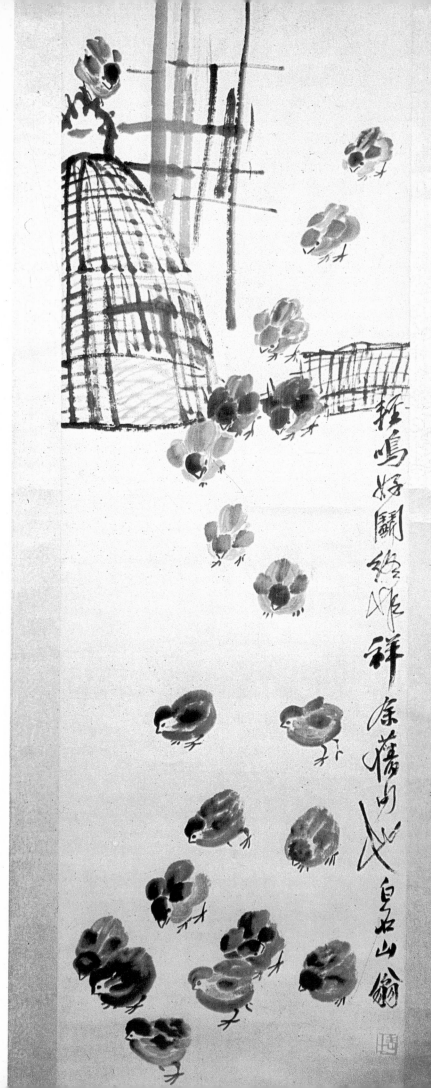

17 Ch'i Pai-shih: In the Court-
yard

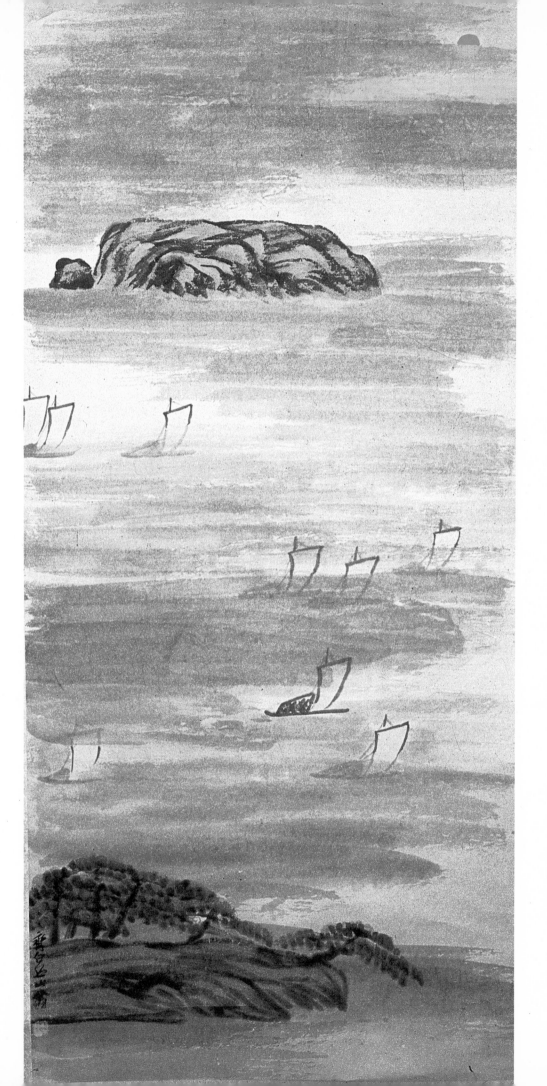

18 Ch'i Pai-shih: Sailing-Boats
in the Mist

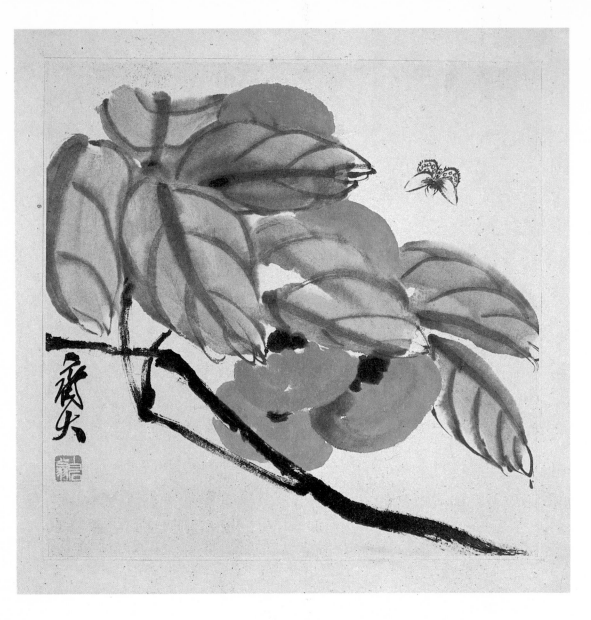

19 Ch'i Pai-shih: A Branch of Persimmon and a Butterfly

20 Ch'i Pai-shih: Huts in a Bamboo Grove

21 Ch'i Pai-shih: Sitting Monk

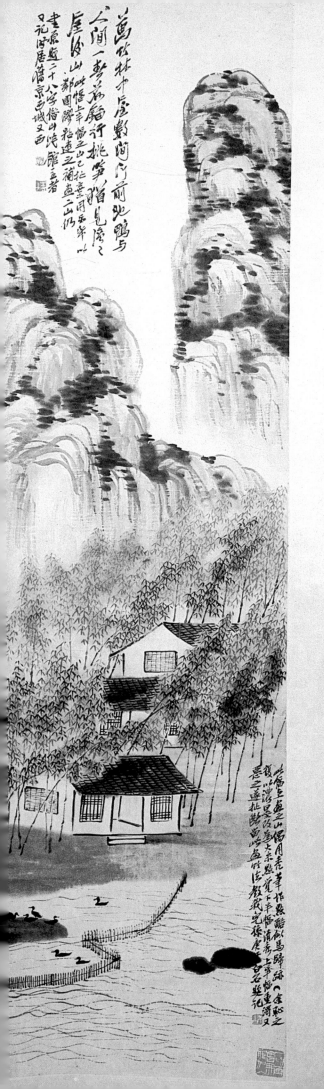

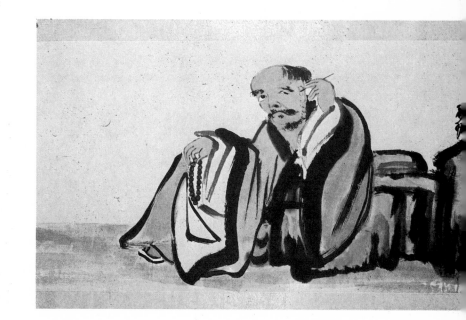

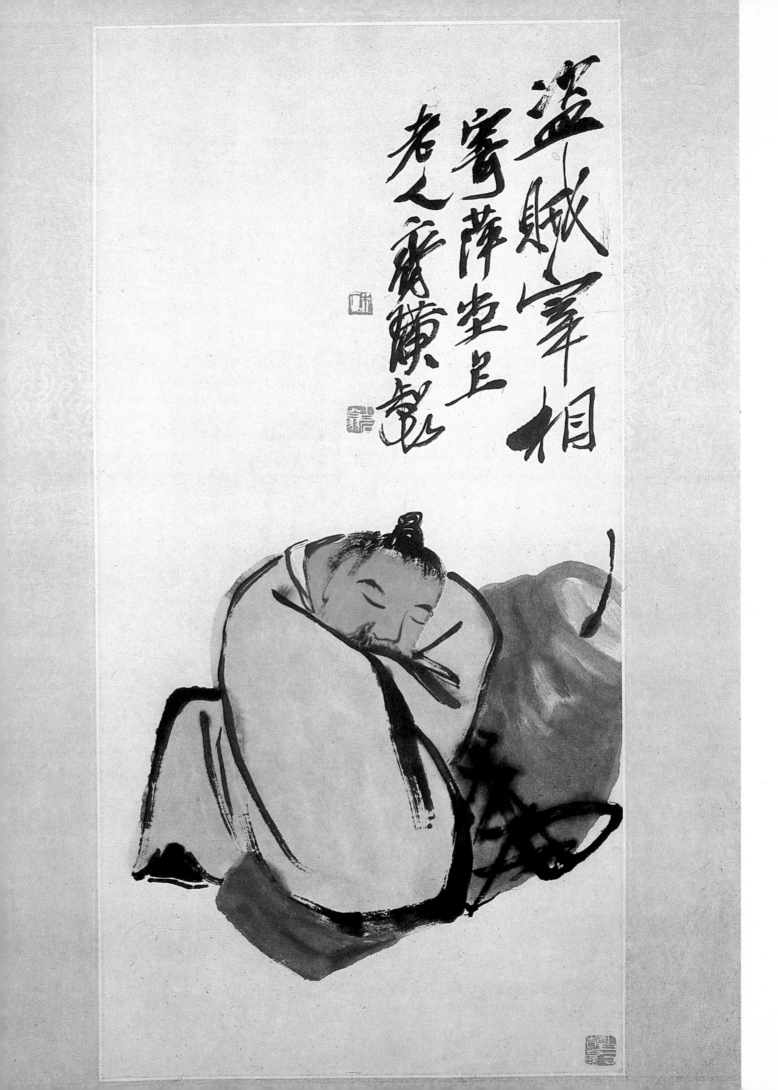

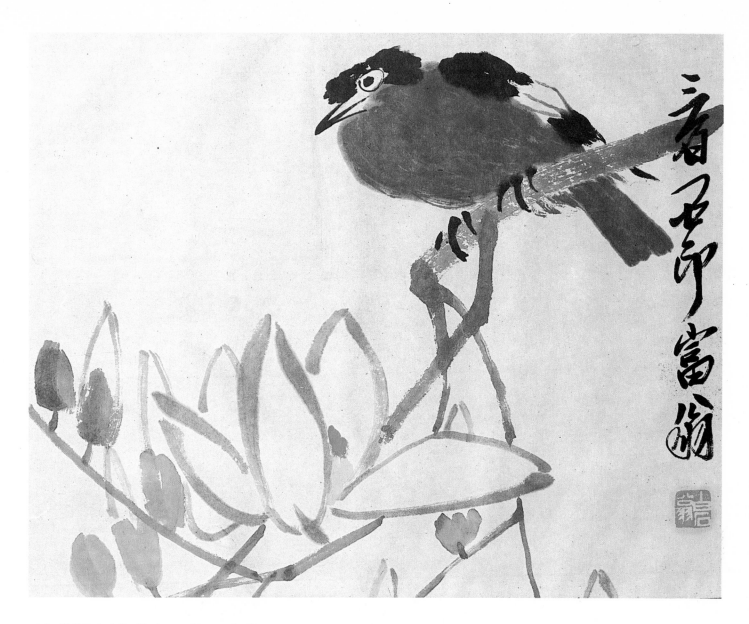

23 Ch'i Pai-shih: Bird on a Magnolia-Tree

22 Ch'i Pai-shih: Drinker (The Robber and Thief Prime Minister)

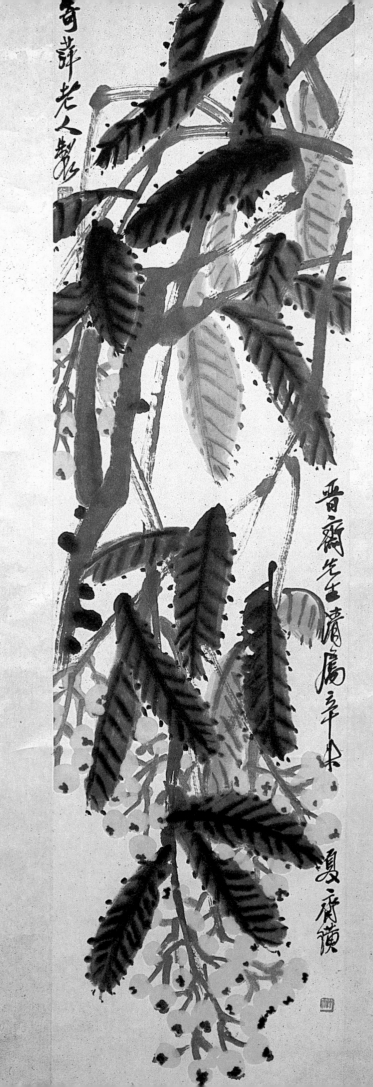

24 Ch'i Pai-shih: Branch with P'i-pa Fruit

25 Ch'i Pai-shih: The Return Home

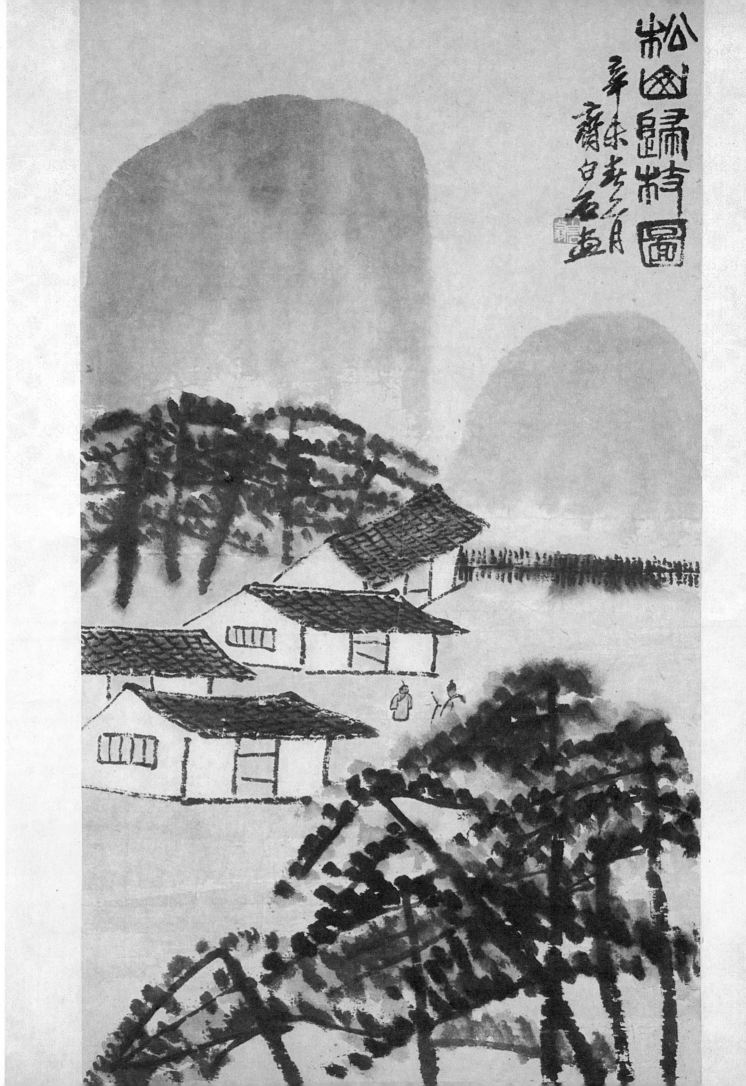

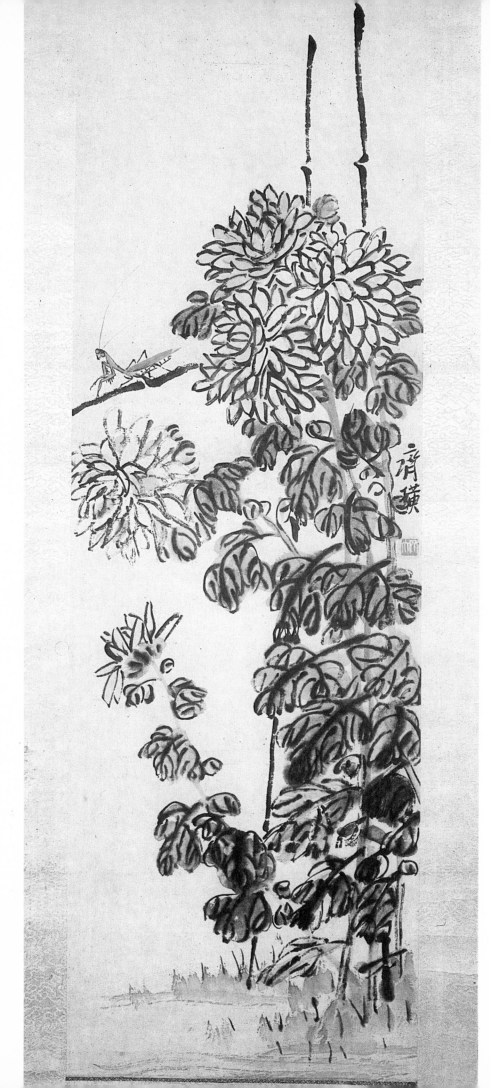

26 Ch'i Pai-shih: Chrysanthemums and Mantis

27 Ch'i Pai-shih: Basket with Persim-mons

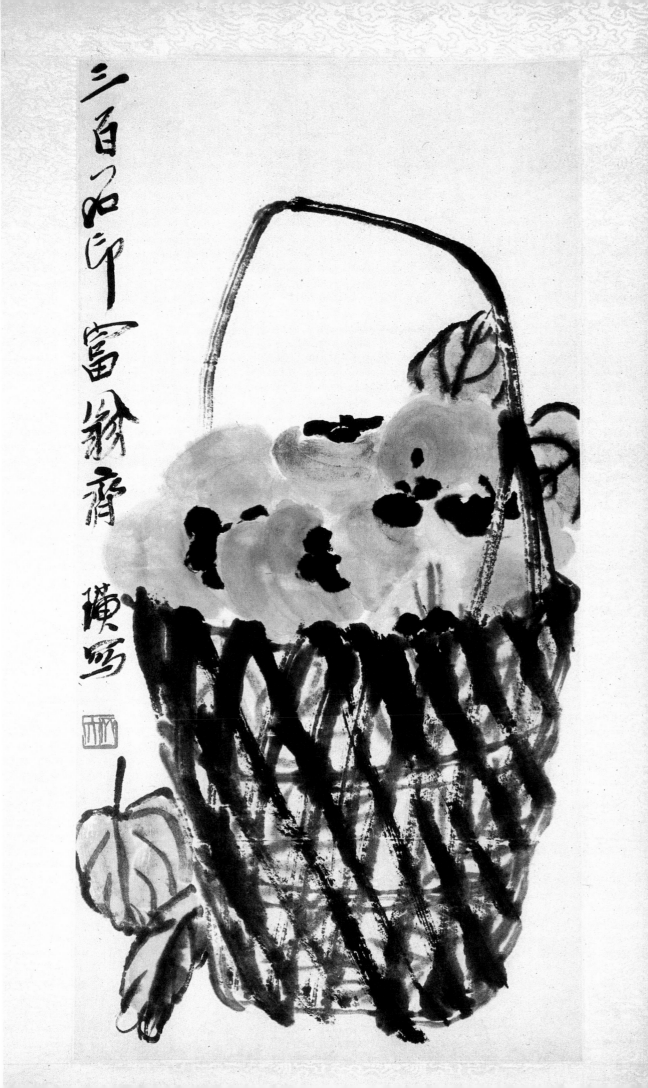

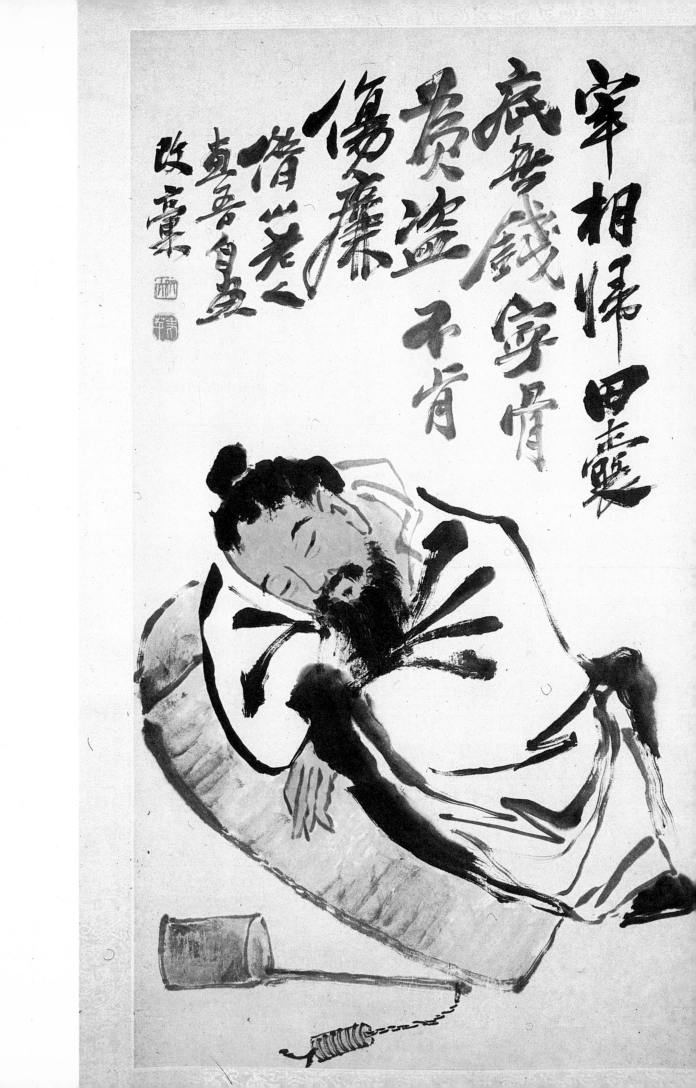

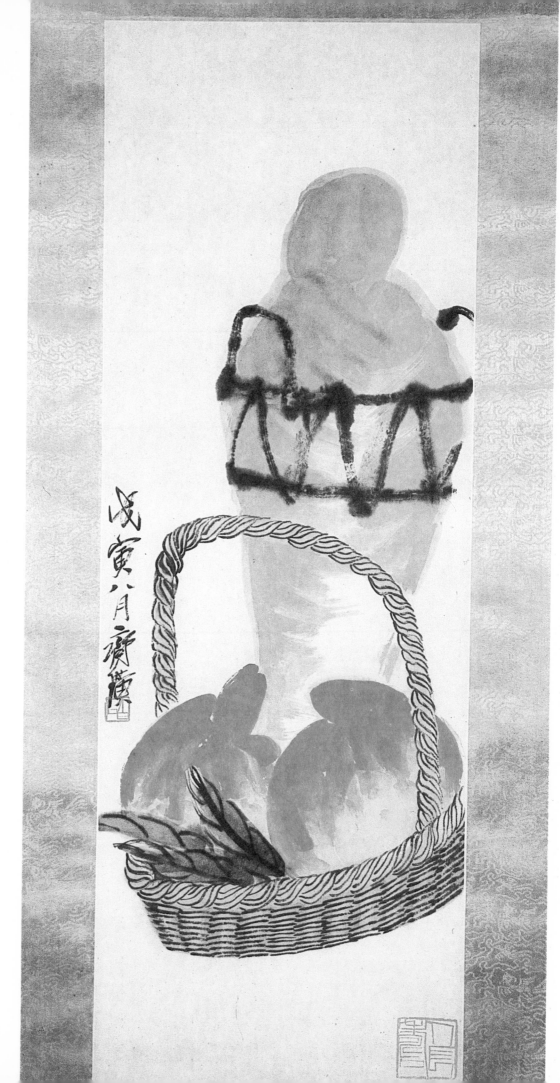

28 Ch'i Pai-shih:The Retiring Prime Minister (in the likeness of Ch'i Pai-shih)

29 Ch'i Pai-shih: Still-Life with Peaches

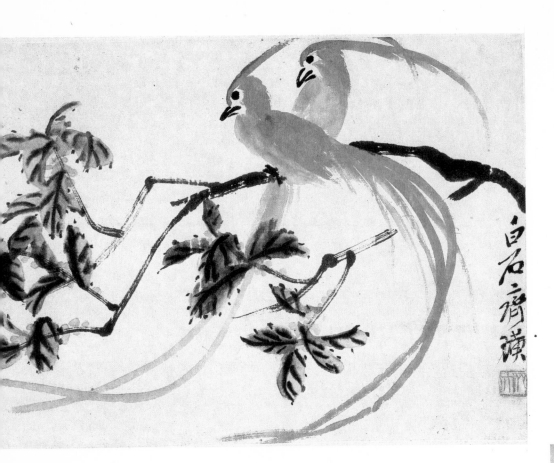

30 Ch'i Pai-shih: Birds of Paradise on a Cinnamon-Tree

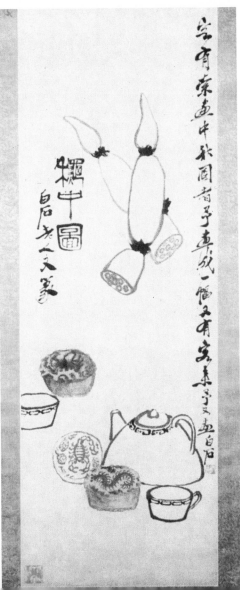

31 Ch'i Pai-shih: Still-Life with the Festivities of the Autumn Equinox

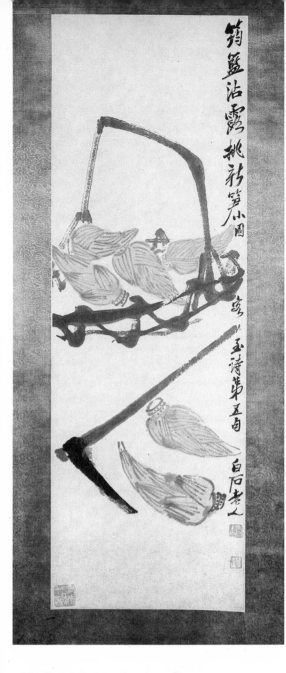

32 Ch'i Pai-shih: Bamboo Shoots

33 Ch'i Pai-shih: Autumn Sailing on the River

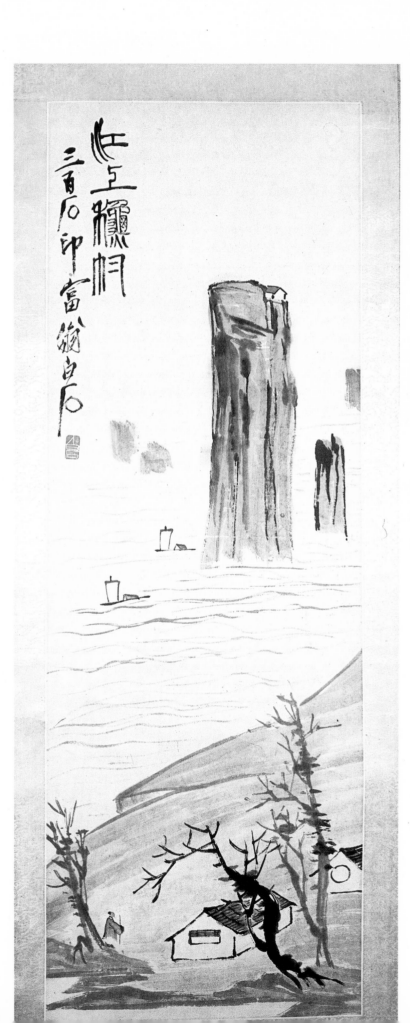

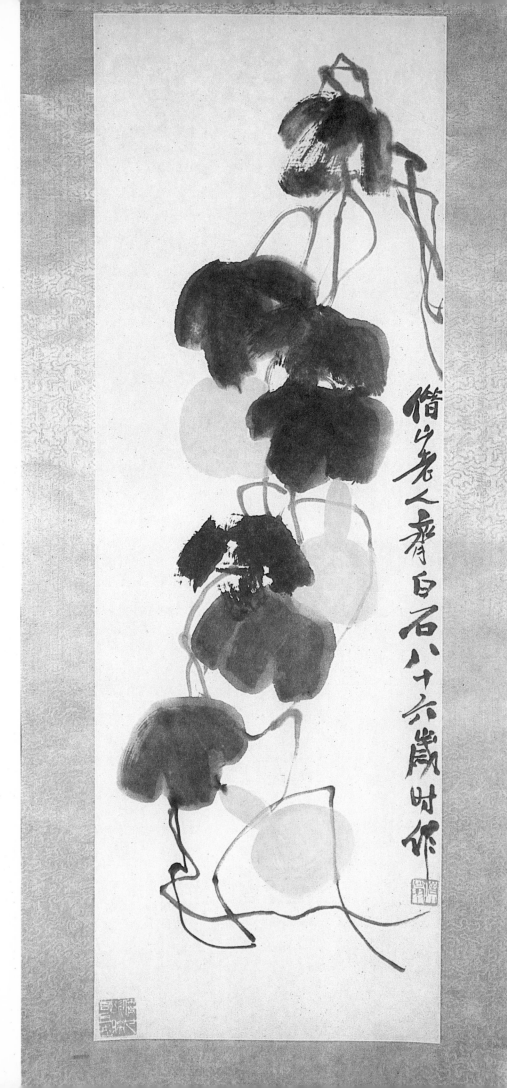

34 Ch'i Pai-shih: Gourds

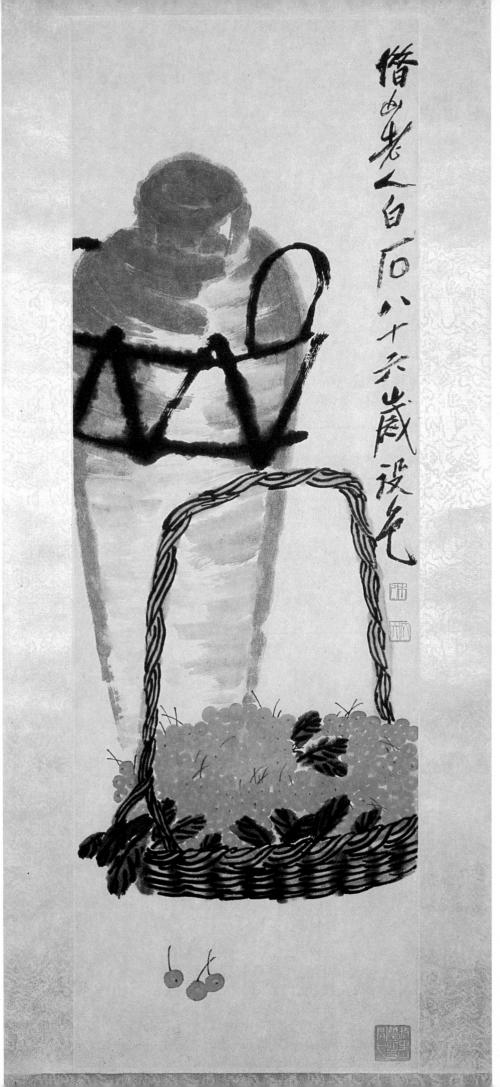

楷山老人白石八十六歲設色花

5 Ch'i Pai-shih: Still-Life
 with Cherries

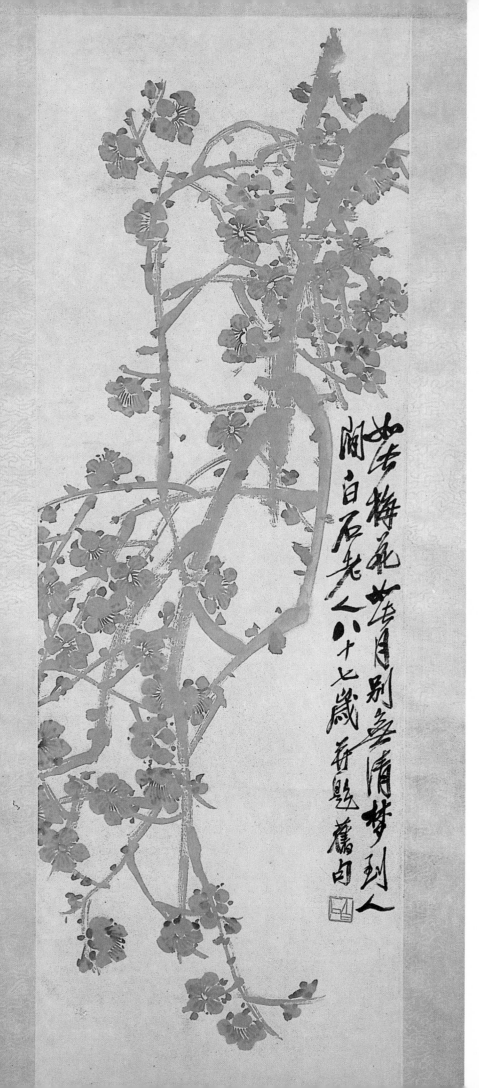

36 Ch'i Pai-shih: Plum Blossom

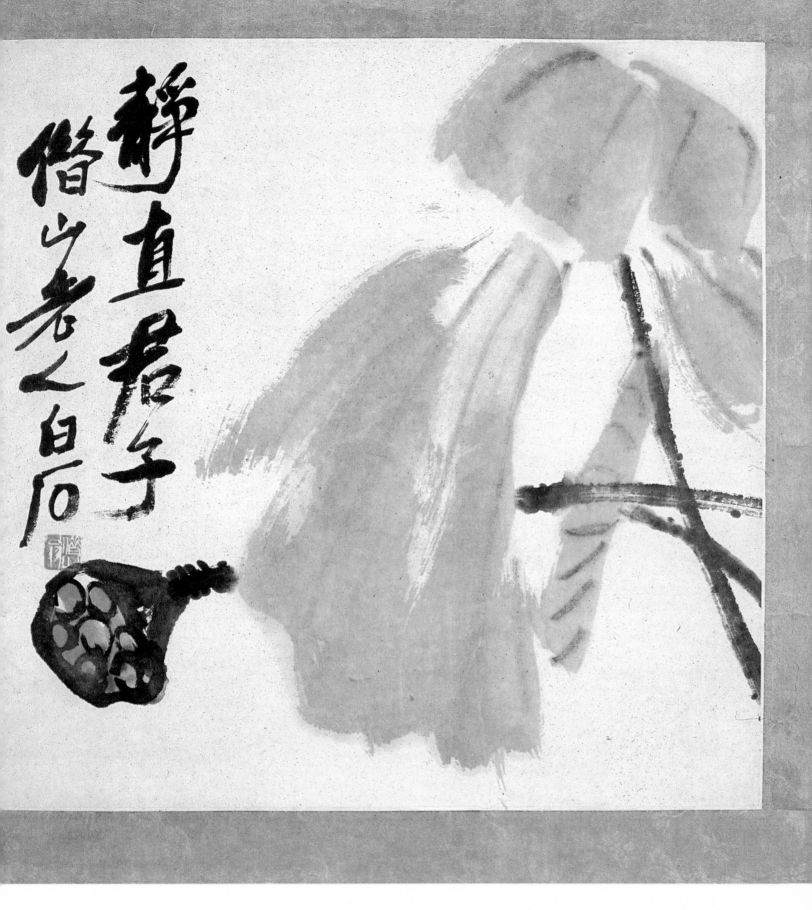

静直君子
偕山老之白石

37 Ch'i Pai-shih: Withering Lotus

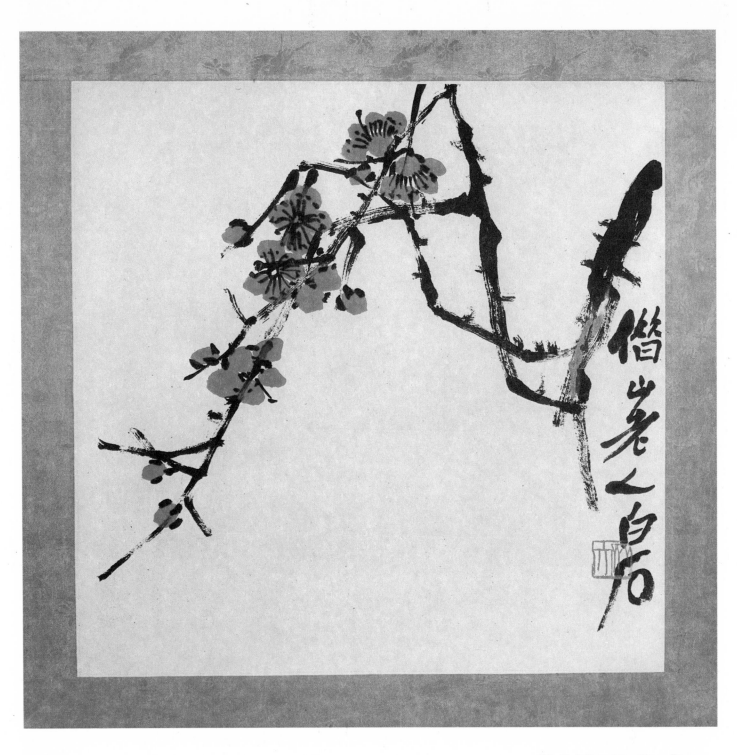

38 Ch'i Pai-shih: Plum Blossom

39 Ch'i Pai-shih: Pomegranates

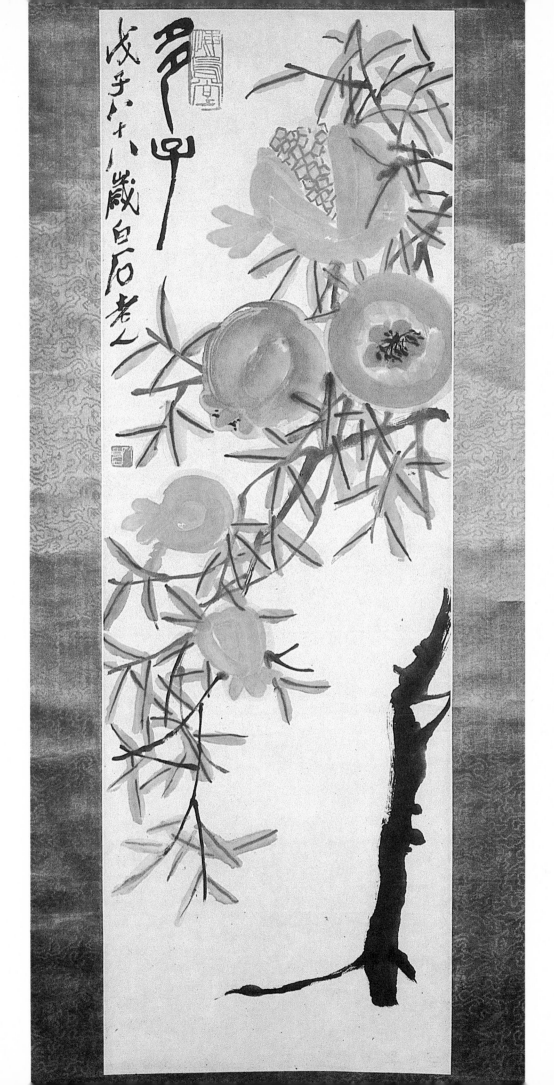

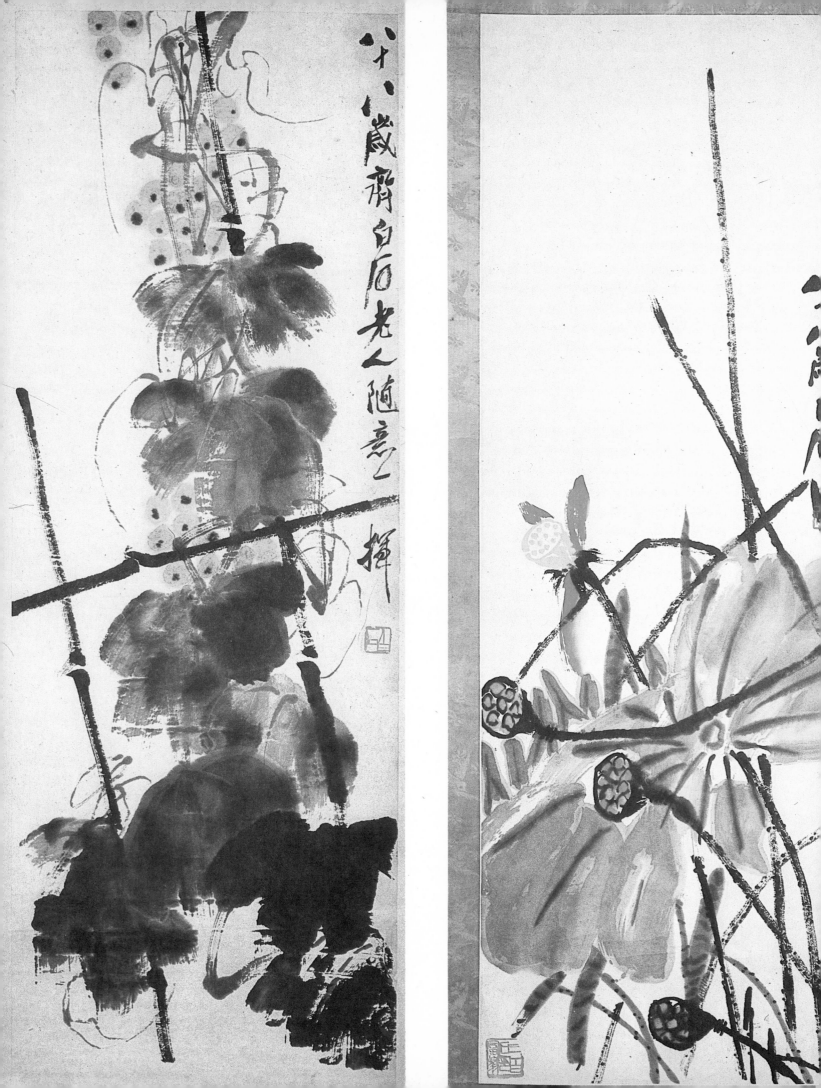

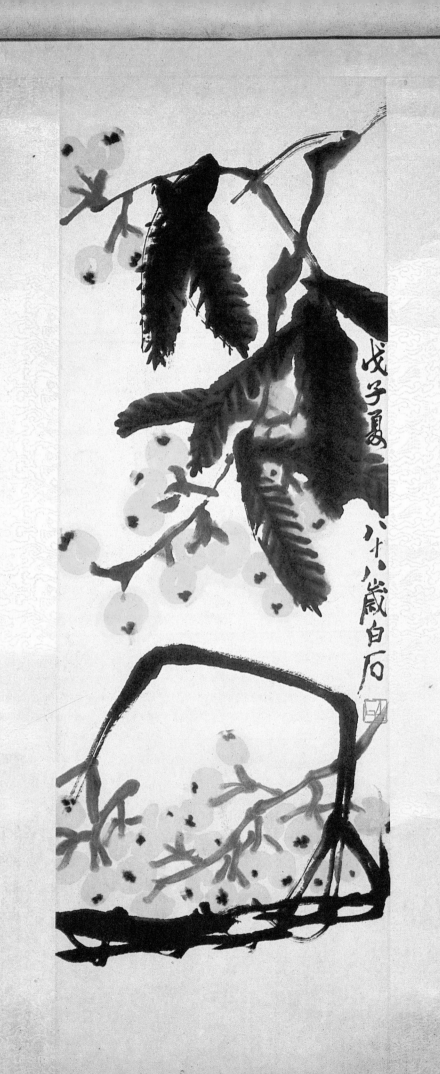

戊子夏

八十八歲白石

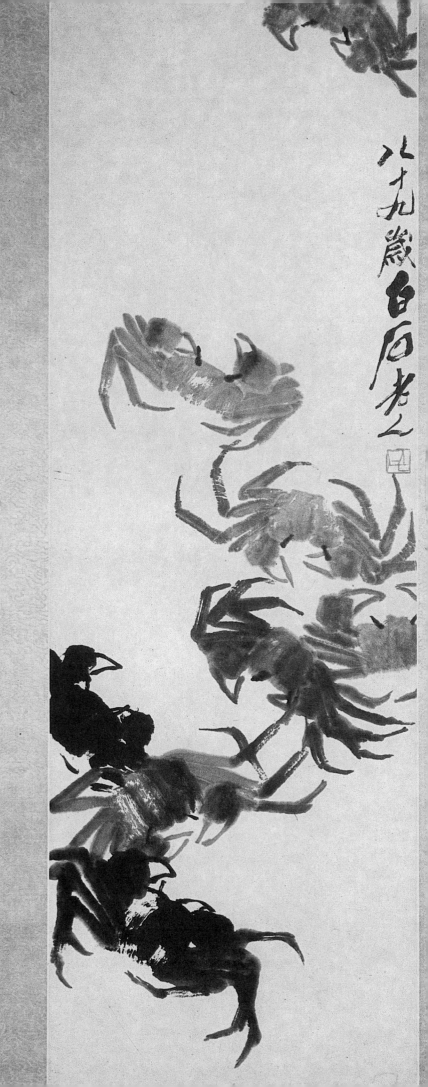

八十九歲白石老人

43 Ch'i Pai-shih: Crabs

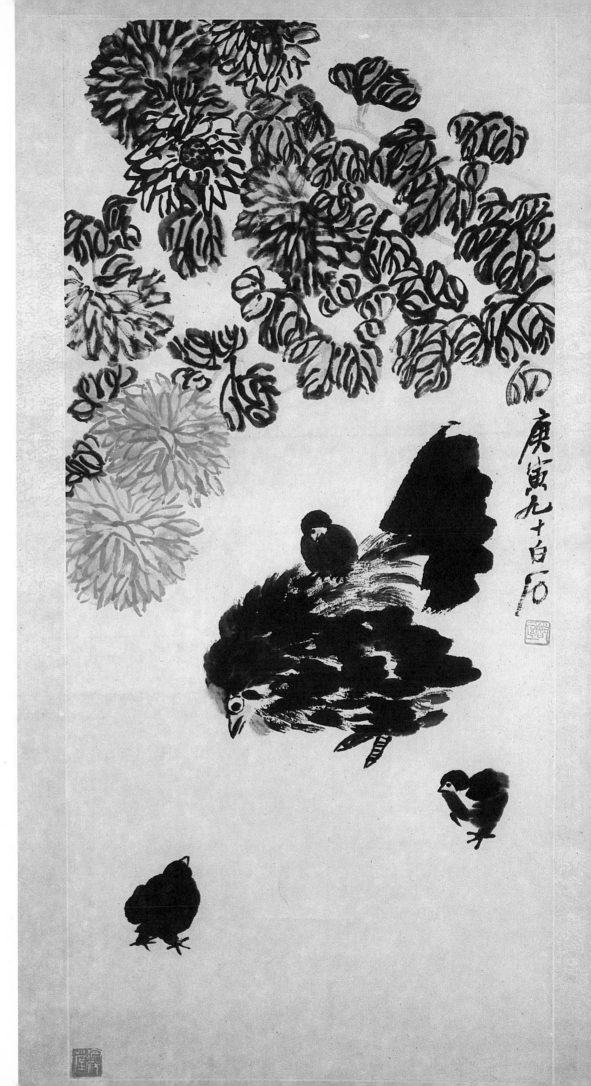

44 Ch'i Pai-shih: Brood-Hen and Chrysanthemums

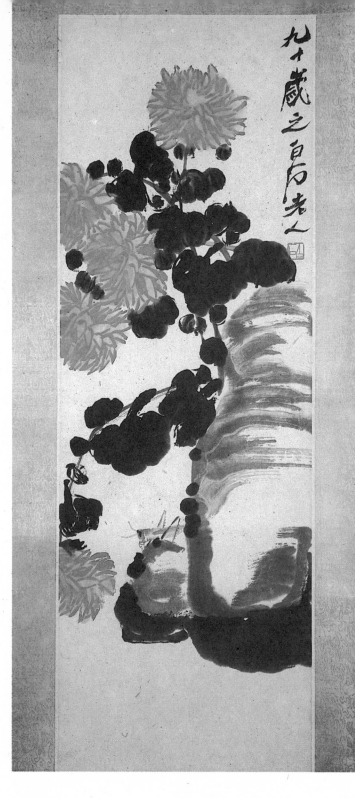

45 Ch'i Pai-shih: Chrysanthemums and Locust

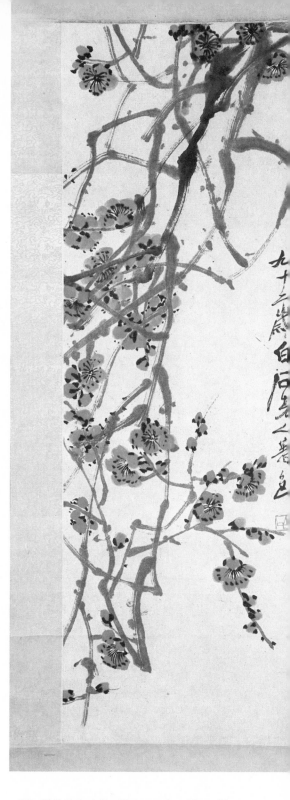

46 Ch'i Pai-shih: Blossoming Plum Tree

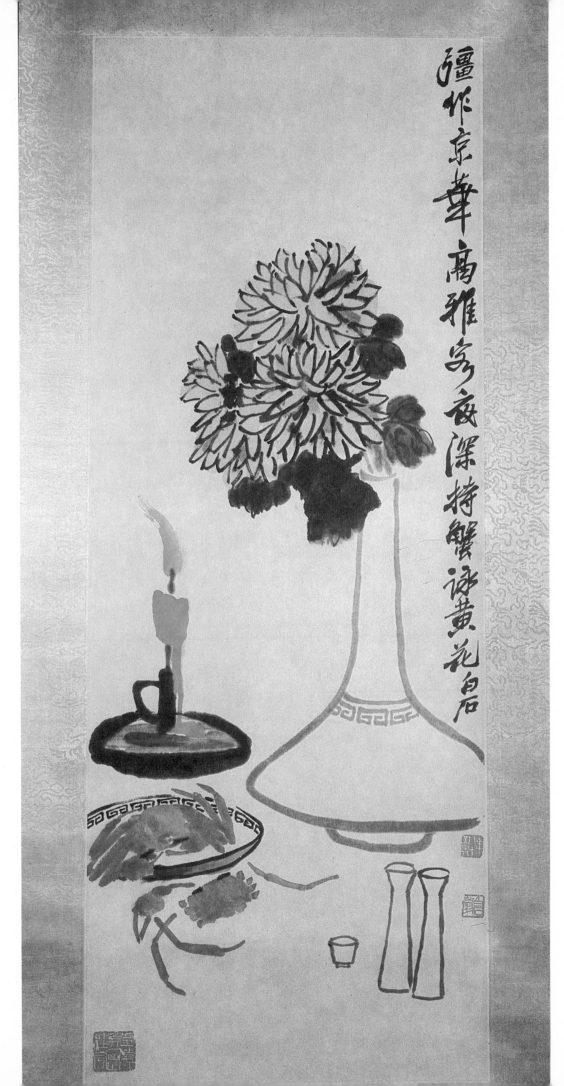

47 Ch'i Pai-shih: Feast at Night

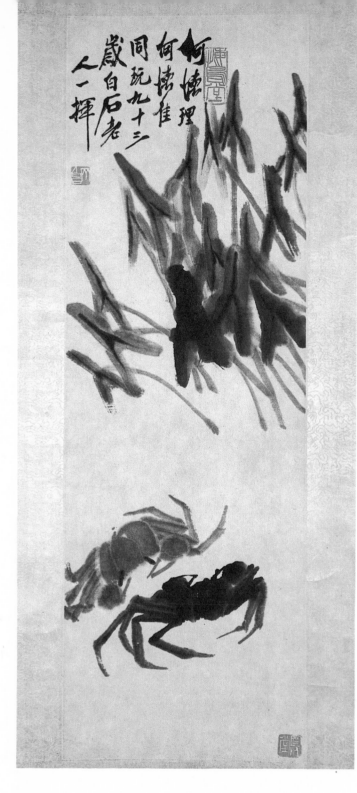

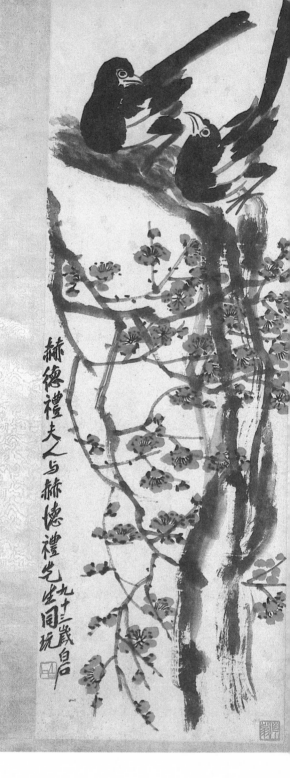

48 Ch'i Pai-shih: Crabs and Arrow-head

49 Ch'i Pai-shih: Magpies on a Blossoming Plum Tree

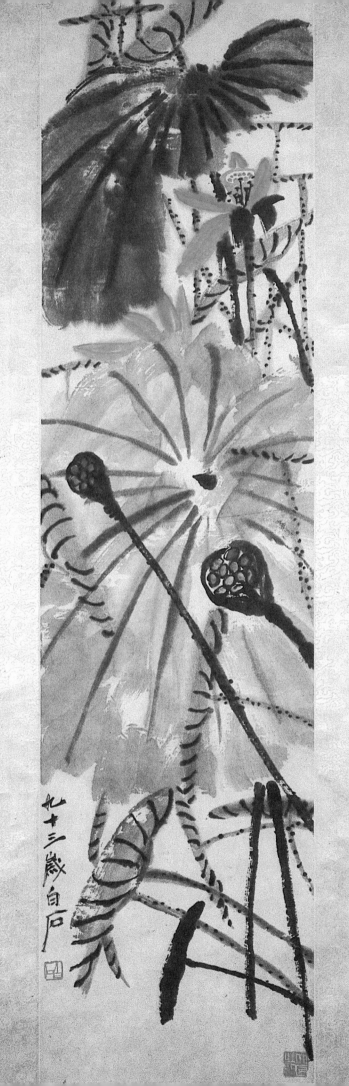

50 Ch'i Pai-shih: Withering Lotuses

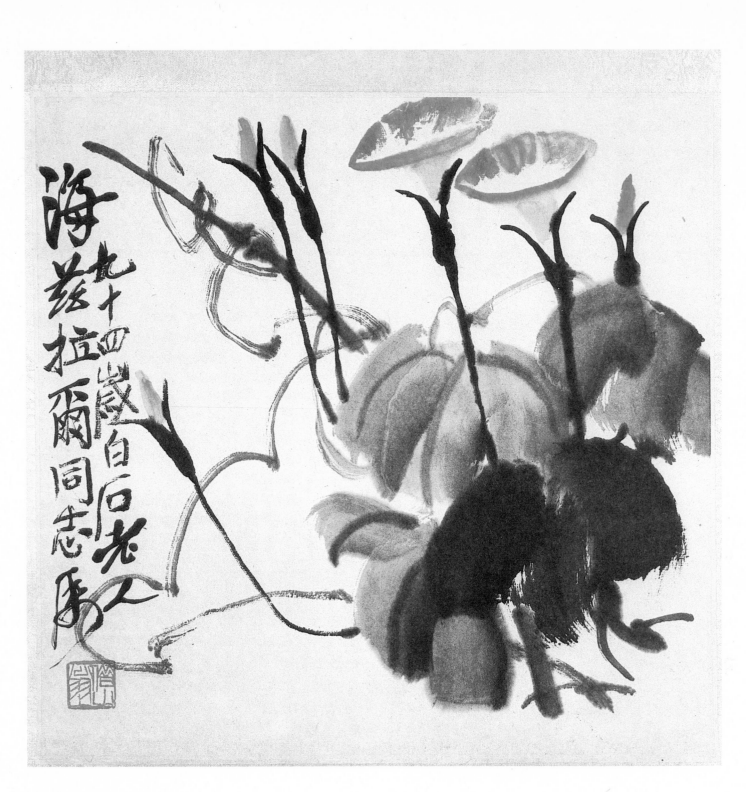

51 Ch'i Pai-shih: Bindweed

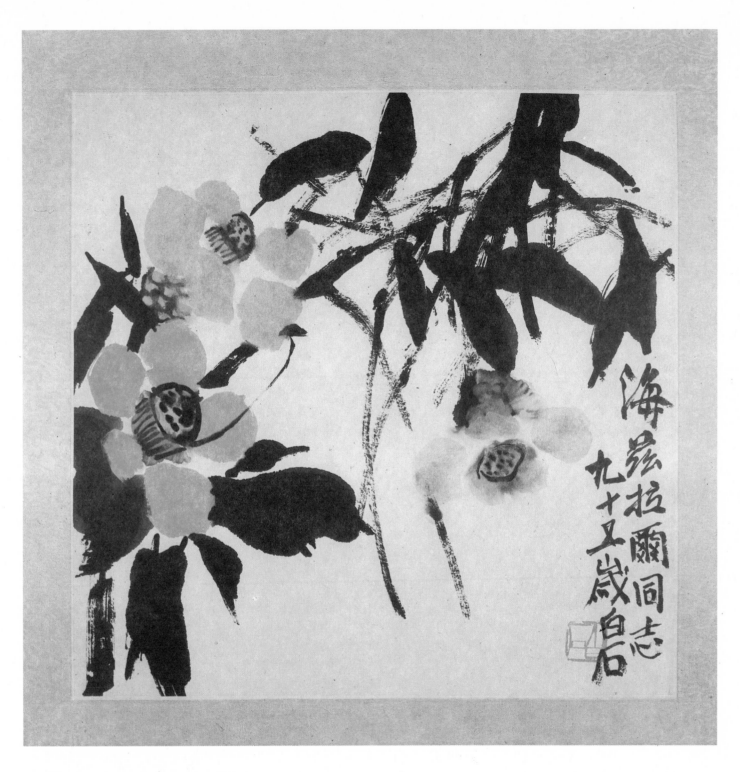

52　Ch'i Pai-shih: Flowering Tea-Shrub

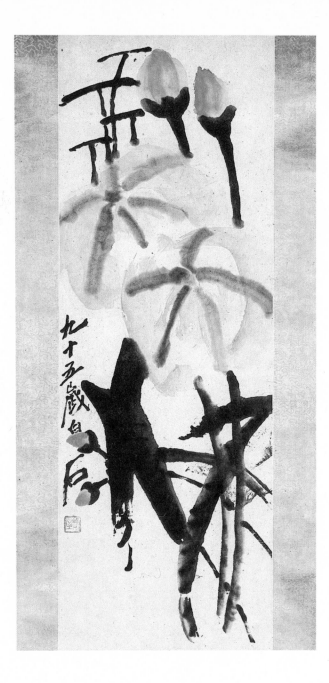

53 Ch'i Pai-shih: Lotuses

54 Ch'i Pai-shih: Vine

55 Ch'i Pai-shih: Lotuses

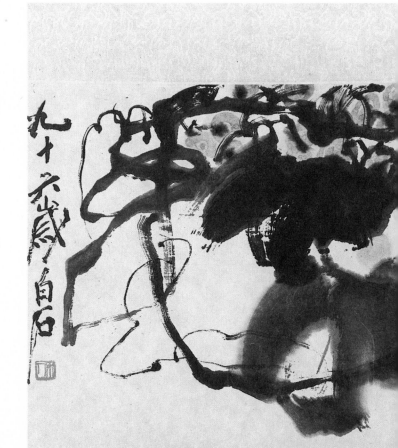

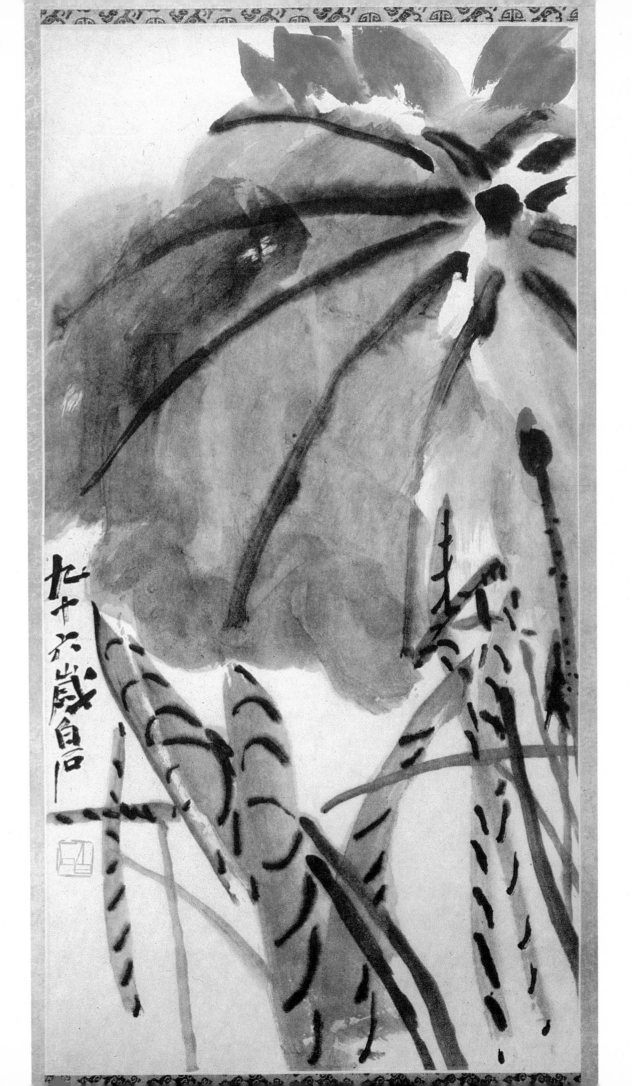

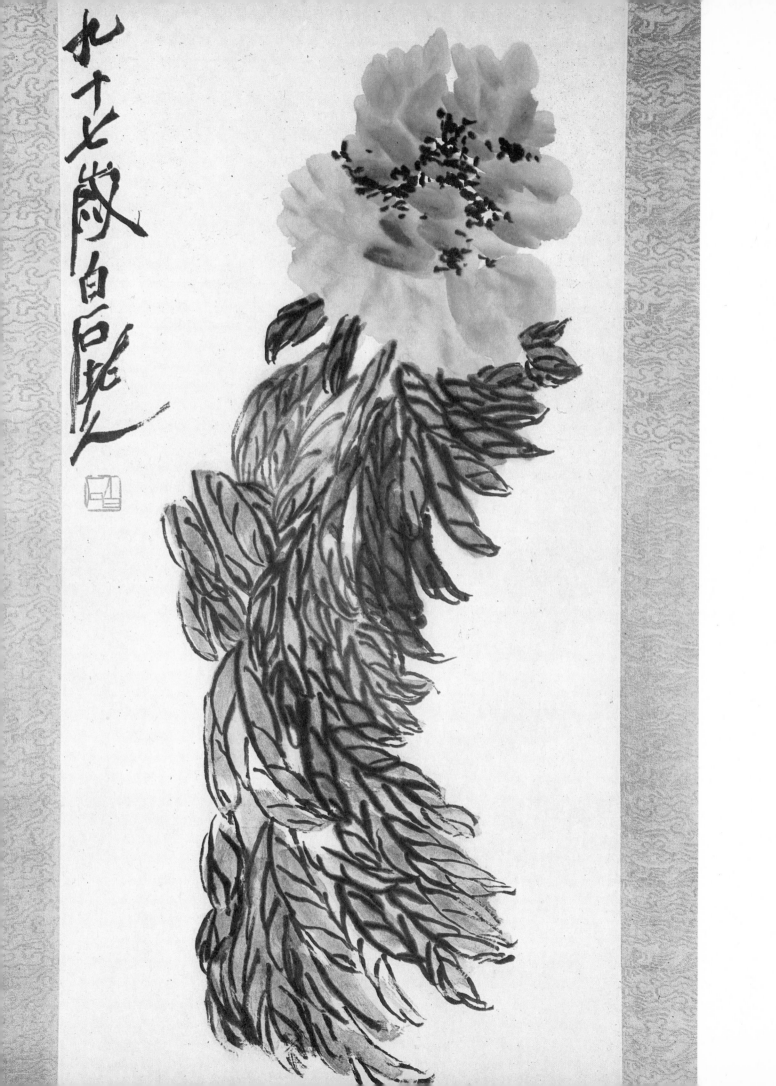

56 Ch'i Pai-shih: Peony in the Wind

57 Huang Pin-hung: Landscape with
Pavilions

携魚冒醉板橋
東潮入蘆花水
打風盡麻江村
秋色老釣舟歸
繫夕陽中
米友堂詩意以
秋蒲小景寫之
癸未冬日
賓虹

58 Huang Pin-hung:
Mountain Land-
scape with Hermit
Settlements

59 Huang Pin-hung:
Landscape near
Ch'ing-ch'êng

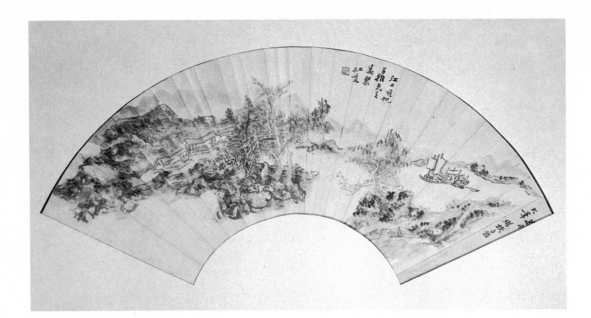

60 Huang Pin-hung: Landscape with
a Sailing-Boat

61 Huang Pin-hung: Dusk in the
Western Mountains

62 Huang Pin-hung: Coastal Scenery
with a Boat

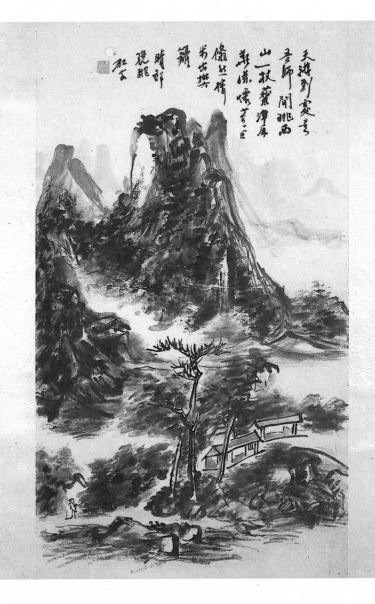

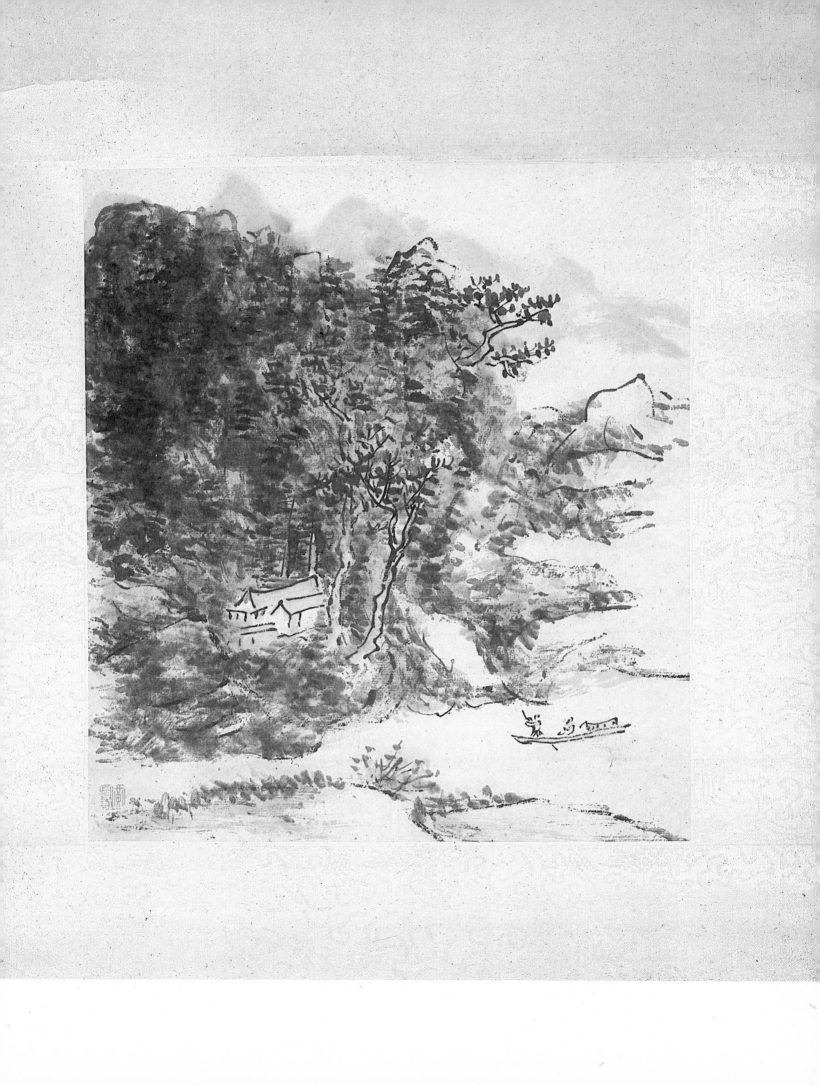

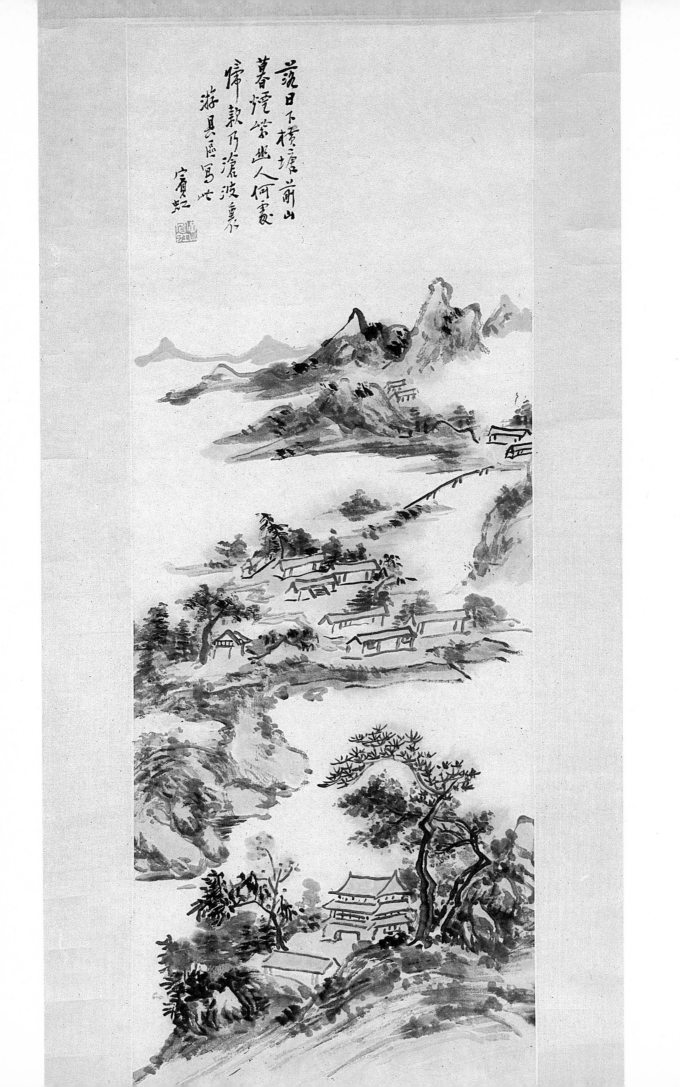

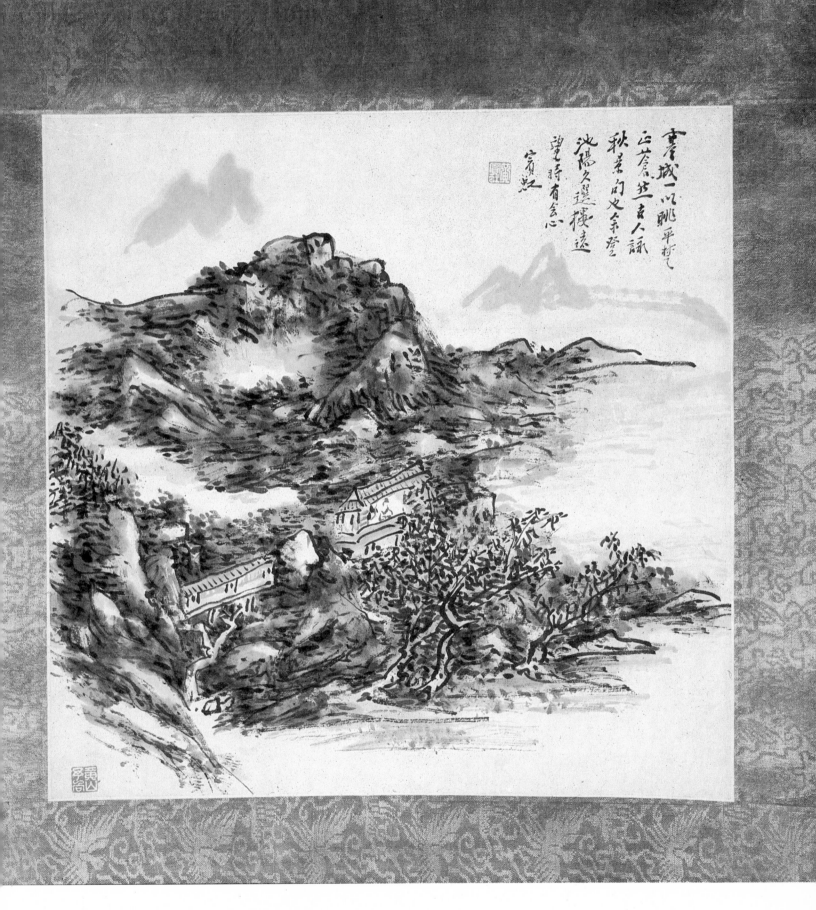

書城一以眺一平林气
正蒼蒼此古人詠
秋暮约足余登
池陽久選擾遠
望覺時有会心
賓虹

64 Huang Pin-hung: Landscape near Chih-yang

63 Huang Pin-hung: Evening Scenery with the Banks of a Lake

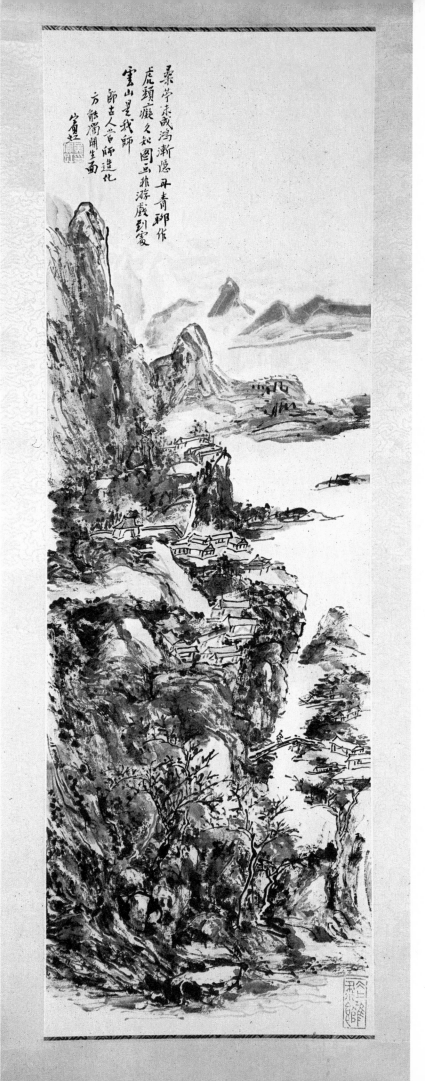

65 Huang Pin-hung: Rocky Coastal Land-
 scape with Dwellings

66 Huang Pin-hung: Landscape with a Waterfall

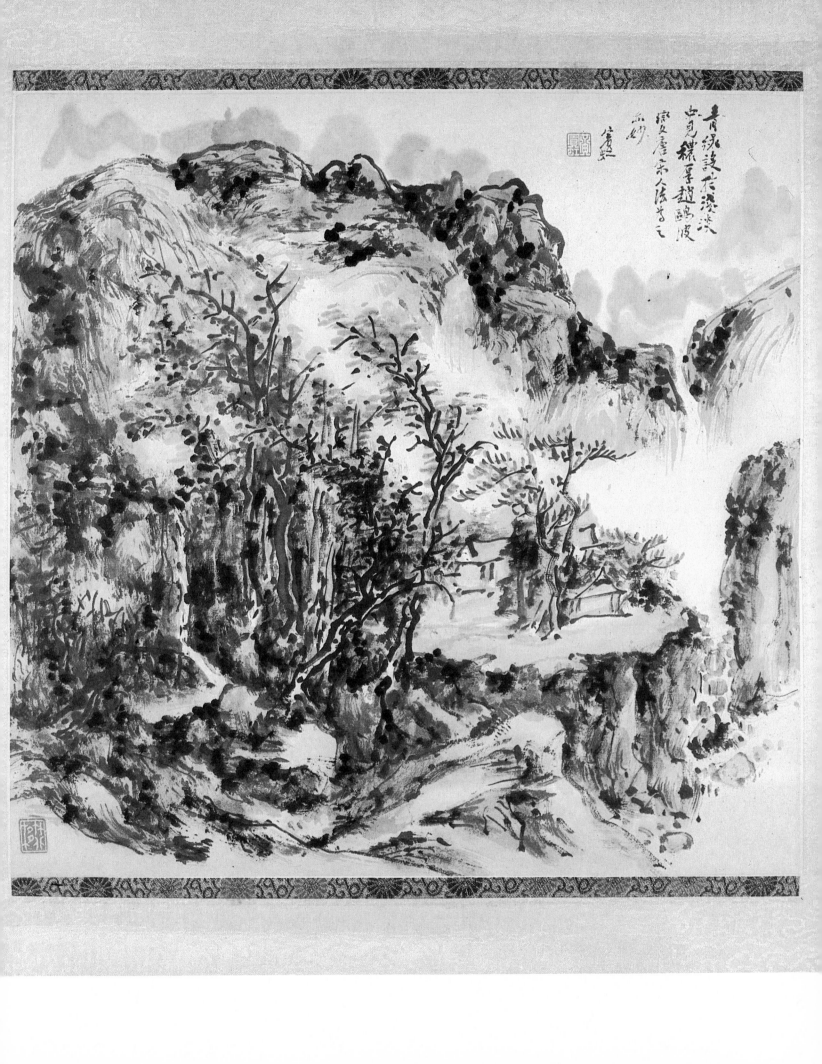

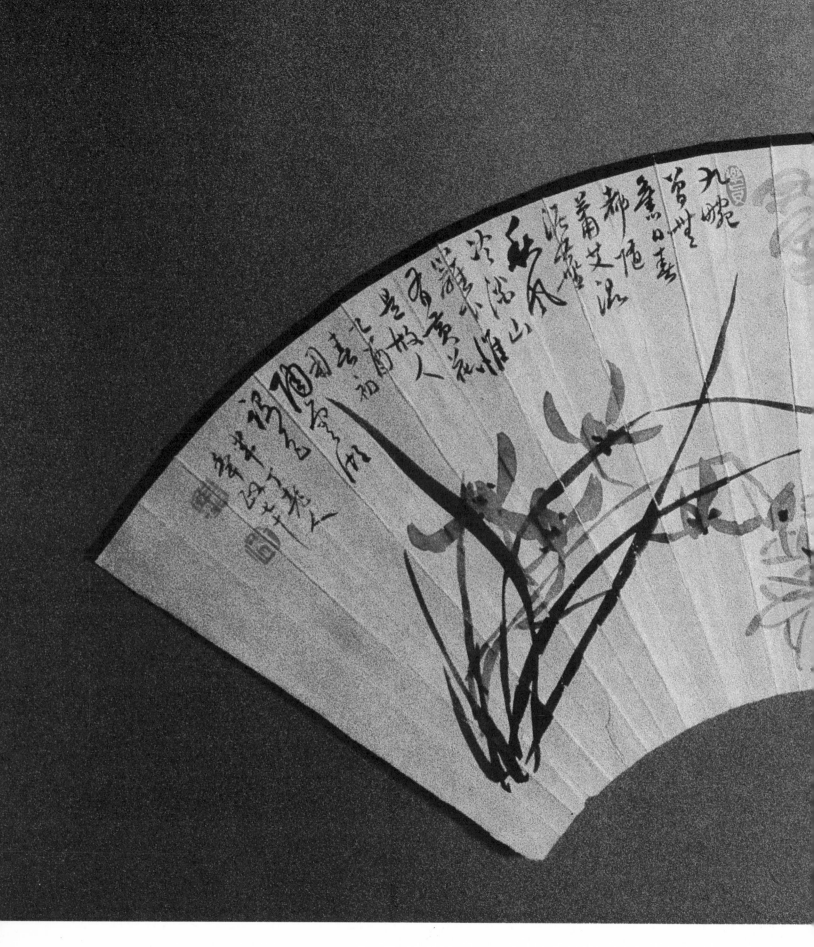

67 Ch'ên Pan-ting: Chrysanthemums and Orchid

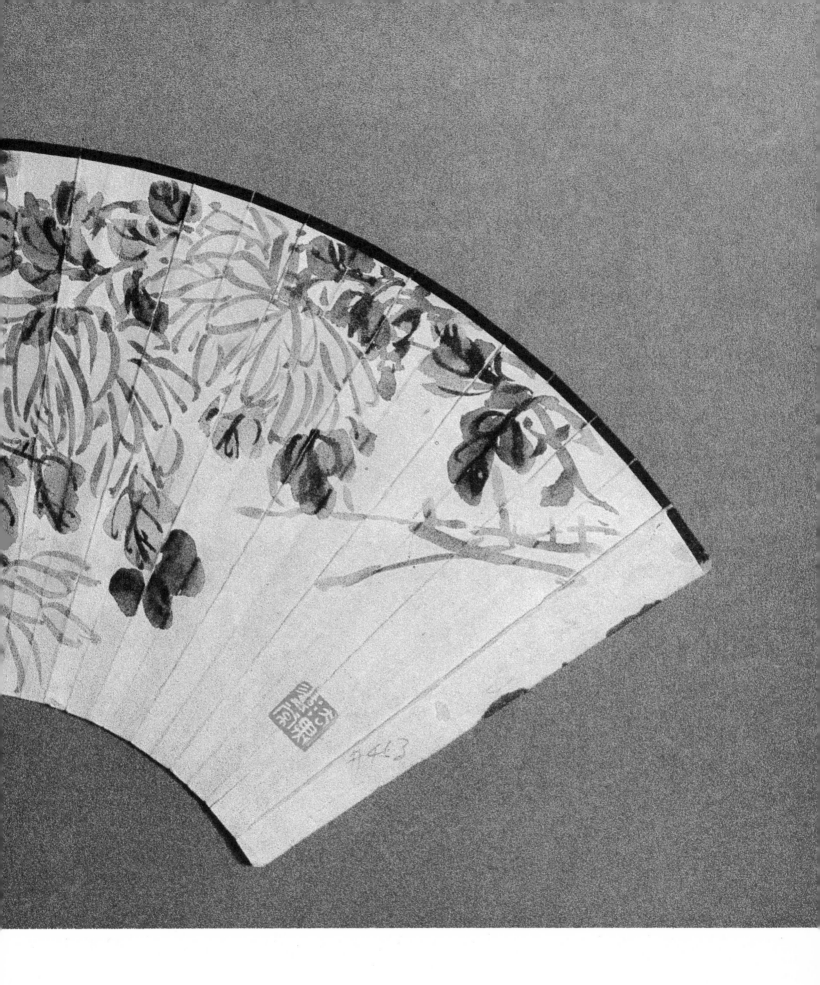

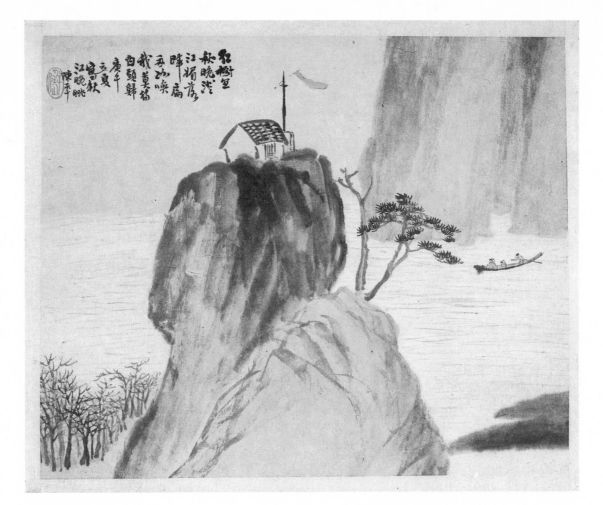

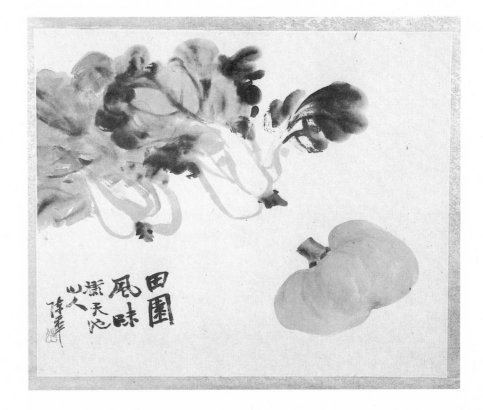

68 Ch'ên Pan-ting: Autumnal Evening on the River

69 Ch'ên Pan-ting: Melon and Chinese Cabbage

70 Ch'ên Shih-tsêng: Land-scape in the Rain

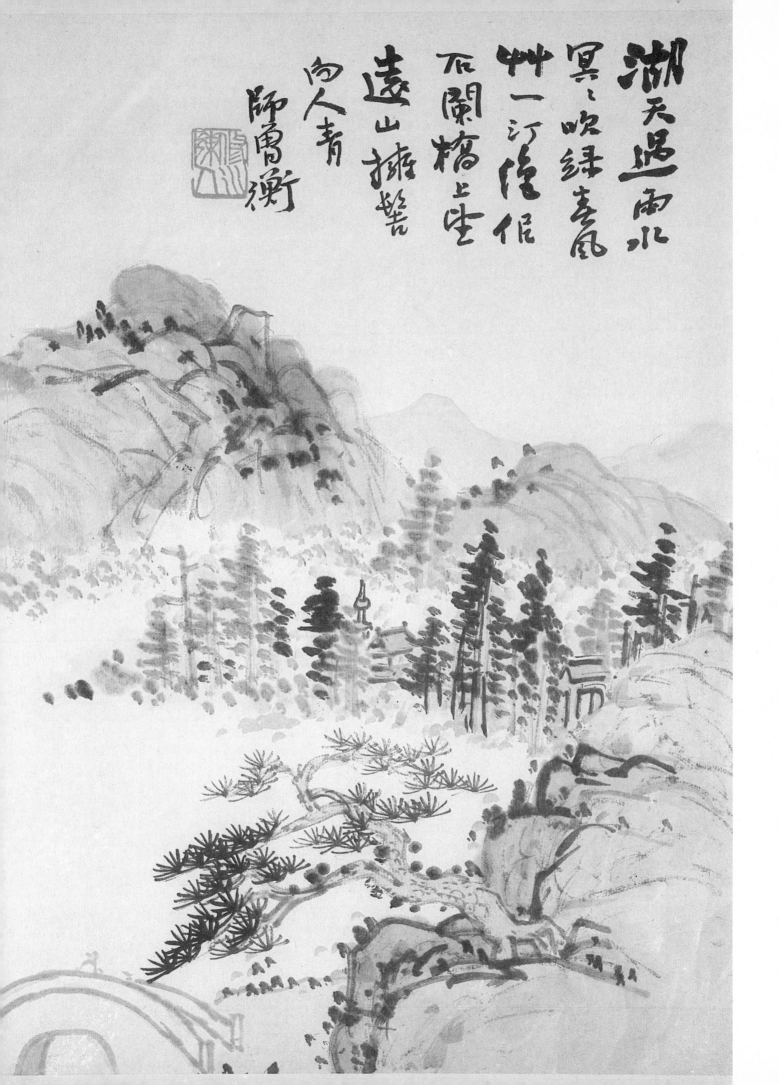

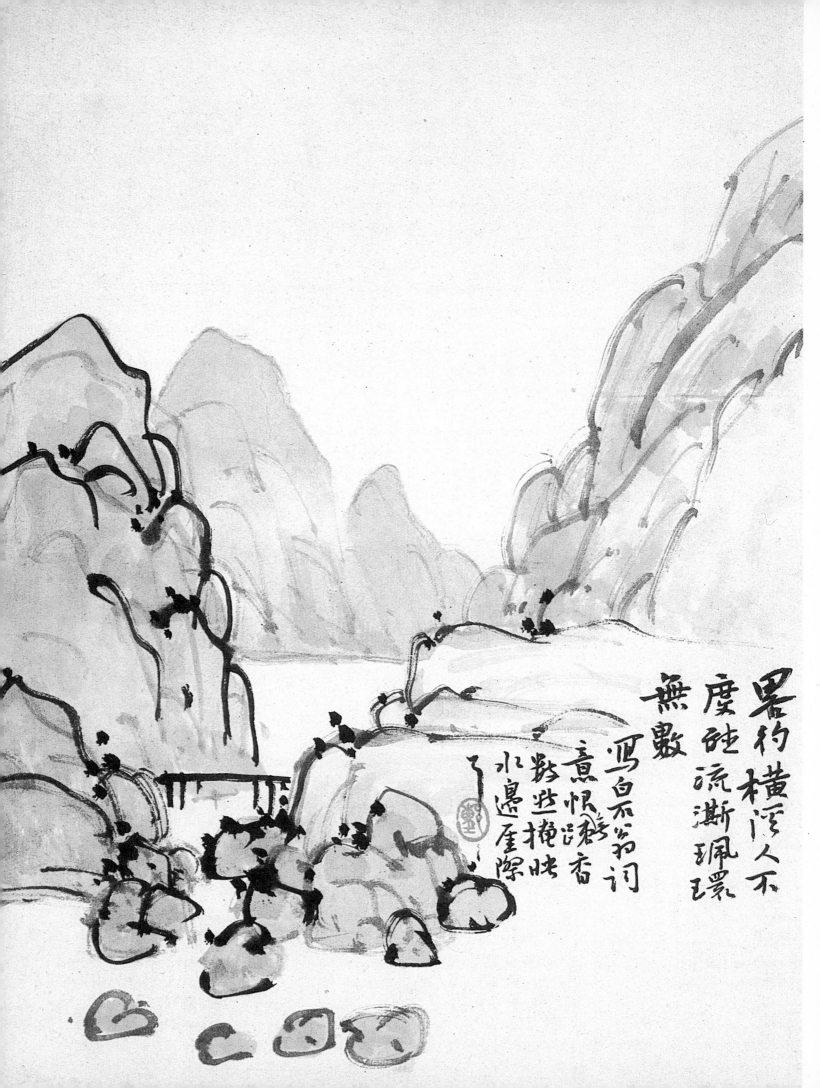

暑行橫陰人不
度但流漸珮環
無數寫白石公詞
　　烹恨雜香
　　數點掩映
　　水邊崖際

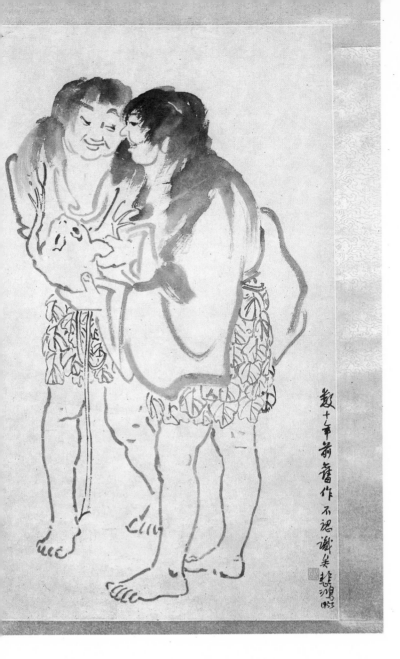

72 Hsü Pei-hung: The Legendary He-he Brothers with a Frog

71 Ch'ên Shih-tsêng: Mountain Stream with Bridge (based on a poem by Ch'i Pai-shih)

73 Hsü Pei-hung: Pines on a Cliff

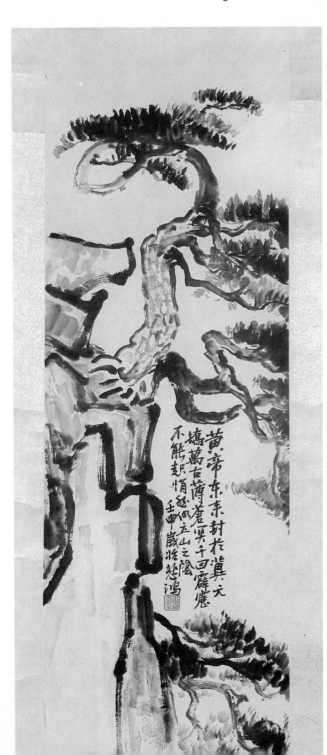

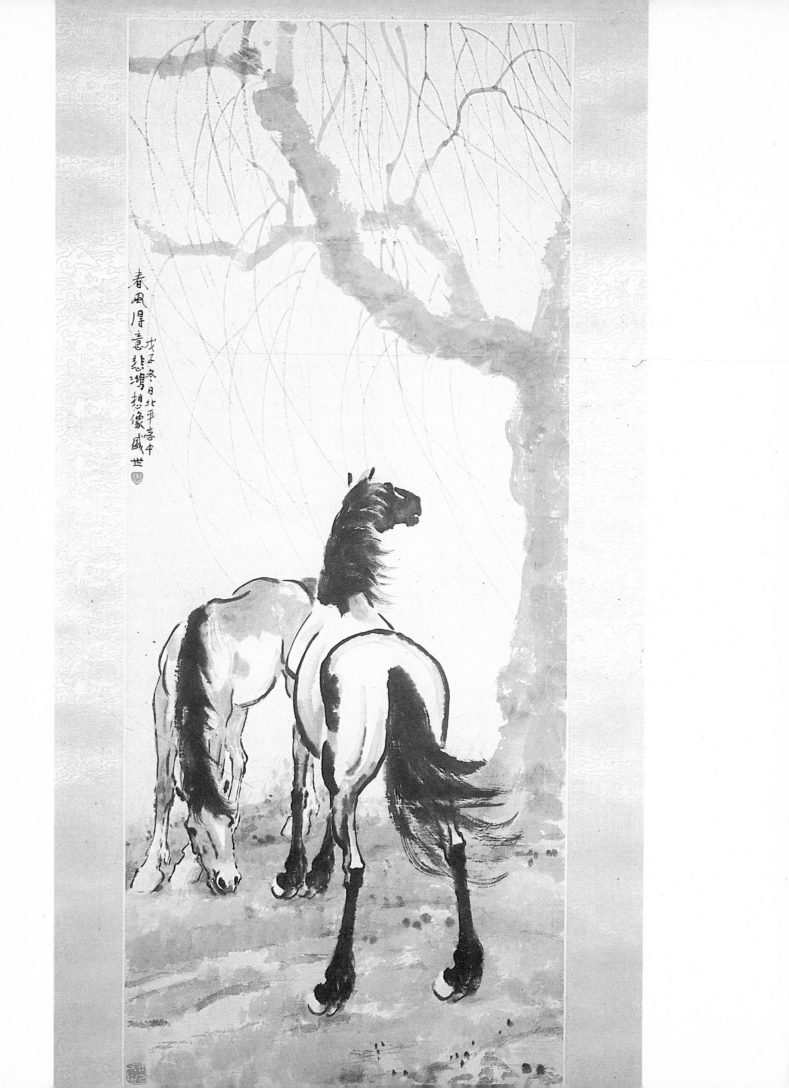

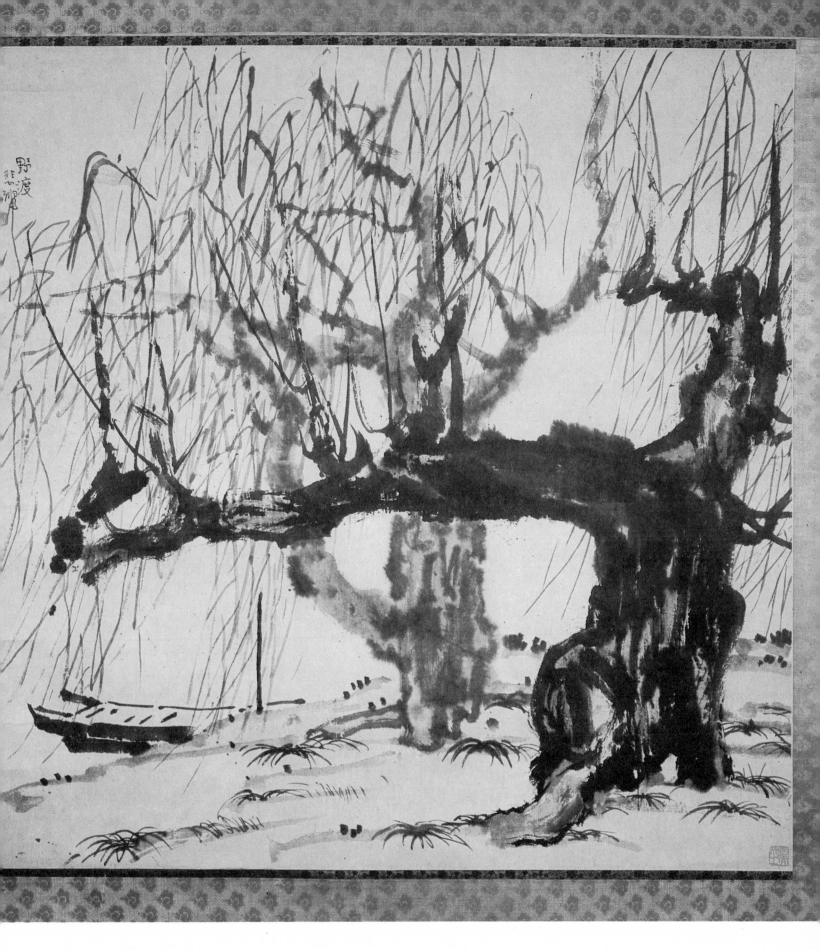

75 Hsü Pei-hung: Lonely Ferry

74 Hsü Pei-hung: Grazing Horses

76 Hsü Pei-hung:
Cocks and Hens

77 Hsü Pei-hung:
Running Horse

78 – 81 Kuan Liang: Scene from the Chinese Opera

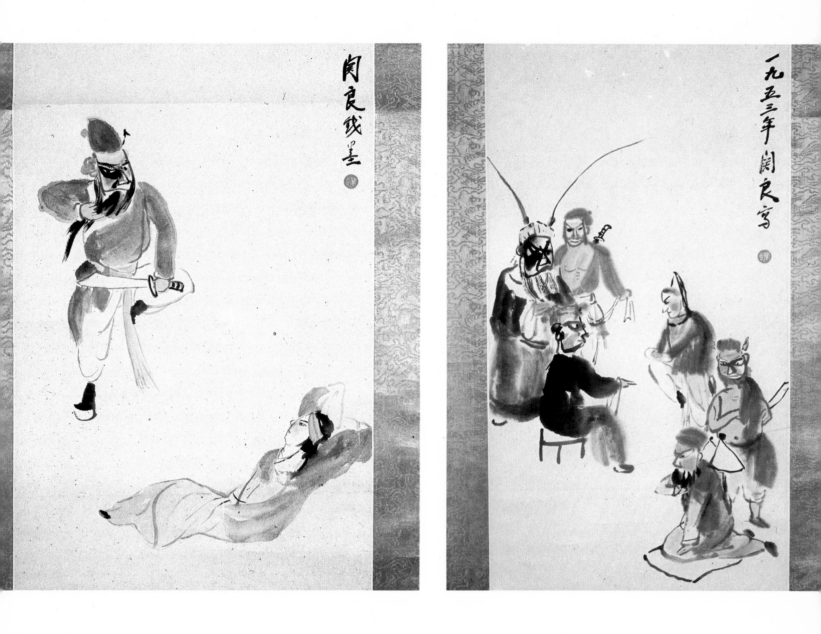

関良戯墨

一九五三年関良写

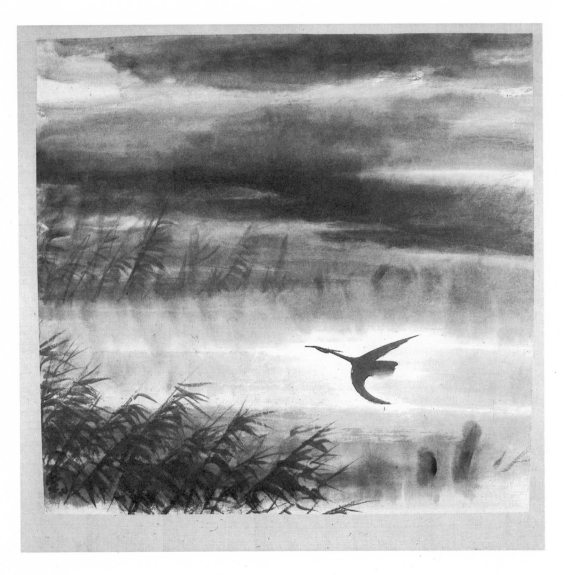

82 Lin Fêng-mien: Heron above the Reeds

83 Lin Fêng-mien: Hamlet below the Mountains

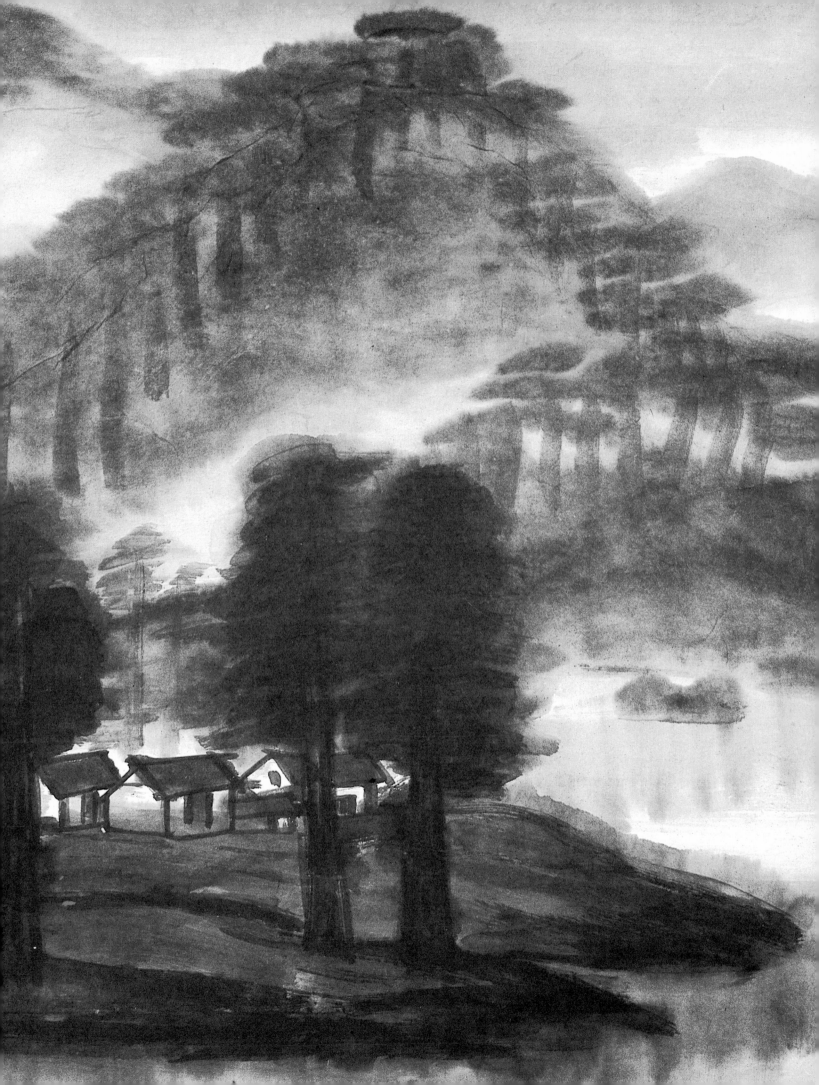

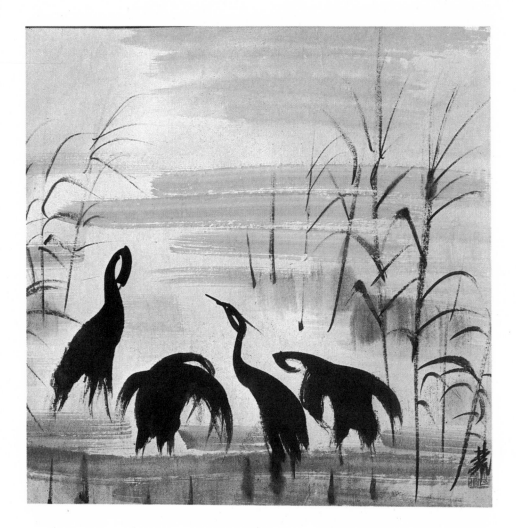

84 Lin Fêng-mien: Herons in the Reeds

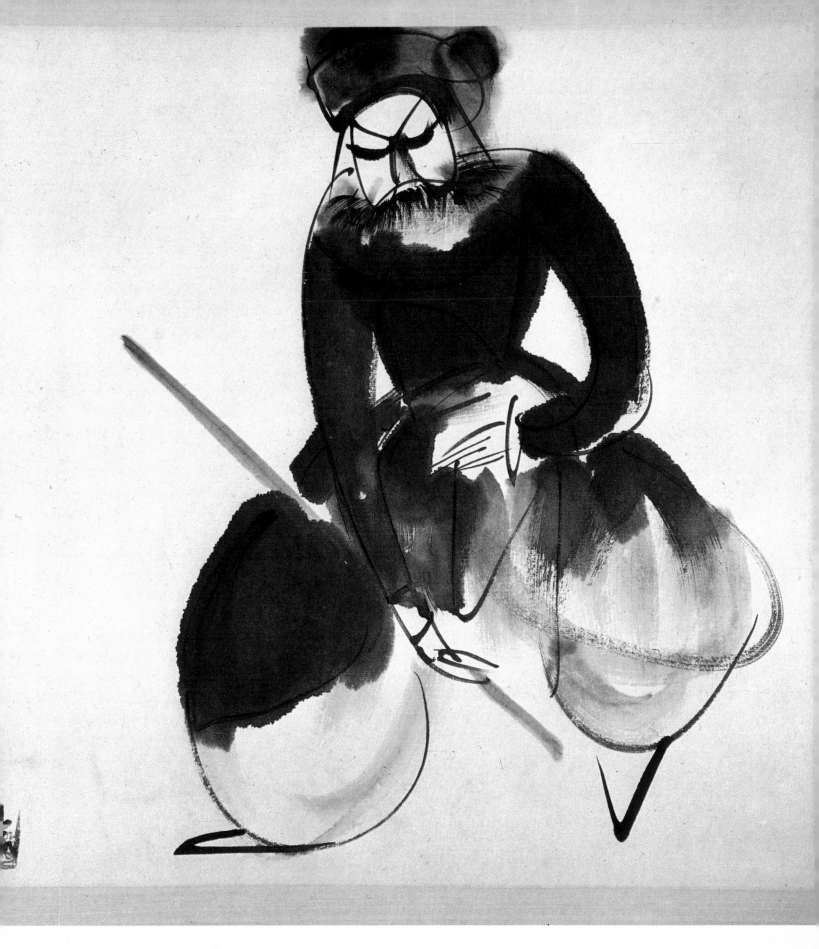

85 Lin Fêng-mien: Actor in the Classical Opera

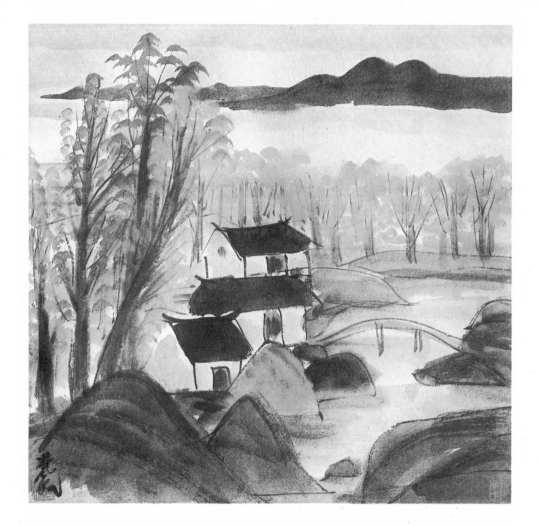

86 Lin Fêng-mien: Landscape with Yellow Trees

87 Lin Fêng-mien: Female Nude

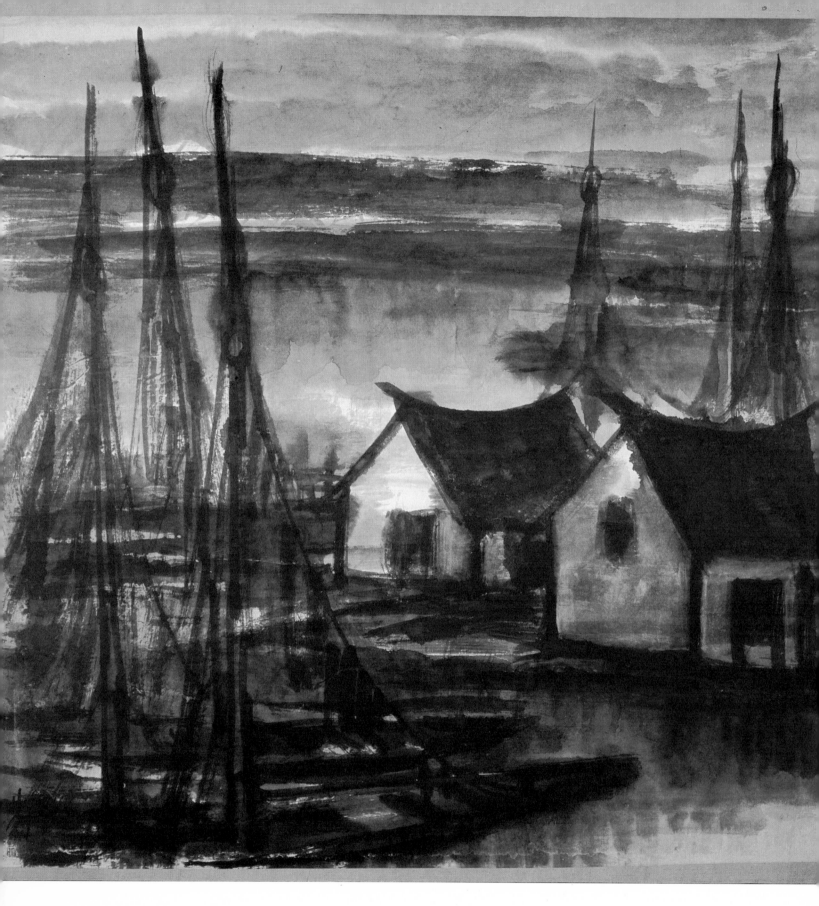

88 Lin Fêng-mien: Fishermen's Houses in the Harbour

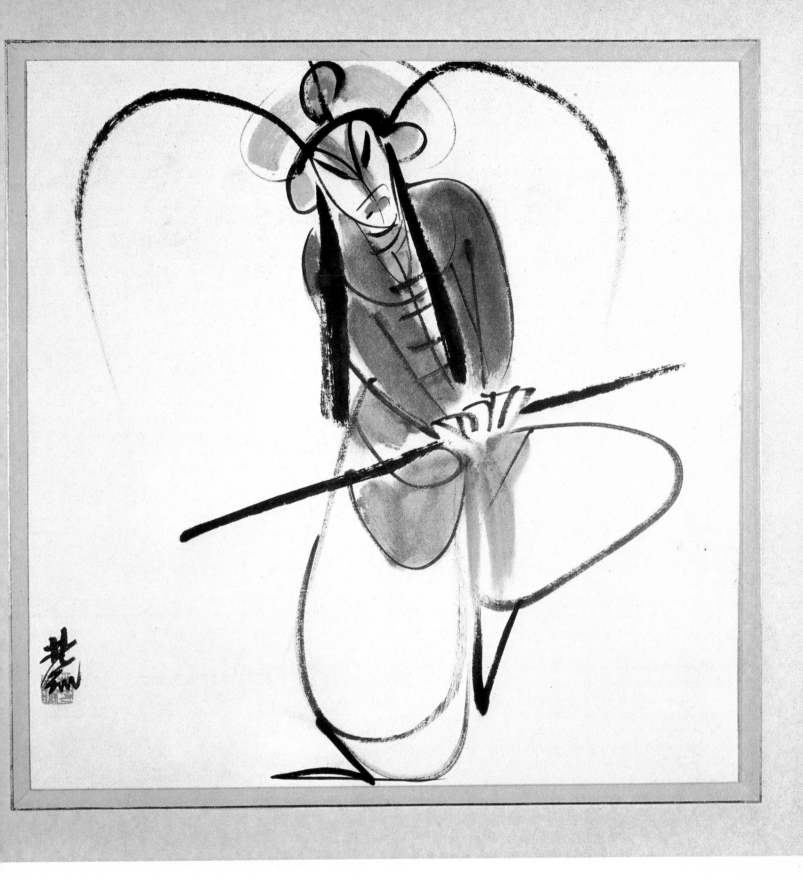

89 Lin Fêng-mien: Actor in the Classical Opera

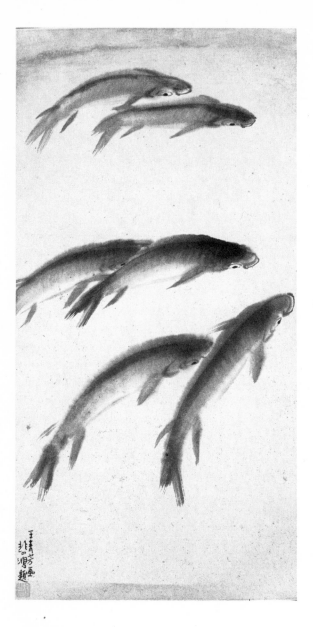

90 Wang Ch'ing-fang: Fishes (Inscription by Hsü Pei-hung)

91 Wang Ch'ing-fang: Pavilions above the Water

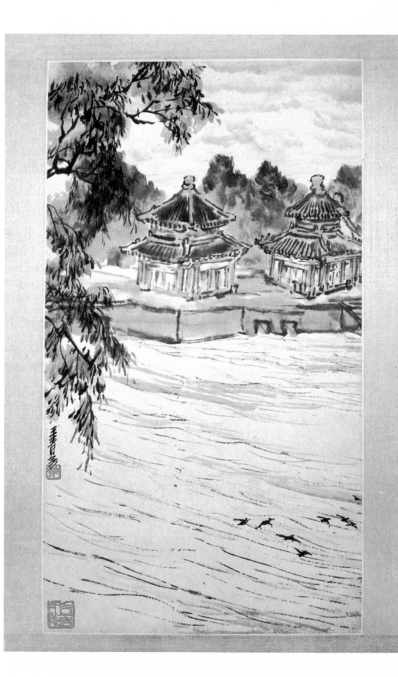

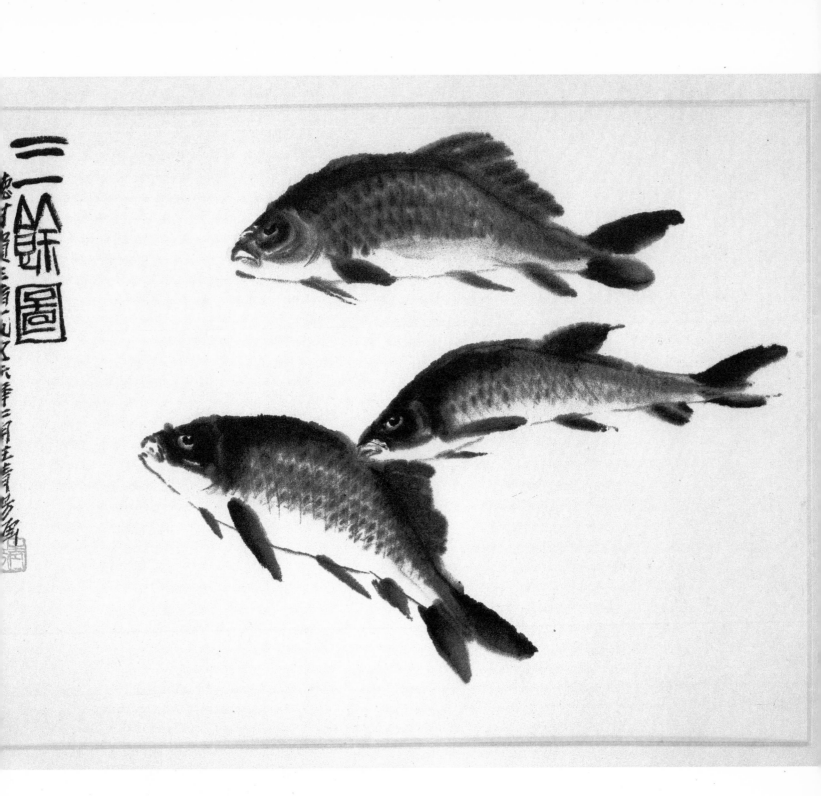

92 Wang Ch'ing-fang: Three Fishes

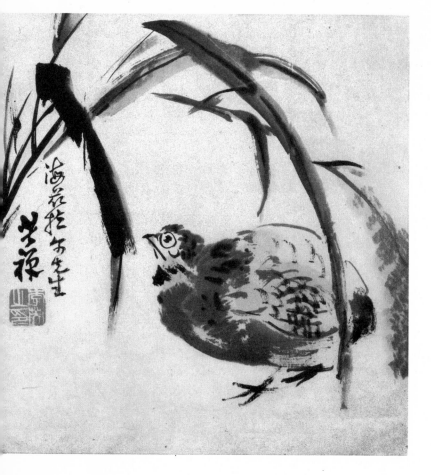

93 Li K'u-ch'an: Quail

94 Li K'u-ch'an: A Pair of Fishes

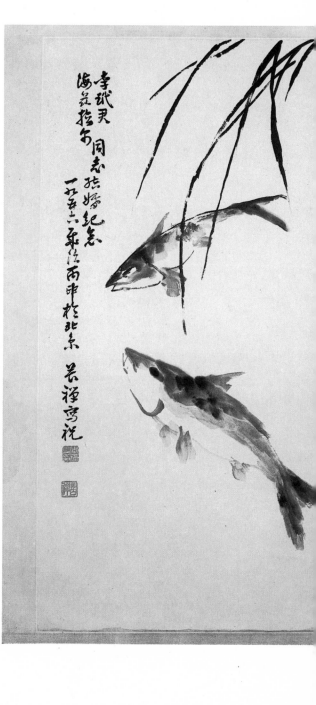

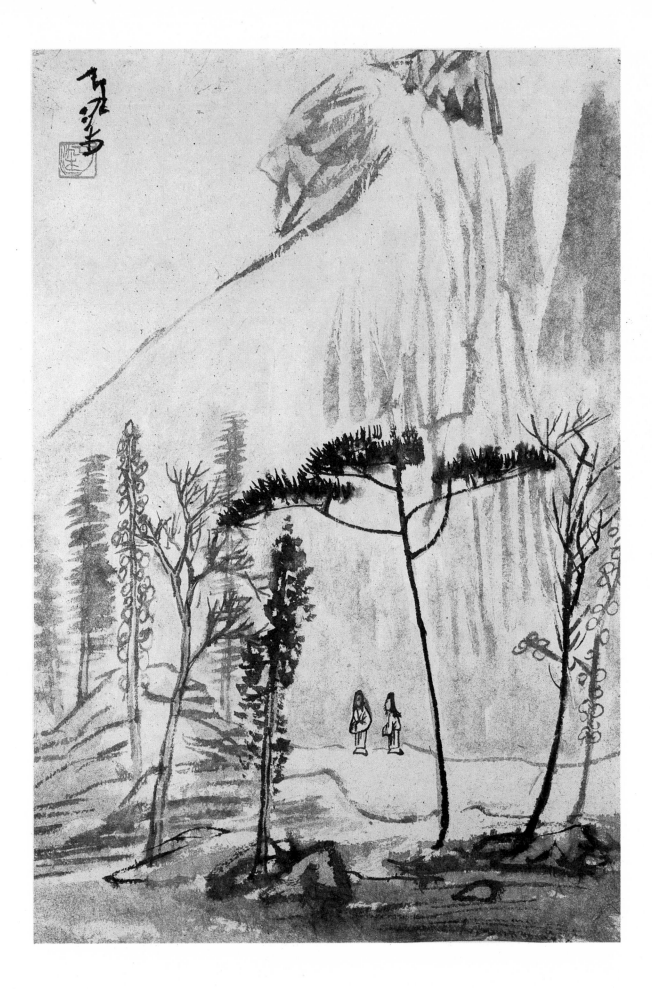

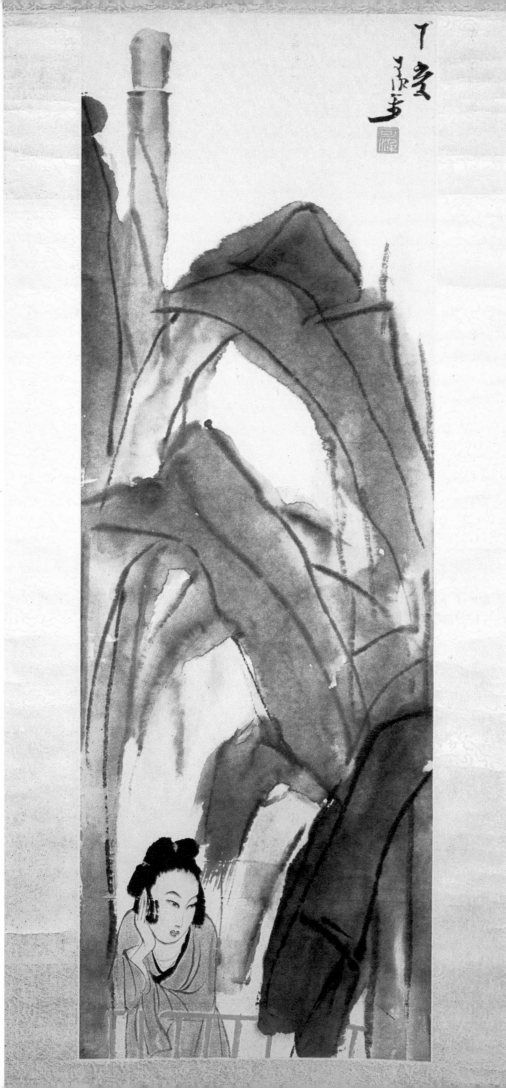

96 Li K'ê-jan: Woman under
 a Banana-Tree

97 Li K'ê-jan: Shepherds
 with a Buffalo

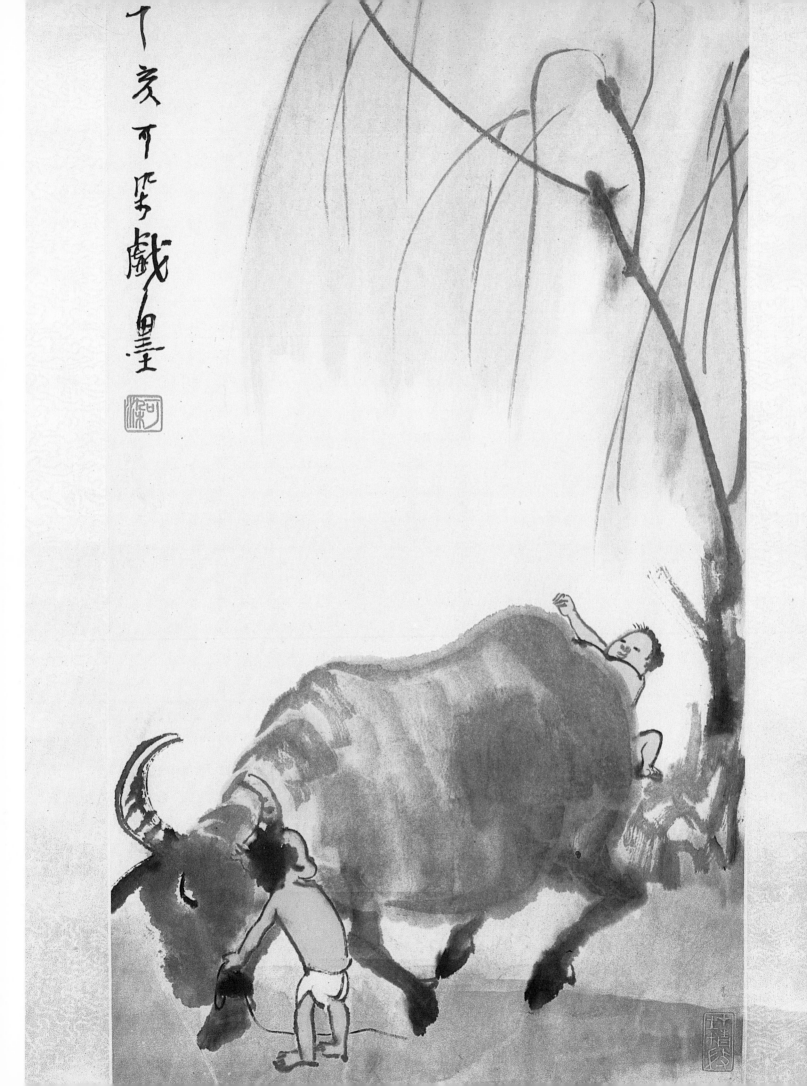

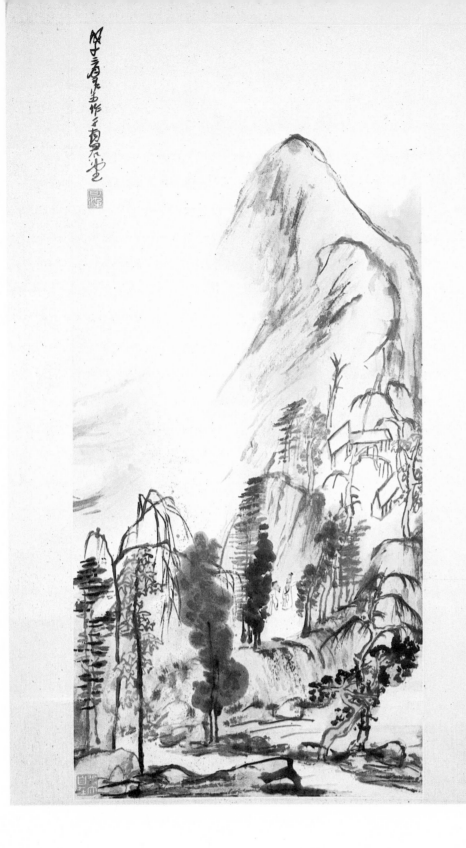

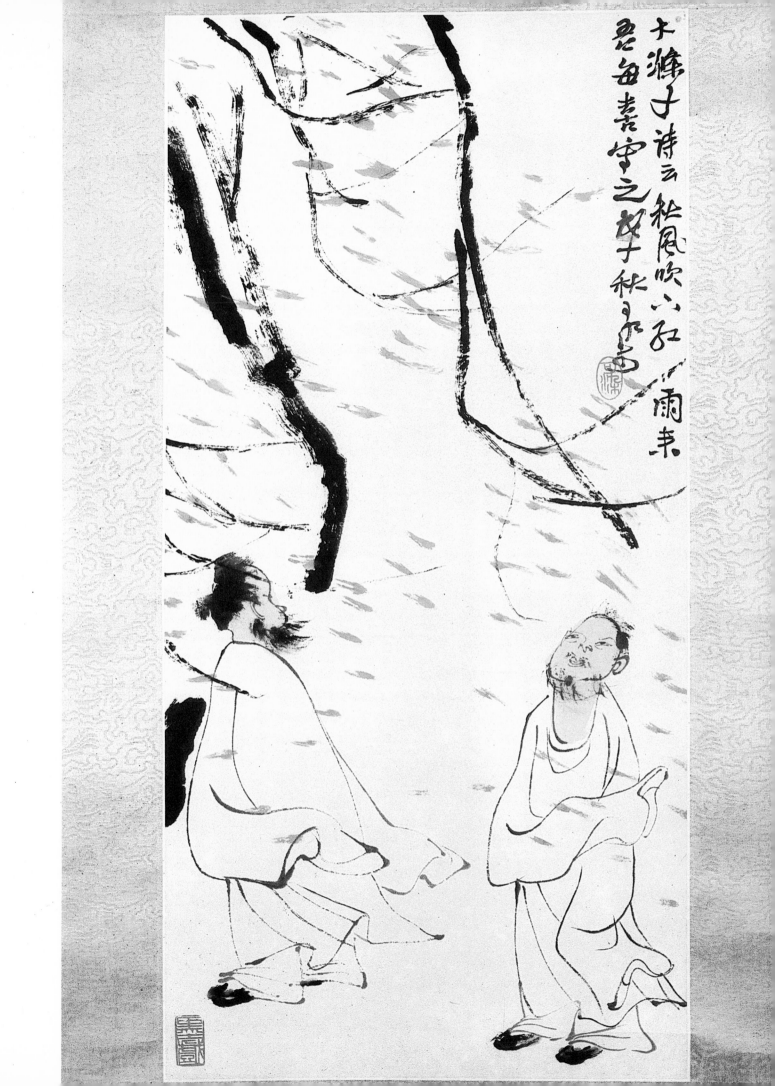

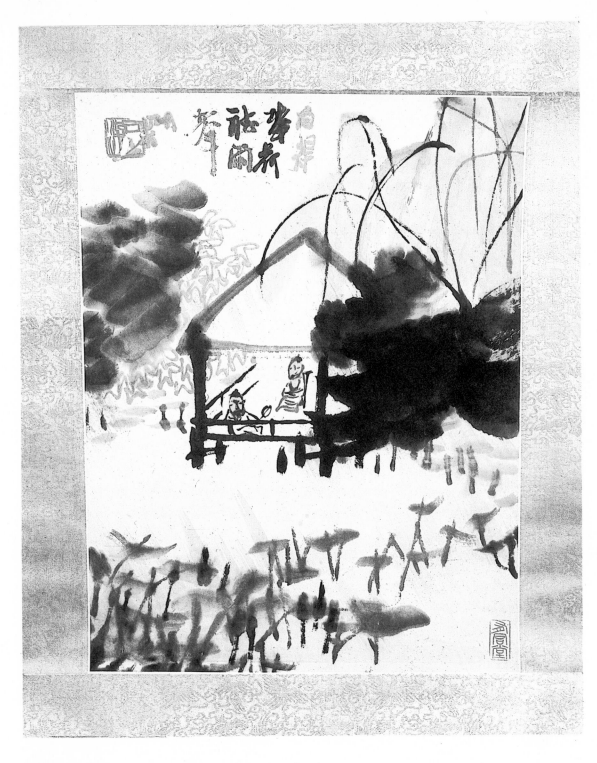

100 Li K'ê-jan: Listening to Rain by the Lotus Pond

101 Li K'ê-jan: Chung Kuei, the Exorcist

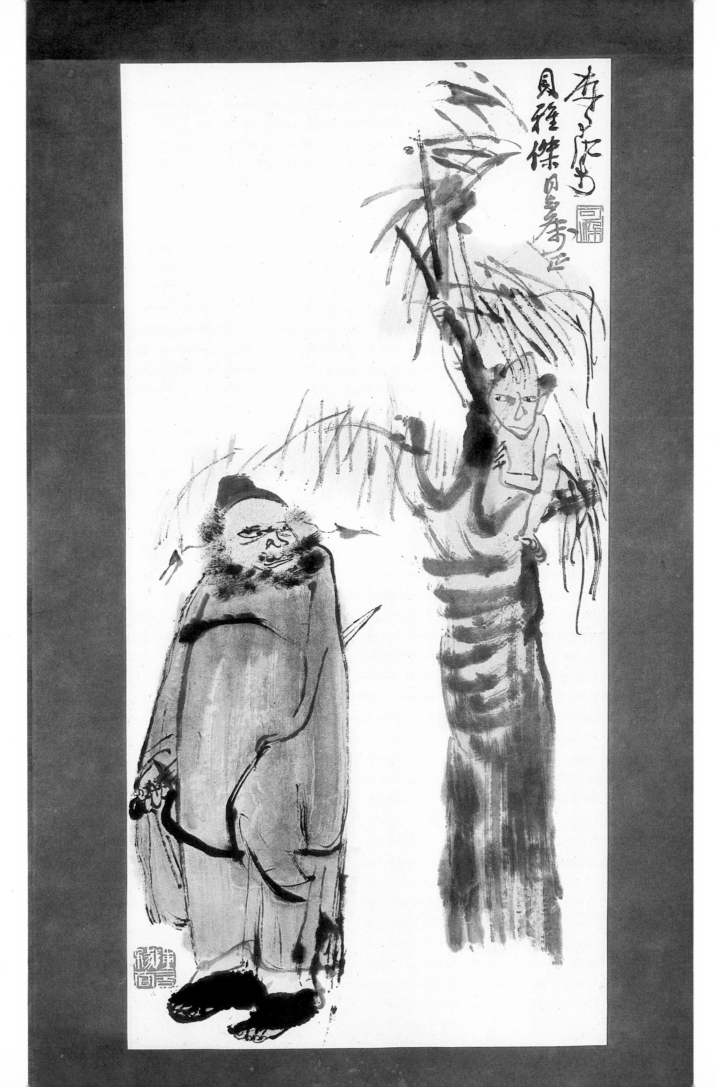

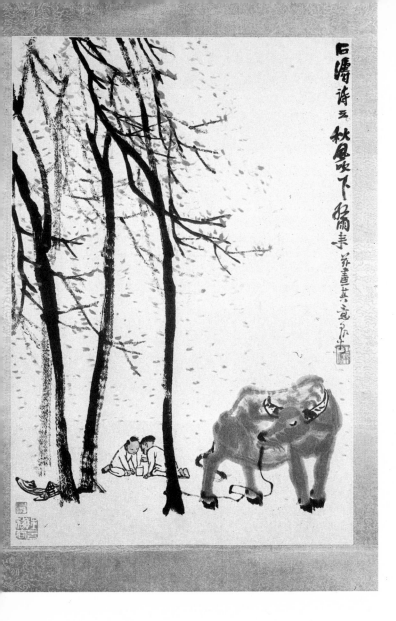

石濤詩之
秋風吹下猶爾
莽畫其之意
[artist signature and seals]

102 Li K'ê-jan: Autumnal Wind on the Pasture
(based on a poem by Shih T'ao)

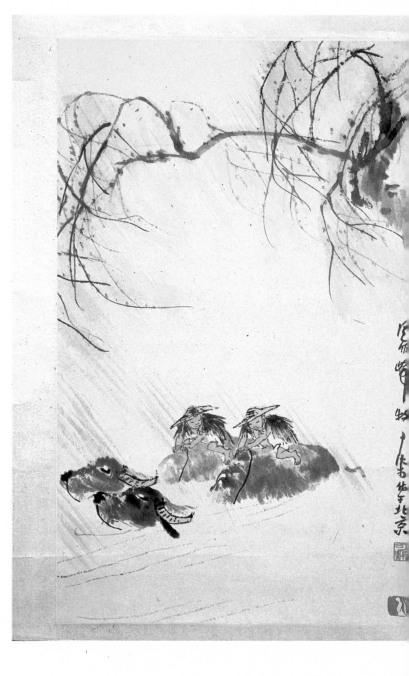

103 Li K'ê-jan: Return from the Pasture in Wind and Rain

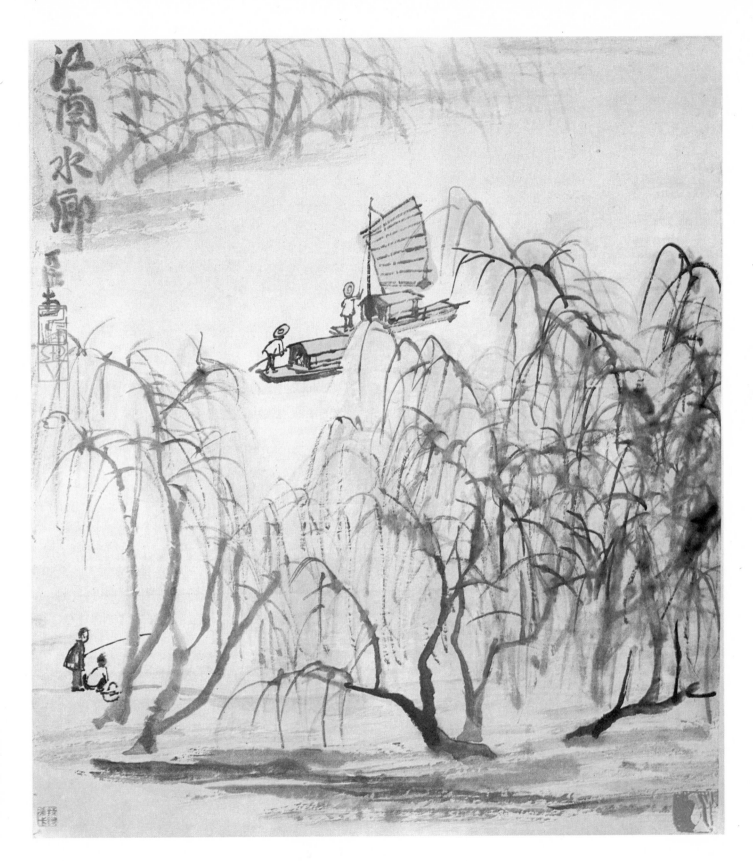

104 Li K'ê-jan: By the River in the South of the Country

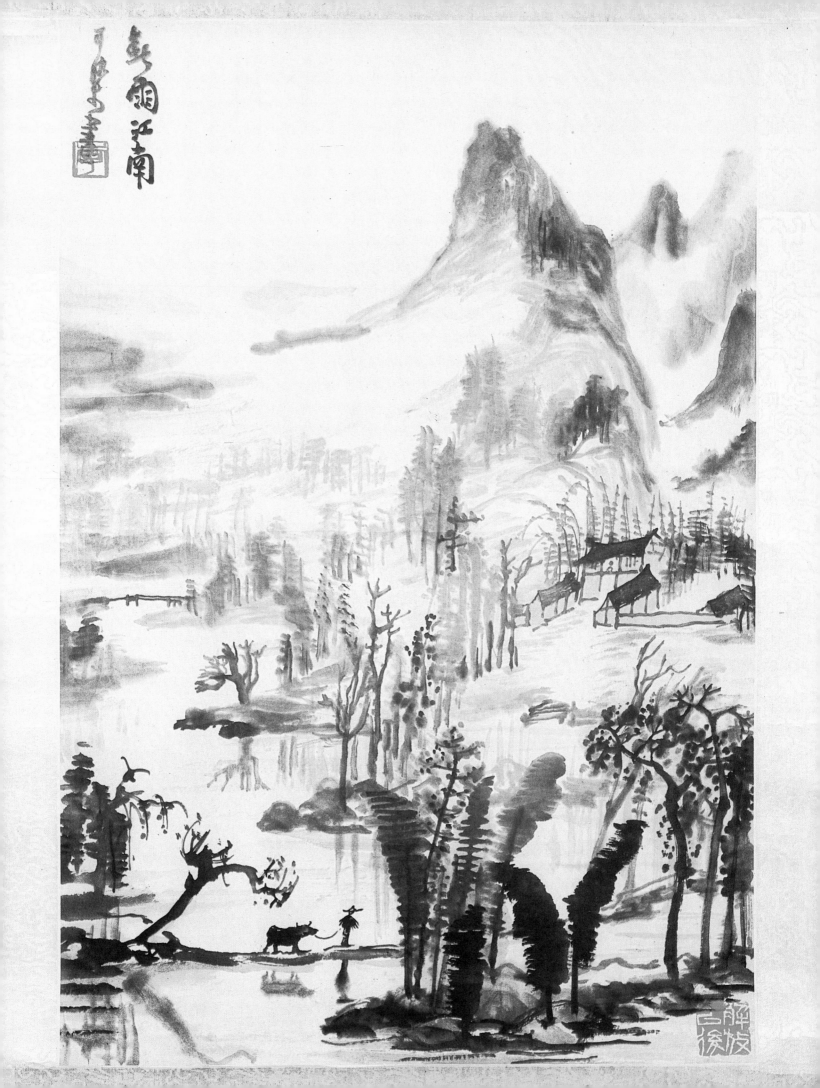

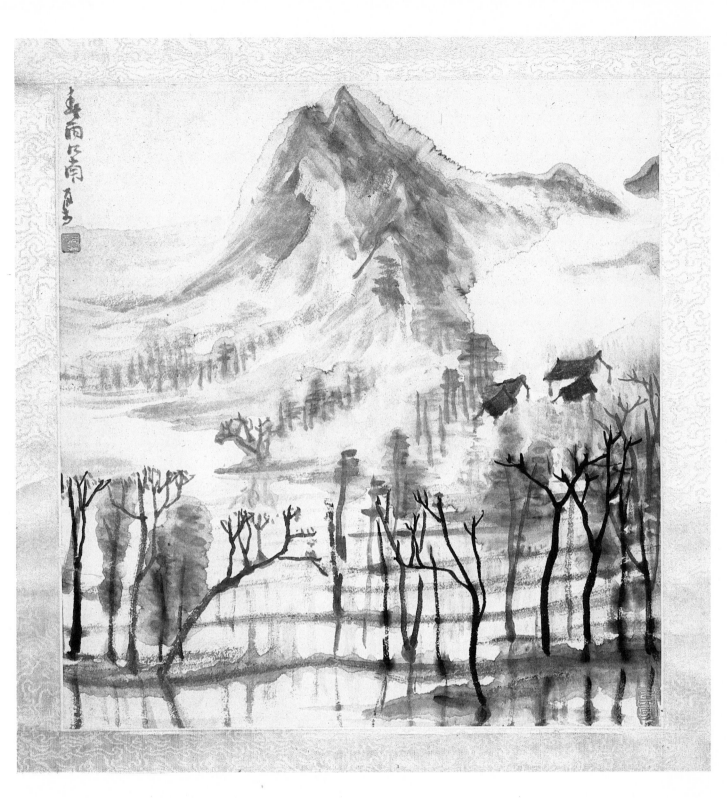

106 Li K'ê-jan: Spring Rain in the Southern Landscape

105 Li K'ê-jan: Southern Chinese Landscape in Spring Rain

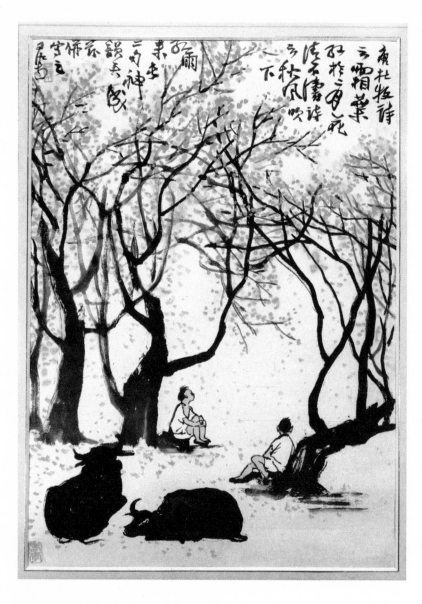

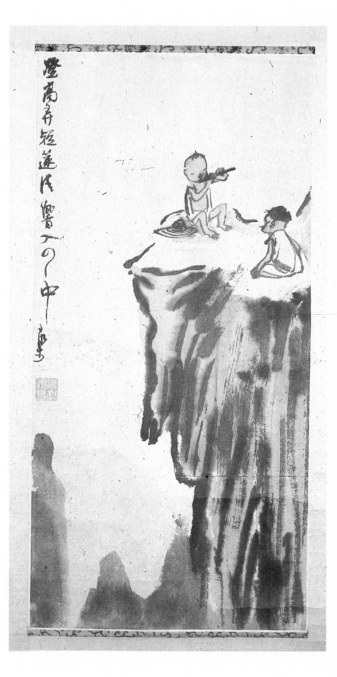

107 Li K'ê-jan: Red Leaves (based on a poem by Tu Fu and Shih T'ao)

108 Li K'ê-jan: Shouting into the Clouds

109 Li K'ê-jan: Spring Walk to the Chi-ch'ang Park

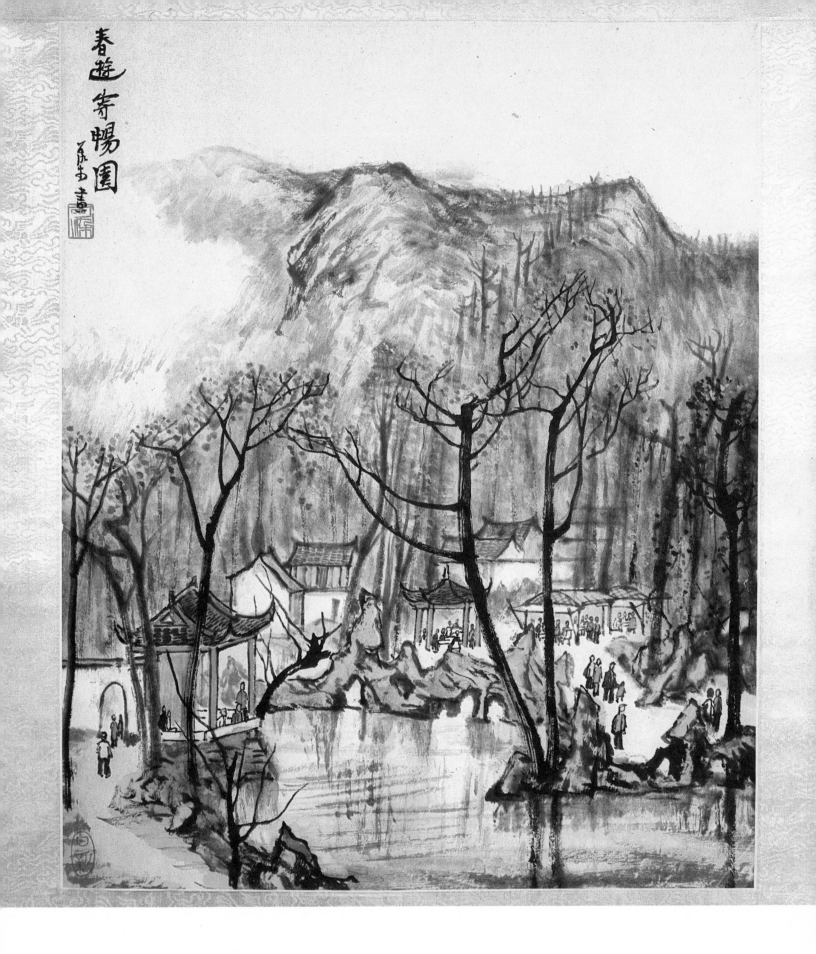

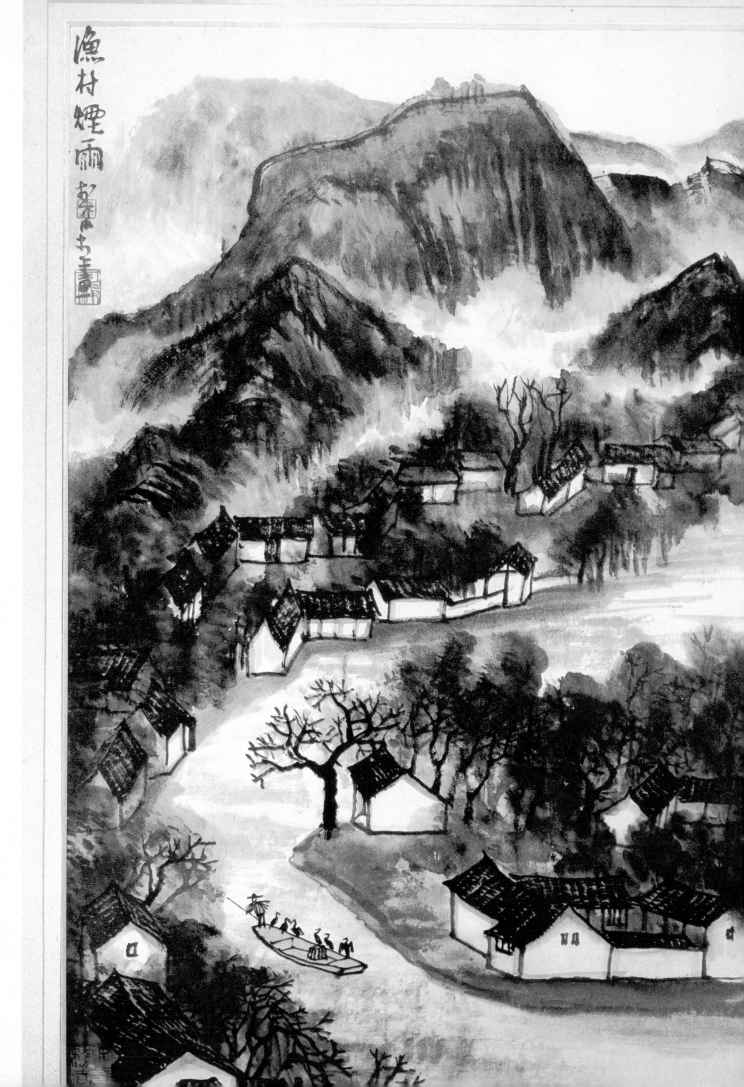

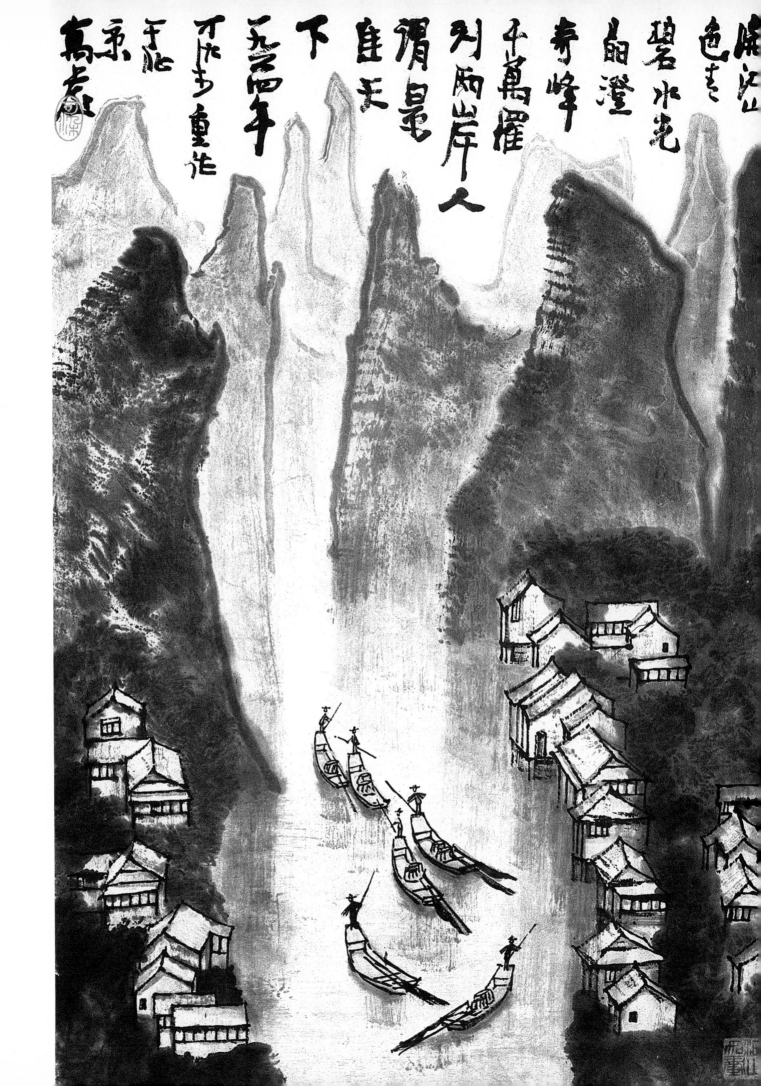

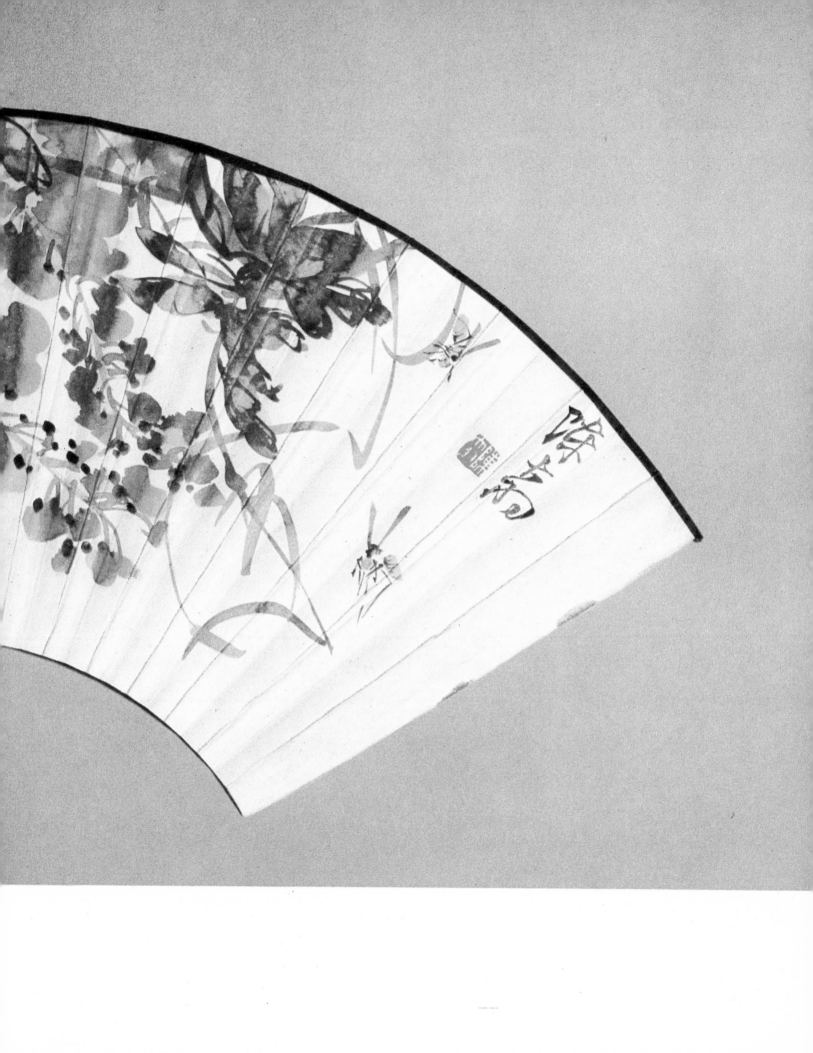

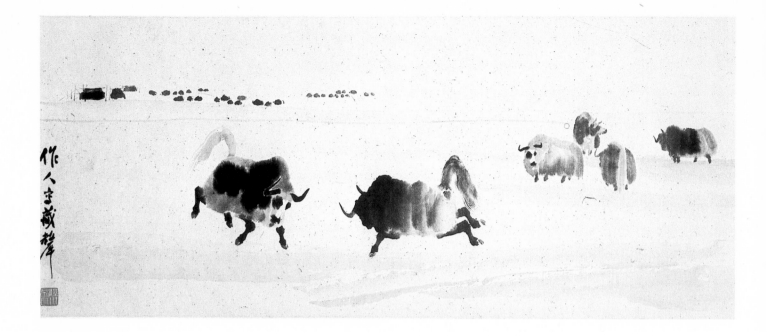

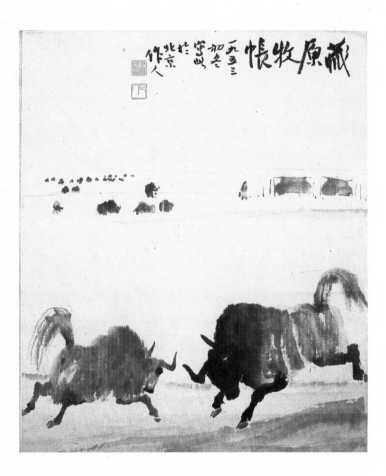

113 Wu Tso-jên: Yaks

114 Wu Tso-jên: Shepherds' Tents on the Tibet-
an Uplands

115 Wu Tso-jên: Two Elephants

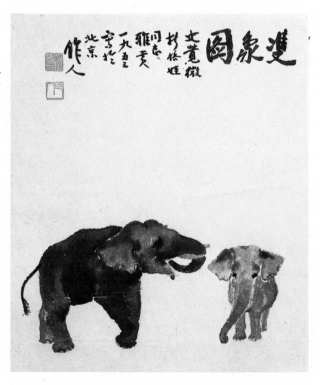